ROCK'N'ROLL YEARS 1960-2000

THE PHOTOGRAPHERS' CUT

VISION ON

Published by Vision On ©2000

FOREWORD

ROCK'N'ROLL 1960-2000

THE PHOTOGRAPHERS' EDIT

The UK's leading rock photographers were asked to choose their favourite pictures - the pictures that mean the most to them - this collection is the result. With the help and support of 24 photographers this book charts the last 40 years of popular music history. It is their cut... Their edit.

The pictures illuminate the differences and similarities between the legends and fashions that have inspired three generations of fans and musicians alike. These are pictures that will remain as fascinating for future generations as they were when they were taken. From The Beatles and The Stones, via The Clash and The Jam, to Madonna and Blur there can be just one thread that links them - it's only rock'n'roll, but we like it...

INTRODUCTION

"The picture says it all," notes Pennie Smith alongside her shot of Pete Townshend, live and airborne in 1983. Well, it's a grand old line and someone had to use it. No doubt, every one of the photographers would like to have got there first. Choosing from a lifetime's photographs was difficult enough. But then to be asked to explain *why*… Don't you understand, photographers are about the eye not the intellect, the instinctive left side of the brain not the analytic right? Anyway, isn't a picture worth a thousand words? Possibly, but if a picture does say it all exactly, what "all" might that be?

Of course there's art. But initially it depends on who is paying the bill. These are professional photographers and professional subjects. Commercial needs, fears and aspirations impinge on everything they do together.

Live shots are a rock staple. The moment of magic truth is the ideal, the picture that feels like now forever, that you can hear, that makes you sweat and go "Mmmm!" Like Mick Rock's immortal snap of David Bowie giving head to Mick Ronson's guitar. "I believe this was a completely spontaneous act," says Rock. "David didn't warn me about it. I was on the side of the stage and he provided me with an instant classic." Like Pennies Smith catching The Clash's Paul Simonon about to smash a bass guitar. "Paul didn't look happy all evening so I watched and waited, then ran 'cos I thought he was coming at me!" says Smith.

Yet, in truth, performers are rarely unaware of the cameras pointed their way. They play to the thousands in the hall *and* the hundreds of thousands who will see the paper the next day. For at least the last 20 years, stars have had the photographers chucked out of the stage-front pit after three numbers so that they can throw helpful shapes while their hair still looks nice, then forget about it and concentrate on the crowd. So paparazzi snaps are probably the closest the public ever gets to a glimpse of rock-star reality. Consider John Hopkins's picture of The Beatles walking from their car through a scattering of bystanders towards the *Juke Box Jury* studio: no drama, but a pure slice-of-life moment with only Ringo Starr even aware the camera was there - and seizing his moment to front the band.

At the other end of the commercial spectrum come the pictures actually commissioned by the artists themselves for record sleeves or other publicity uses. In this category are Rankin's luminous portrait of Madonna and Jill Furmanovsky's observation of Noel Gallagher alone in a hotel room (born from her long-term stint as Oasis's visual documentarist). Obviously, if the subject is paying the bills, means and ends all flow one way and most of the potential conflicts of interest involved in a shoot are eliminated. Which only goes to show that good pictures can result from co-operation as well as tension.

But it's a tangled web. Several pictures in this book testify to the power of duplicity and the photographer's willing role as intermediary between a star with an "image" to project and fans with a fantasy to feed. Gered Mankowitz's portrait of a sweetly smiling Jimi Hendrix is almost a case of "at last the truth can be told". The Hendrix he knew, contrary to the legend, was always stoned but rarely out of control, and of "charming, modest and funny" disposition. But, says Mankowitz, because "the look at the time was very unsmiling", during their sessions they felt obliged to stop laughing for long enough to get at least a couple of decent "cool sneer" shots. Similarly, it may be a disturbing revelation for Joy Division fans to hear Kevin Cummins' admission that he always released pictures of Ian Curtis "looking serious" because "it propagated the Manchester miserabilist myth" whereas "nothing was further from the truth.

Sorry to disappoint you, but Ian Curtis liked a pint. He didn't just sit on the bus reading Sartre."

Despite veiled levels of artifice and deliberate reader manipulation, the Hendrix and Curtis pictures are posed straightforwardly. However, quite a few of the photographers' fondest memories were of elaborate plots hatched in collaboration with artists in pursuit of something different, to shock, amaze, get a reaction somehow. It could be with body paint: Cummins worked with Suede's Brett Anderson for six hours, constantly slapping on new coats as cracks appeared. It could be with lighting: Rock had a "visceral, intuitive thing" that told him to light Freddie Mercury from above as Joseph von Sternberg had lit Marlene Dietrich in the 1932 movie *Shanghai Express*. It could be with image-bending costumes or montage: Steve Pyke superimposed Shaun Ryder on to a '60s poster of Che Guevara. And then, of course, there were the New Romantics (Pardon a moment's coarseness, but, through all the phases and fashions of rock'n'roll, are Spandau Ballet the only band in this book who really do look daft? Or is that a generation thing?)

Still, acknowledging all that sweated creativity, it may be that some of the most durable images are the product of happy accidents. The versatility of rock photographers is often under-appreciated. Certainly, they like nothing better than poncing about a studio tended by a team of assistants. But kick them out on to the street and most of them become formidable news-hounds. In this regard, the indefatigable Cummins probably takes the prize with his resonant picture of (since disappeared) Manic Street Preacher Richey Edwards backstage in Bangkok, his chest cut in lines, blood running down like notes on a stave. "A fan had sent him a set of ceremonial knives before the show, with a note asking him to cut himself on stage," says Cummins. "He refused, thinking this would be too theatrical. However, during a break in the show when James

sang 'Raindrops Keep Falling On My Head', Richey was backstage carefully slashing his chest. When I asked him why, he simply said, 'Because he asked me to. I didn't want to disappoint him.'"

Which just goes to show the picture may not necessarily say it all *every* time. A word of explanation may add something. A word of critical comment, in fact a dialogue, is hardly to be avoided if we are to explain to one another why we love or hate this or that photograph just as we do with a film or an episode of our favourite TV show.

For instance... To get personal, the music in action, the soul and the beat captured in a frame. Bowie and Ronson, and the Clash, certainly, but also other less sensational images rendered entrancing maybe beautiful as still life. Chic, in Jill Furmanovsky's photograph, carved as hard and passionate as a Michelangelo tableau, the funk made over in renaissance marble... And finally the Pennies Smith "picture says it all" Townshend: a coiled spring with knees up and heels tucked back for optimum illusion of height, nothing below him and above him only a spotlight sunburst sky, the star suspended in eternal elegance like those familiar, impossible times when a great footballer leaps to meet a centre with his head and, to all appearances, waits in mid-air, gravity defied: you look at the page and somewhere inside you're walking on the moon. Or at least I am.

For anyone with open eyes and a sensual imagination this book will repay a good, slow look. Or read. Or listen, even. The picture says it all. It's just that it speaks in tongues.

© Phil Sutcliffe

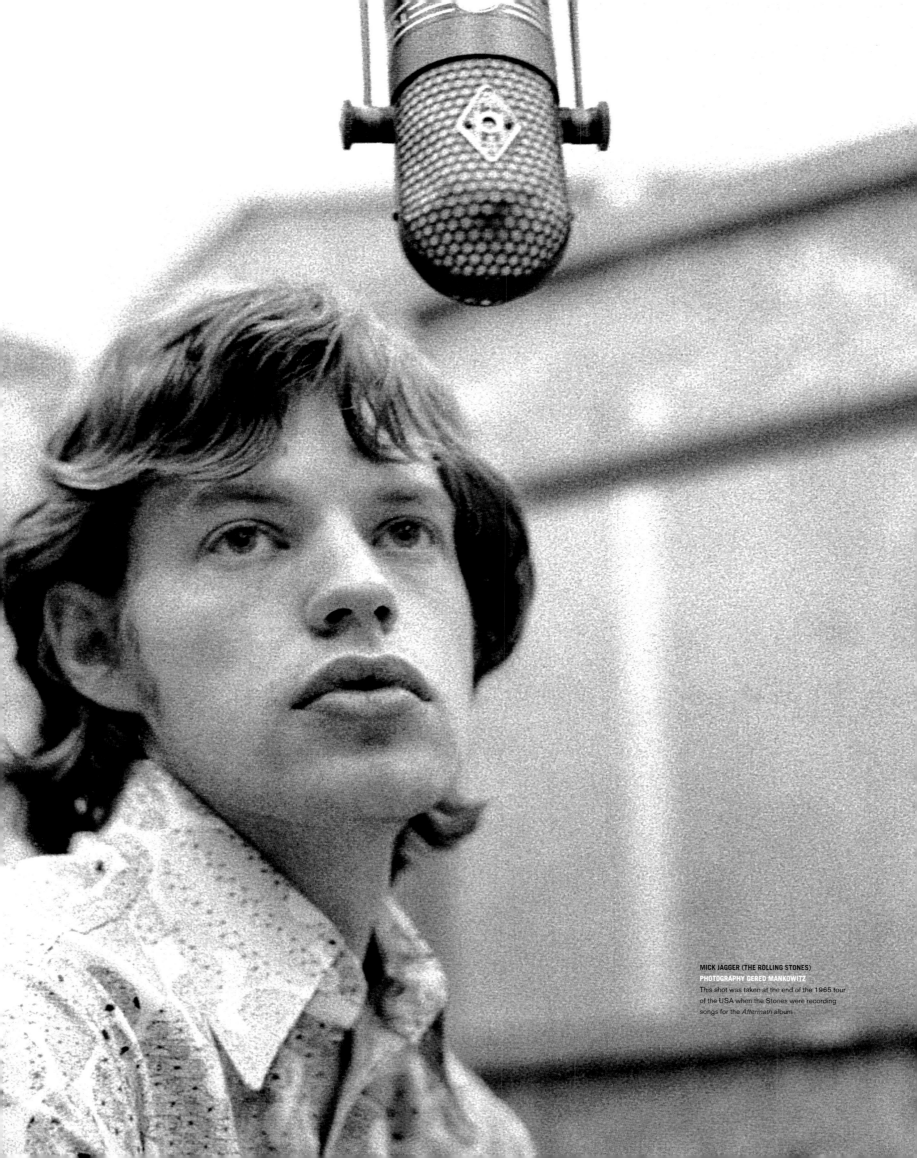

MICK JAGGER (THE ROLLING STONES)
PHOTOGRAPHY GERED MANKOWITZ
This shot was taken at the end of the 1965 tour
of the USA when the Stones were recording
songs for the *Aftermath* album

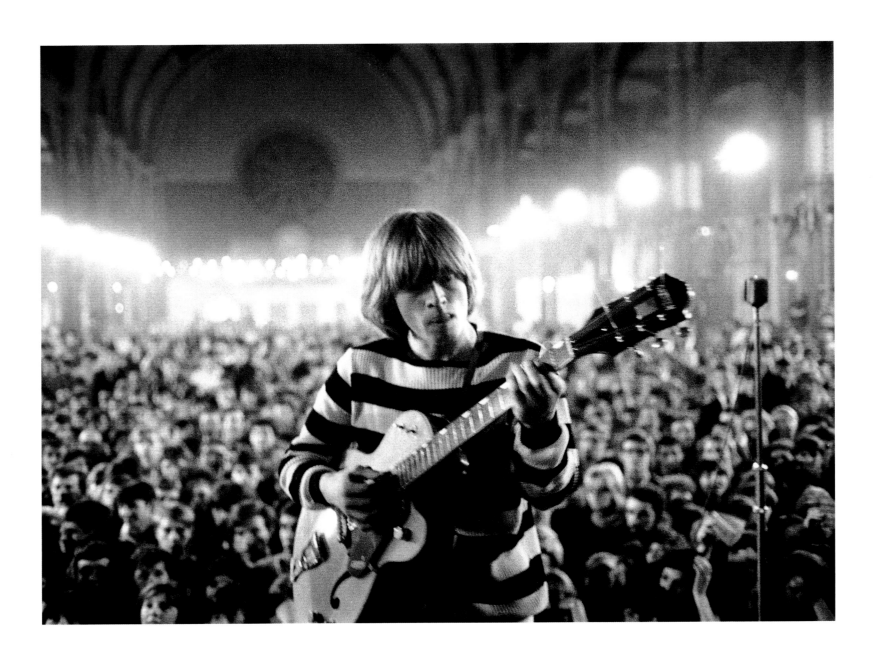

BRIAN JONES
(THE ROLLING STONES)

PHOTOGRAPHY JOHN HOPKINS

Brian Jones performing at an all nighter at
Alexandra Palace

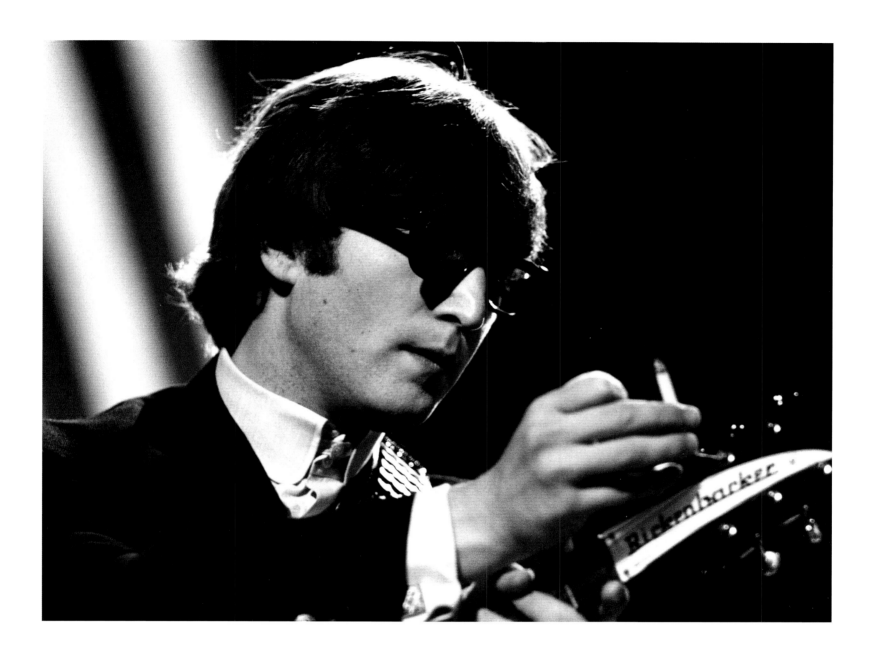

JOHN LENNON
(THE BEATLES THEN THE PLASTIC ONO BAND)

PHOTOGRAPHY JOHN HOPKINS

John Lennon with The Beatles performing on
Ready, Steady, Go!

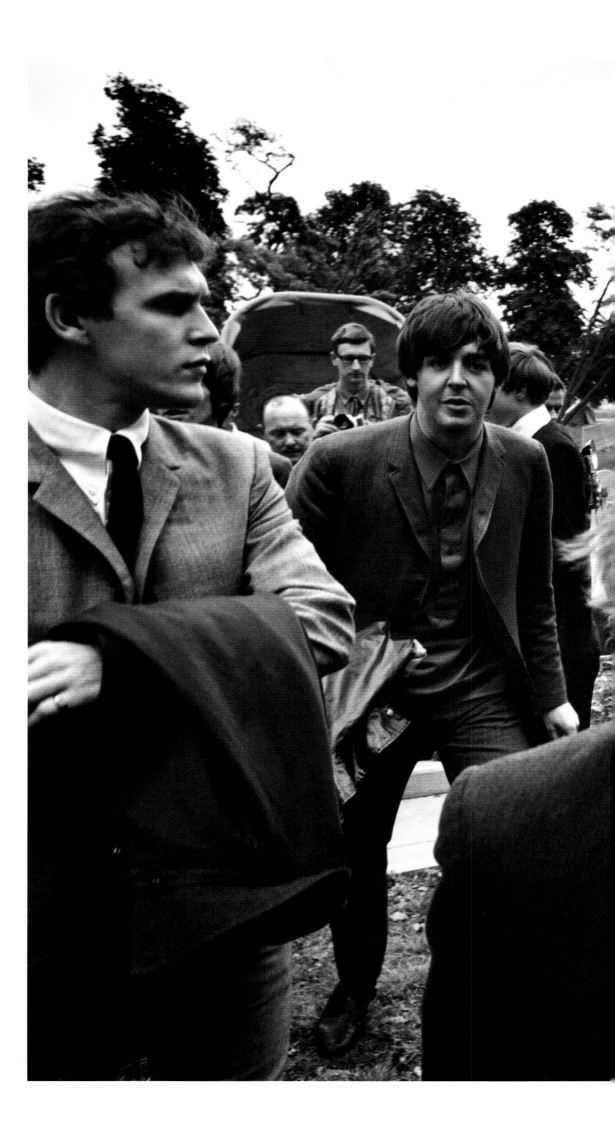

THE BEATLES (RINGO, JOHN & PAUL)
PHOTOGRAPHY JOHN HOPKINS
The Beatles at Teddington Studios on the way to
the filming of *Juke Box Jury*

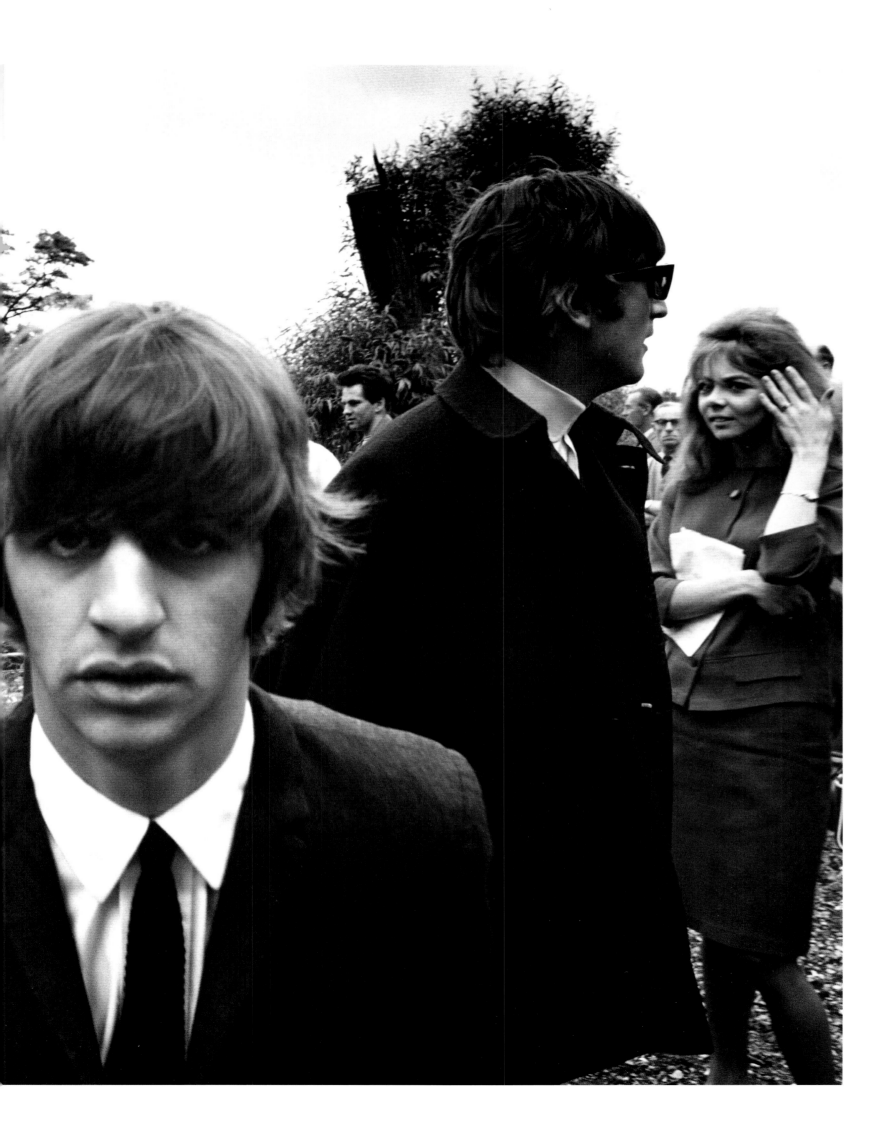

THE ROLLING STONES
PHOTOGRAPHY DAVID WEDGBURY

This was taken on the roof at Decca Records overlooking the Thames. My approach was simplicity: to capture them without dressing them up or searching for locations

MARIANNE FAITHFULL
PHOTOGRAPHY GERED MANKOWITZ

I used to spend a lot of time with Marianne during these early days. On this occasion we were en route to one of her gigs when I spotted this location and thought it would give us a nice background for a portrait. For many years it was my favourite photo of her because it caught her smile so beautifully

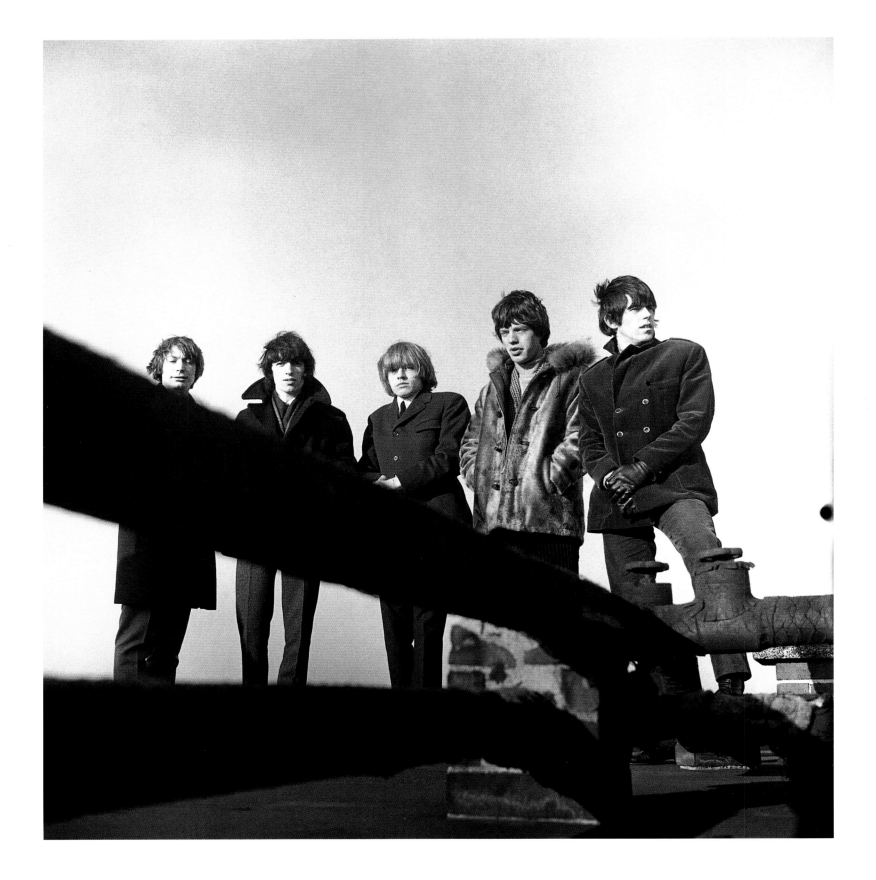

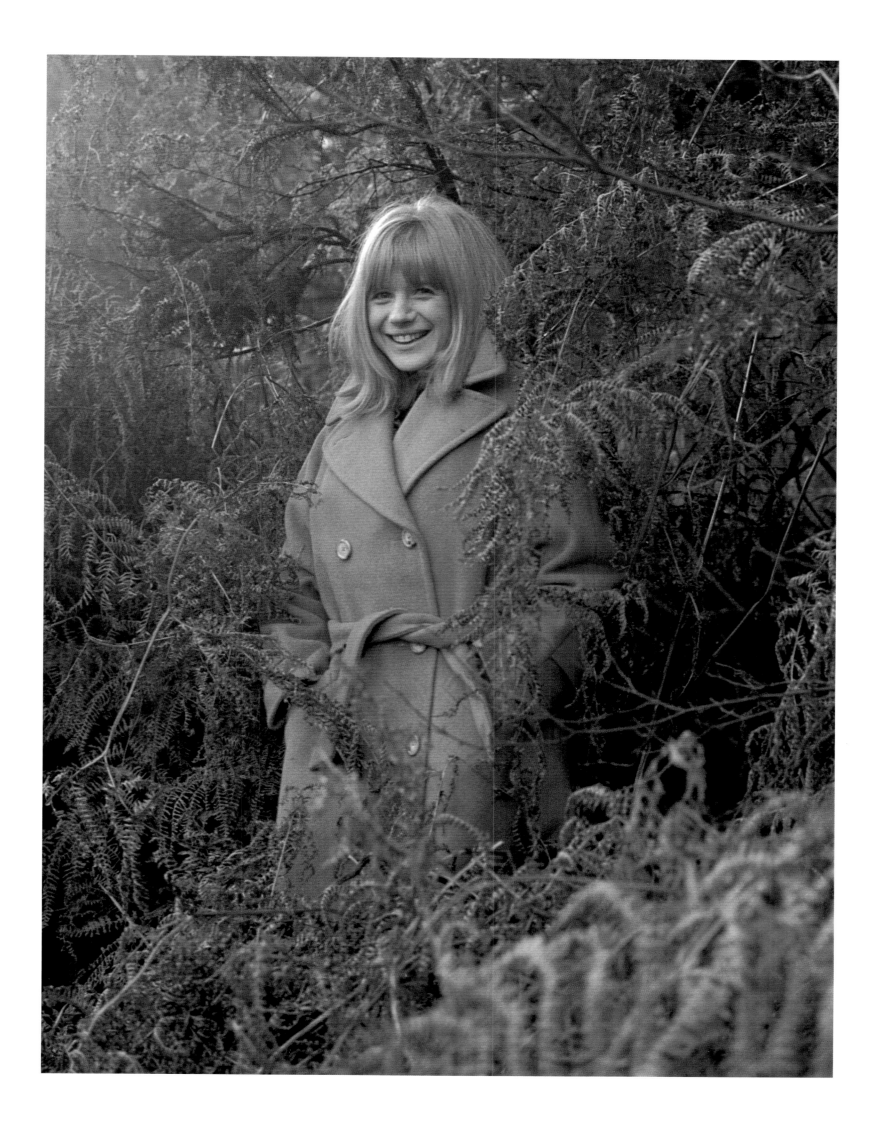

JIMI HENDRIX

PHOTOGRAPHY GERED MANKOWITZ

Jimi was a delight to work with because he looked so wonderful, without, apparently, doing anything special. He looked the epitome of a rock star from the beginning and yet he was always charming, quiet, modest and funny. The look at the time was very 'unsmiling', but we were always laughing so much it was difficult to maintain the cool sneer we were looking for

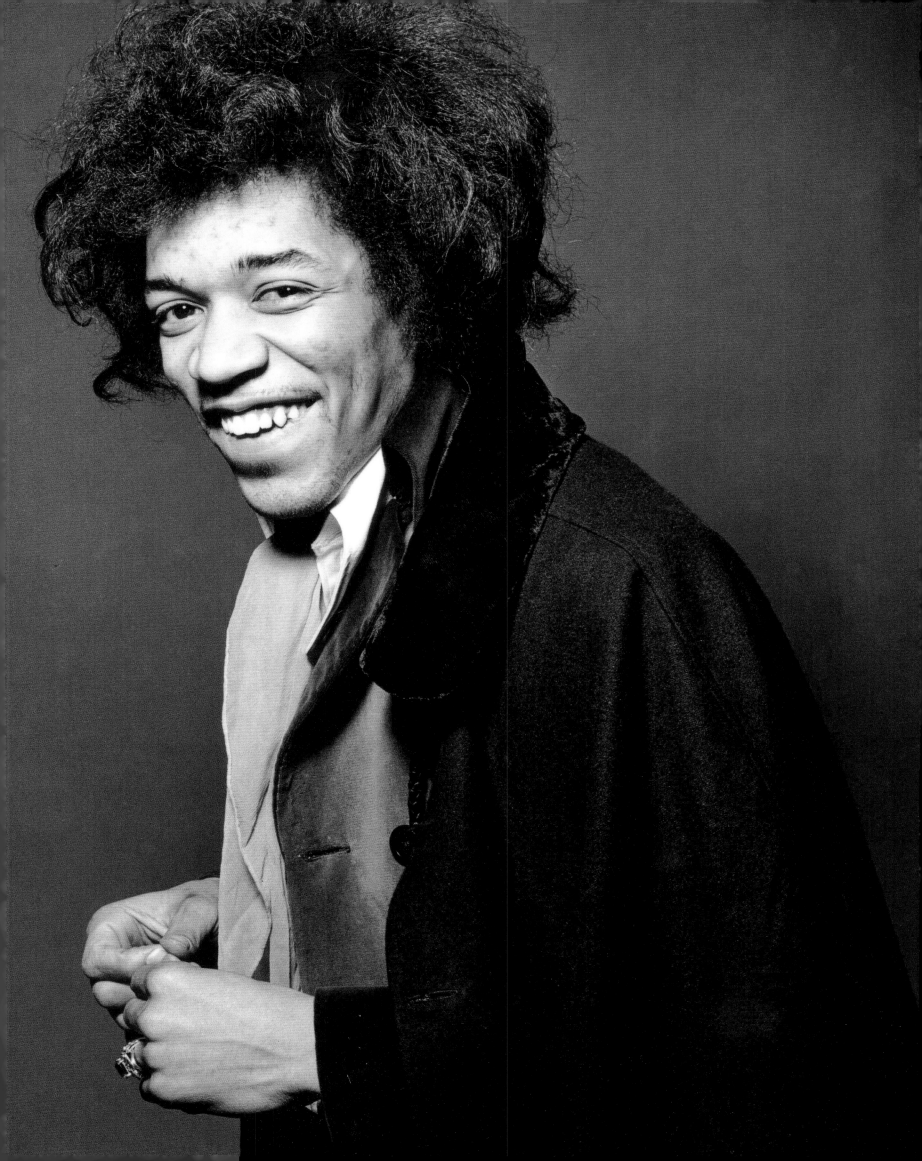

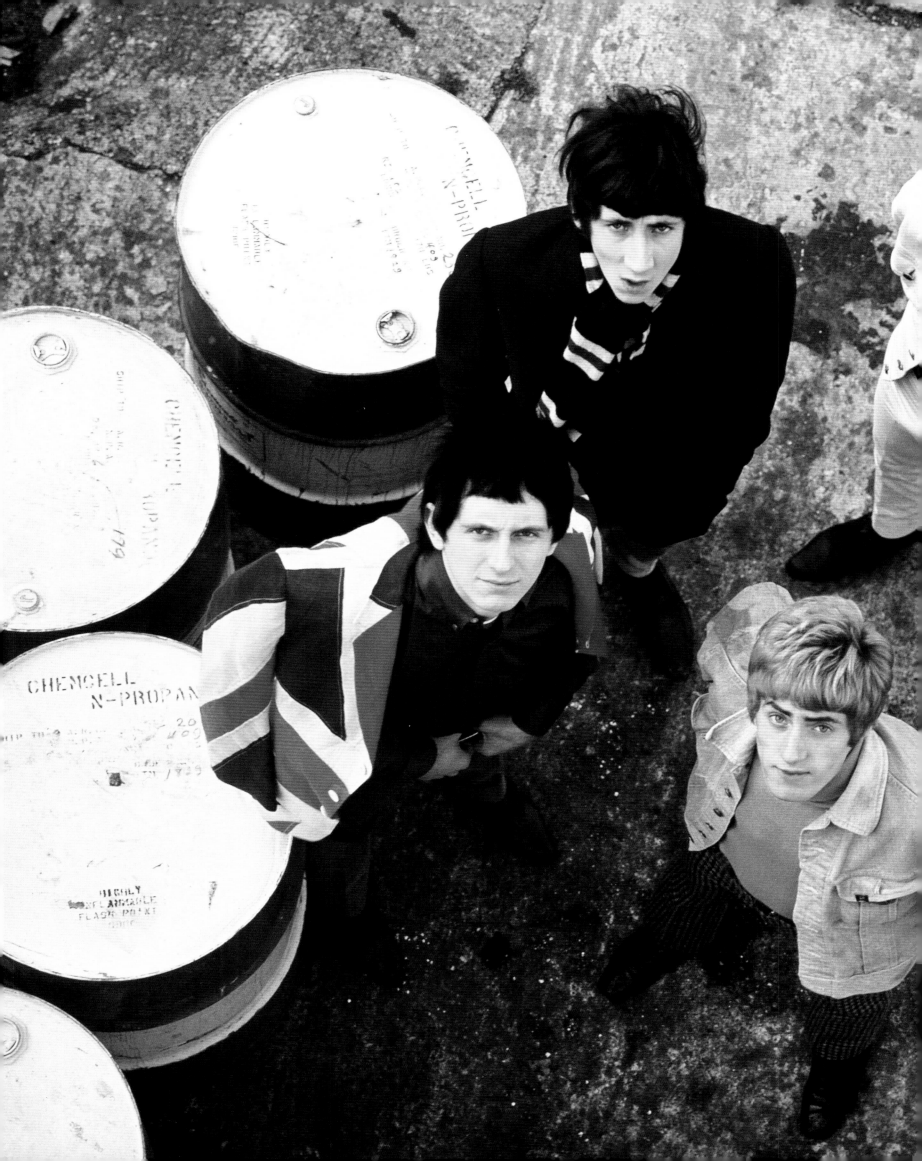

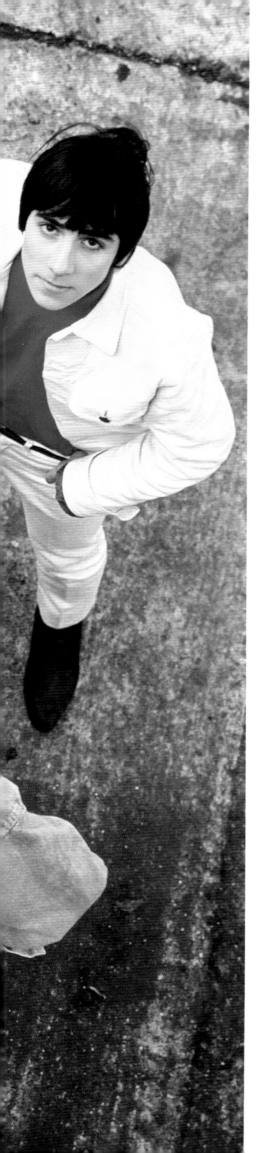

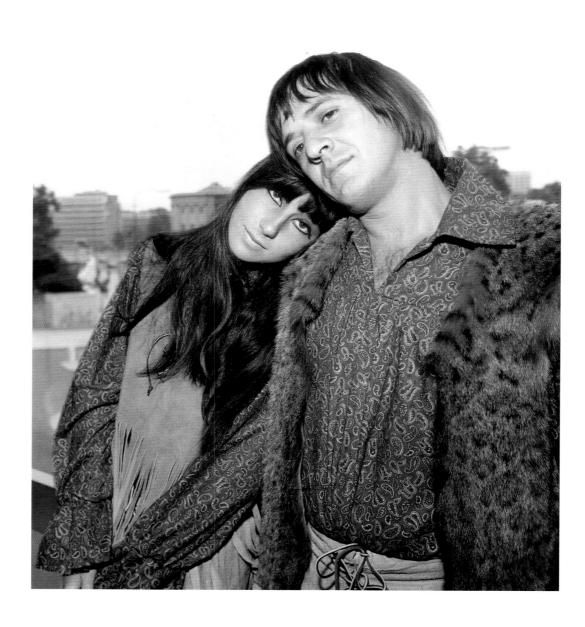

THE WHO
PHOTOGRAPHY DAVID WEDGBURY
The *My Generation* album cover taken at Surrey
Docks hanging out of a crane

SONNY & CHER
PHOTOGRAPHY DAVID WEDGBURY
This was taken when they came across for their
first appearance on *Top Of The Pops*

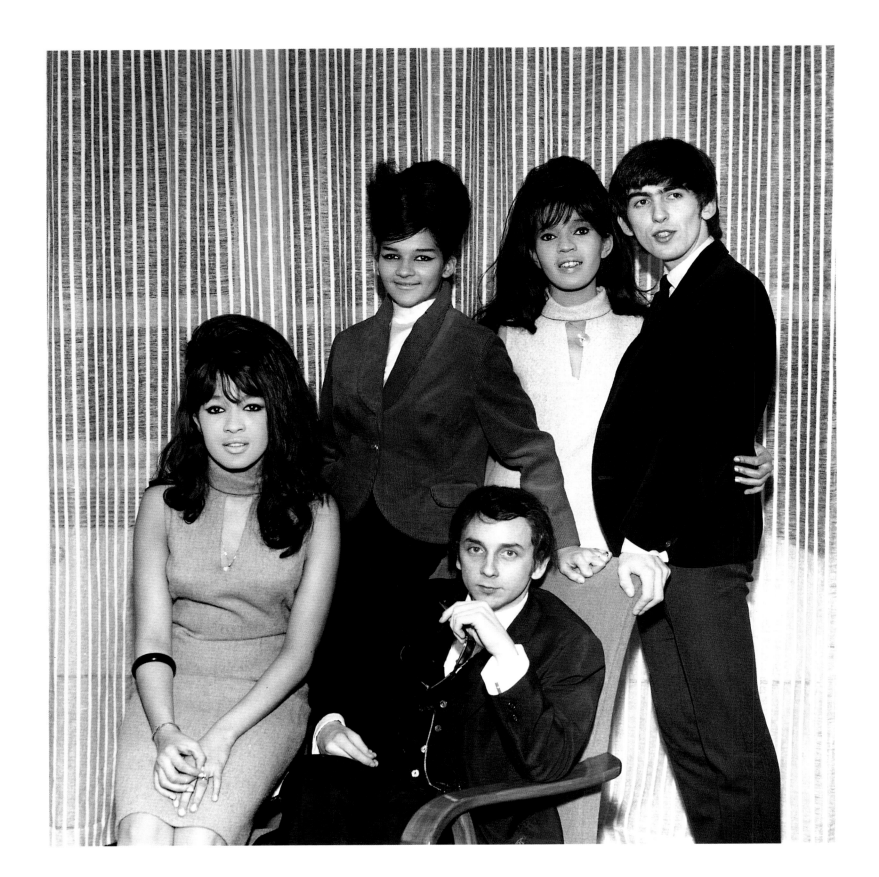

PHIL SPECTOR, THE RONETTES & GEORGE HARRISON
PHOTOGRAPHY DAVID WEDGBURY
Taken at The Ronettes' launch on their first visit to England

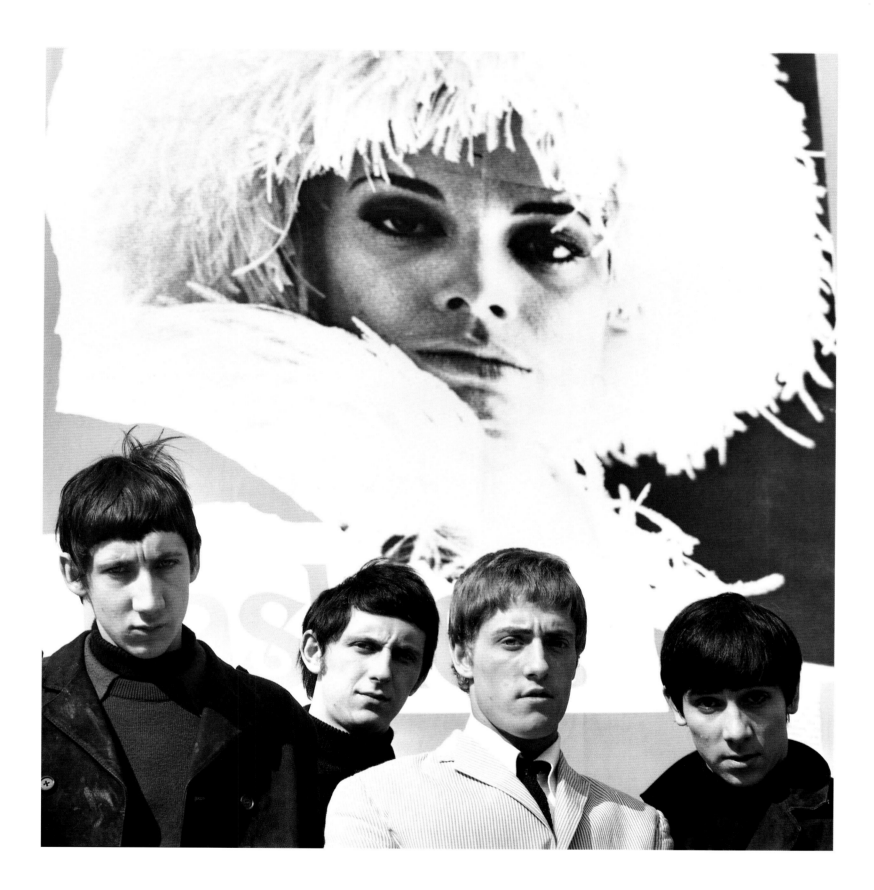

THE WHO
PHOTOGRAPHY DAVID WEDGBURY
An early attempt at pop art photography

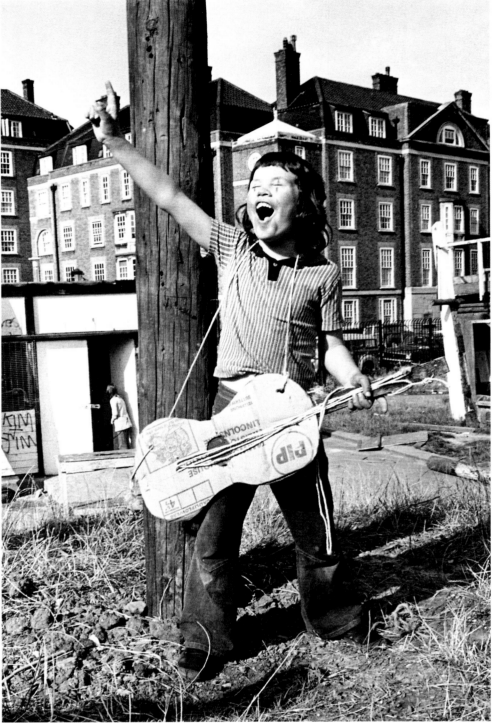

DUDE

This was originally shot for the front cover of Mott
The Hoople's album *All The Young Dudes*. I've
discussed it many times with Ian Hunter. It provoked
a dramatic change in the drugs we were using

DAVID BOWIE AND MICK RONSON

I believe this was a completely spontaneous act,
David didn't warn me about it. I was on the side of the
stage and David provided me with an instant classic

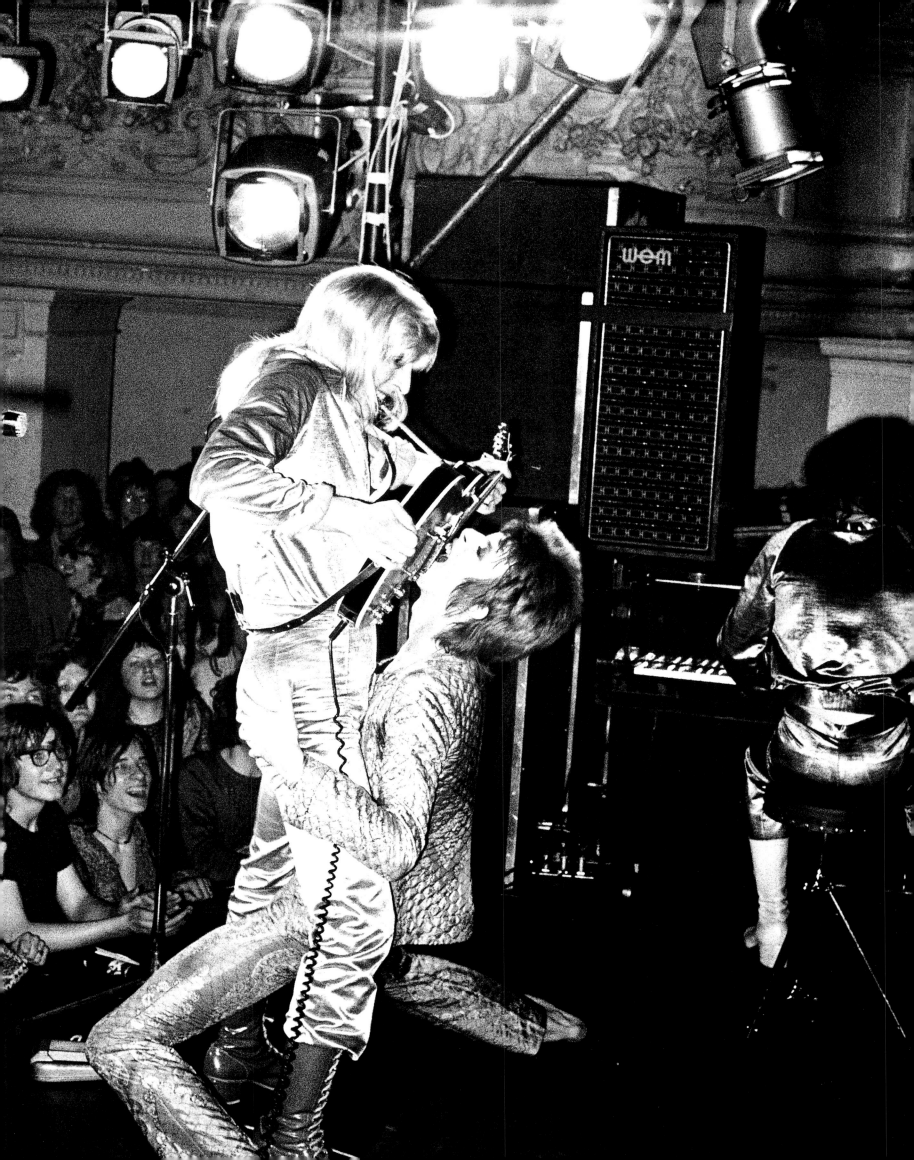

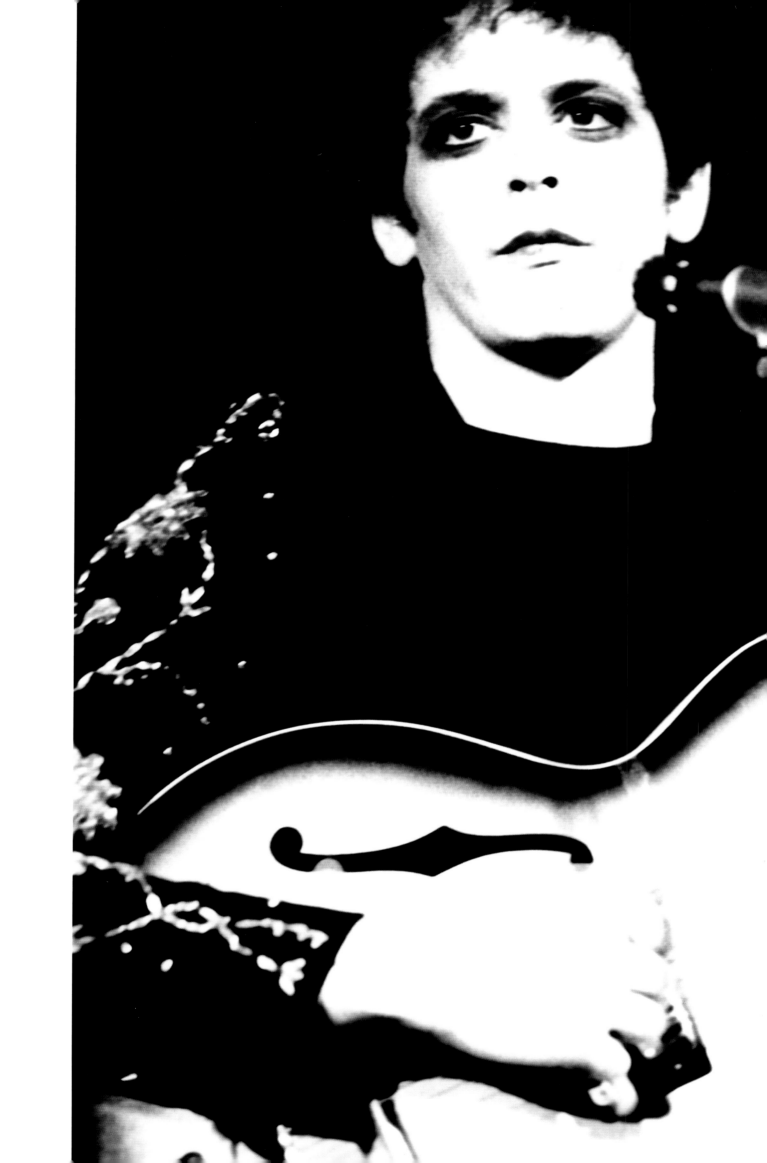

© Mick Rock

LOU REED
(THE VELVET UNDERGROUND, THEN SOLO)
PHOTOGRAPHY MICK ROCK

The cover shot for *Transformer*. This was taken at King's Cross cinema which had been converted into a venue for two months. The day after the concert I wrote, 'The theatre was very hot. Lou was wearing his gauchon style suit. He moved very little but he sweated a lot. His kabuki make-up ran and he let it. Like some exotic presence plucked from a German expressionist film of the silent era, only this time wired for raw sound…' I remember one warm afternoon visiting Lou in Wimbledon for tea and pictures. When we looked over the black and white contact sheets from the concert, Lou focused in on a certain frame. This was the one he especially wanted to see. I didn't notice the negative fall out of focus in the enlarger when I made the first test print. But I still recall the instant tingle when I saw the result of that oversight taking form in the developer. Now, that was magical!

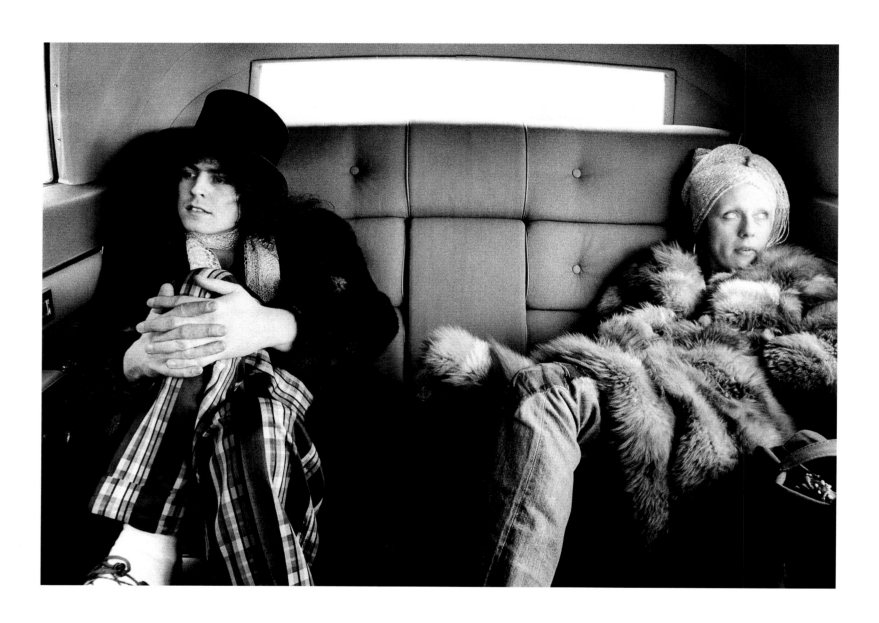

MARC & JUNE BOLAN

PHOTOGRAPHY KEITH MORRIS

Early morning in a limo in Detroit, there was a
distance between them that I needed to record

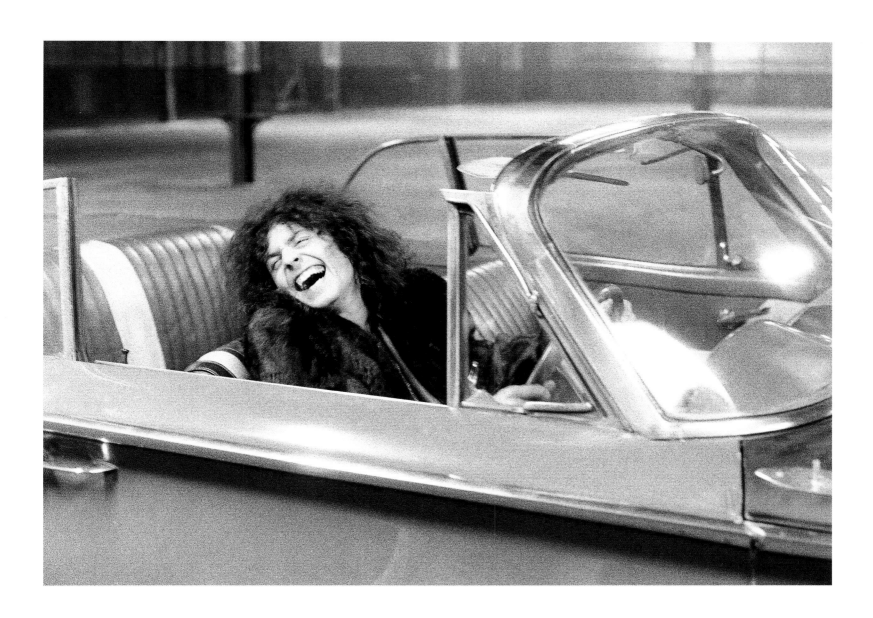

MARC BOLAN (T-REX)

PHOTOGRAPHY KEITH MORRIS

Taken on the set of his film *Born To Boogie*, we were chatting and looking at the car that was used in the film, he told me he'd never learnt to drive because he believed he'd be killed in a car crash (he was). It was a chance to get a unique picture of him behind the wheel

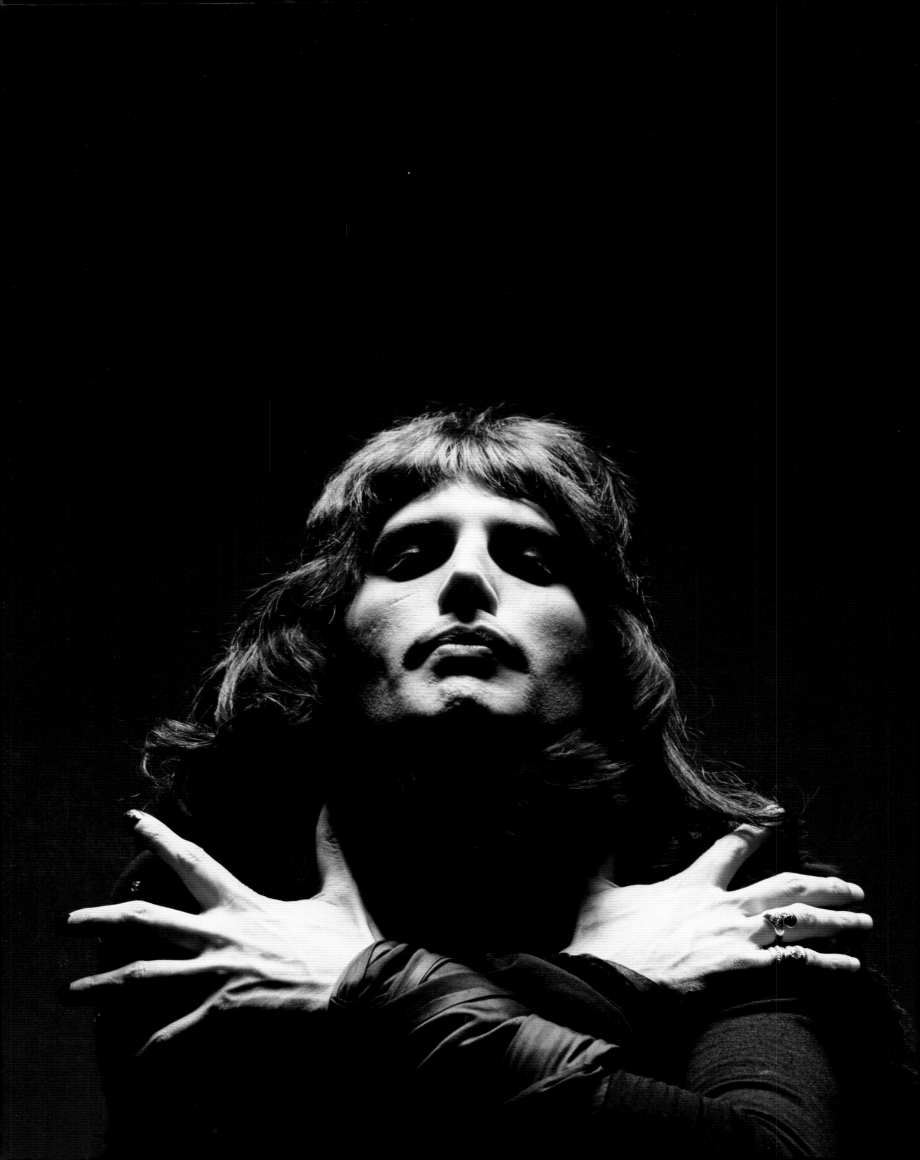

FREDDIE MERCURY (QUEEN)

I had discussed a photo of Marlene Dietrich from the film *Shanghai Express*, it was one of those visceral, intuitive things. Glamorous, mysterious and classic. So I went to Freddie, he understood it immediately and sold the rest of the band on the idea
© Mick Rock

PINK FLOYD

The fact that this image exists at all is a miracle. During *The Wall* era, Pink Floyd's Roger Waters was especially touchy. Although I had worked with them for years, when their management found out I had taken images without permission at this show, my film was confiscated and it disappeared forever. Luckily one roll survived hidden in a pocket and produced three good images, of which this is one. Ironically, the band ended up using this image themselves many years later in a box set of their recordings

JIMMY PAGE (LED ZEPPELIN)
PHOTOGRAPHY PENNIE SMITH
My first *NME* commission - in at the deep end

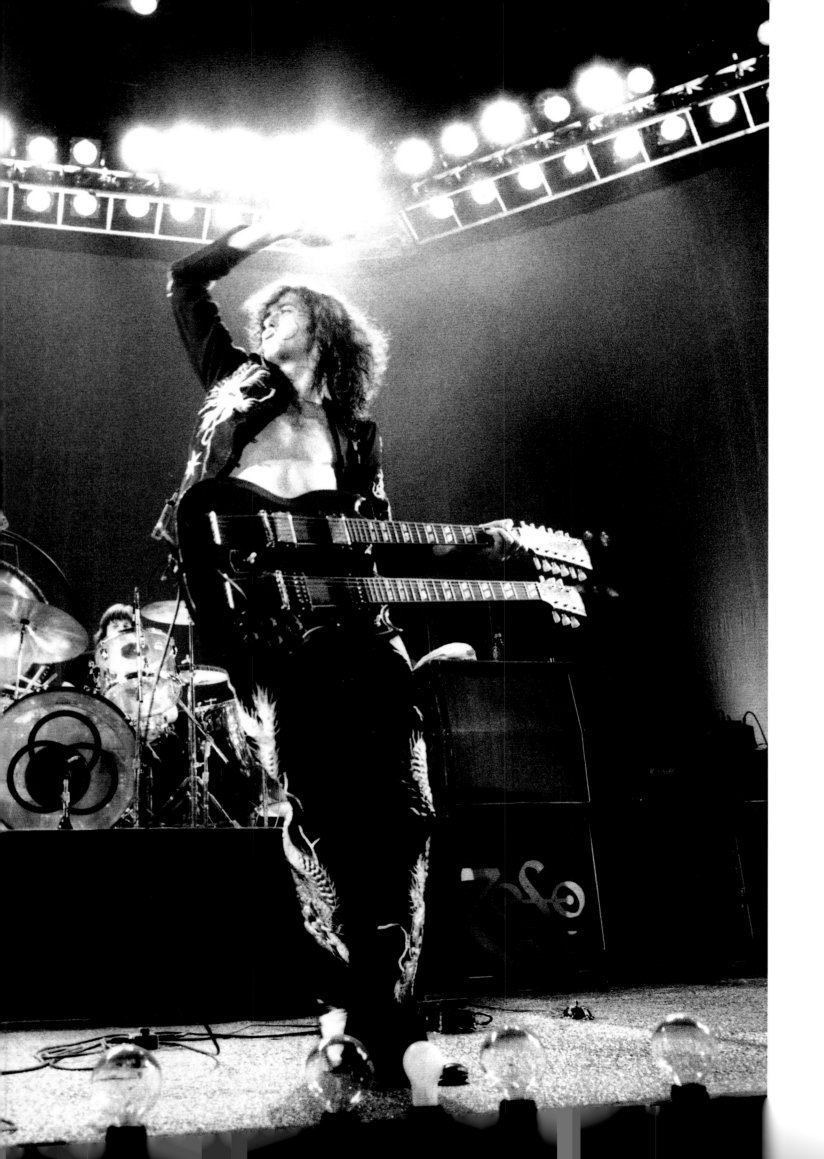

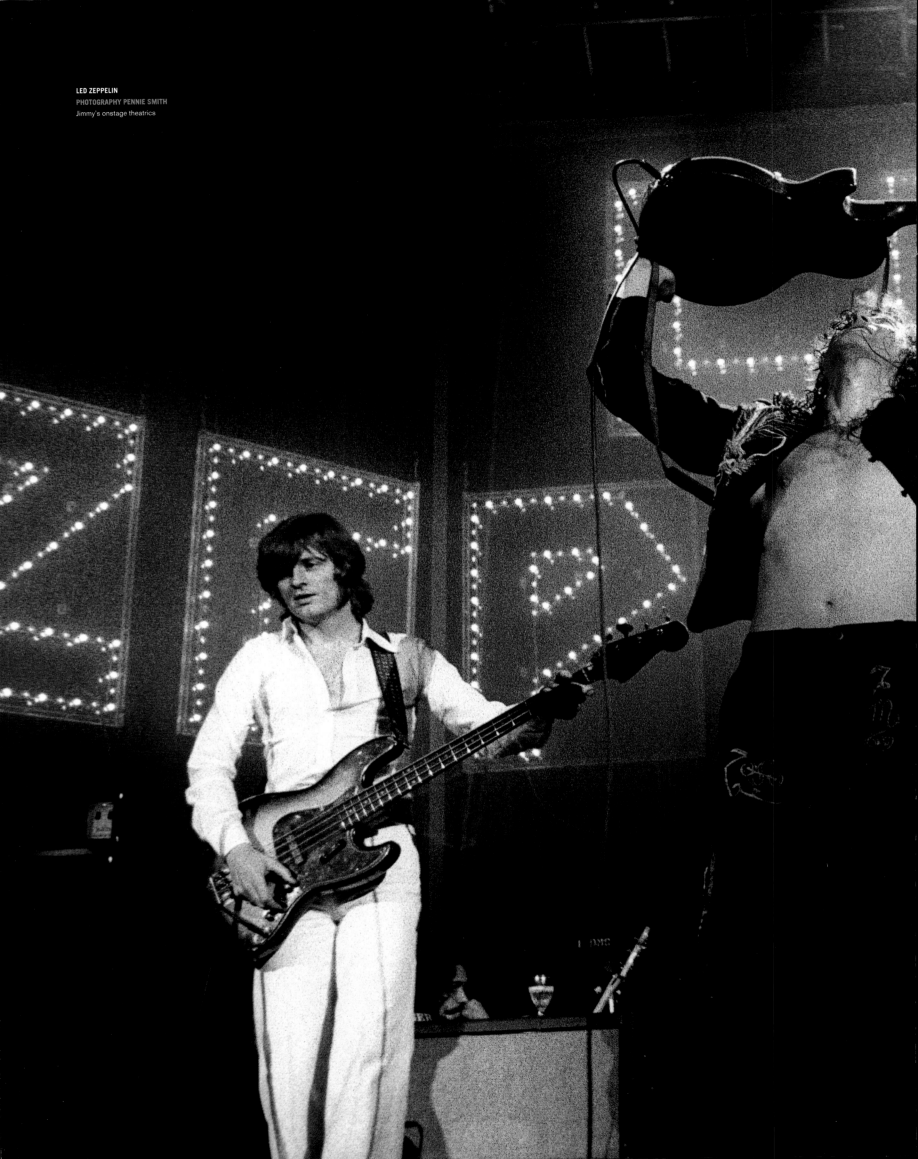

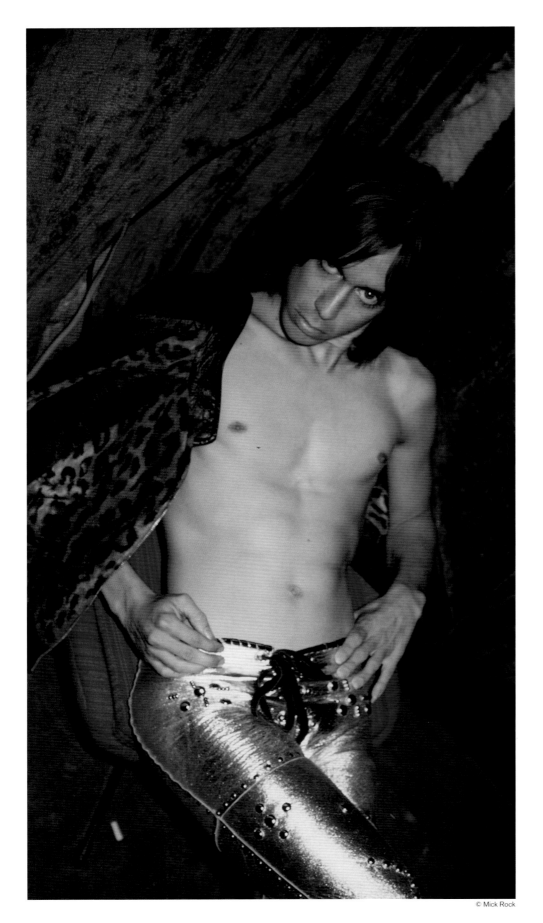

IGGY POP (THE STOOGES, NOW SOLO)

PHOTOGRAPHY MICK ROCK

This was part of a session taken of The Stooges in a smouldering basement rehearsal studio off the Fulham Road. The Stooges felt very comfortable there. Iggy was wearing the same silver trousers as he wore at the Raw Power concert. In retrospect he looks so young and pouty, it's impossible to see the brooding master within his soul

PAUL SIMENON (THE CLASH)

PHOTOGRAPHY PENNIE SMITH

London Calling album cover. Paul didn't look happy all evening so I watched and waited (then ran 'cos I thought he was coming at me!)

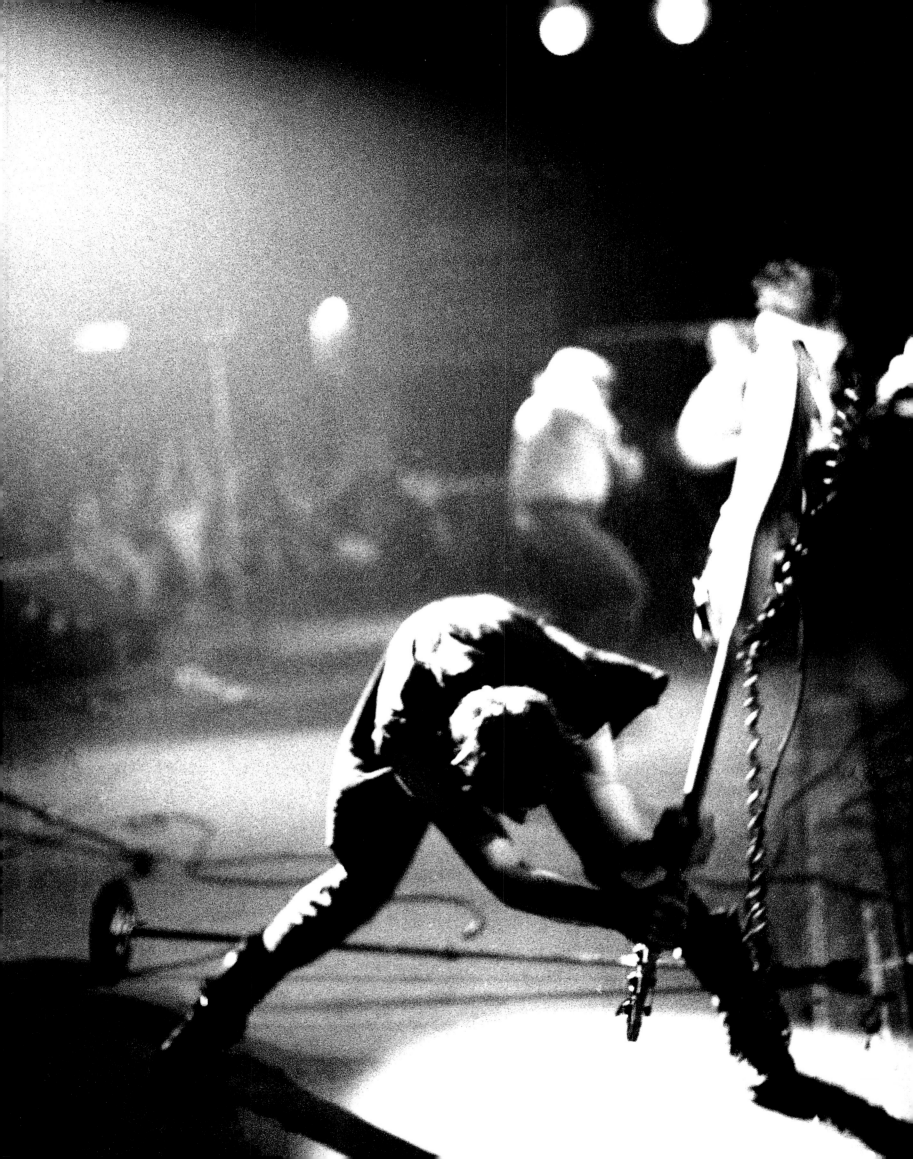

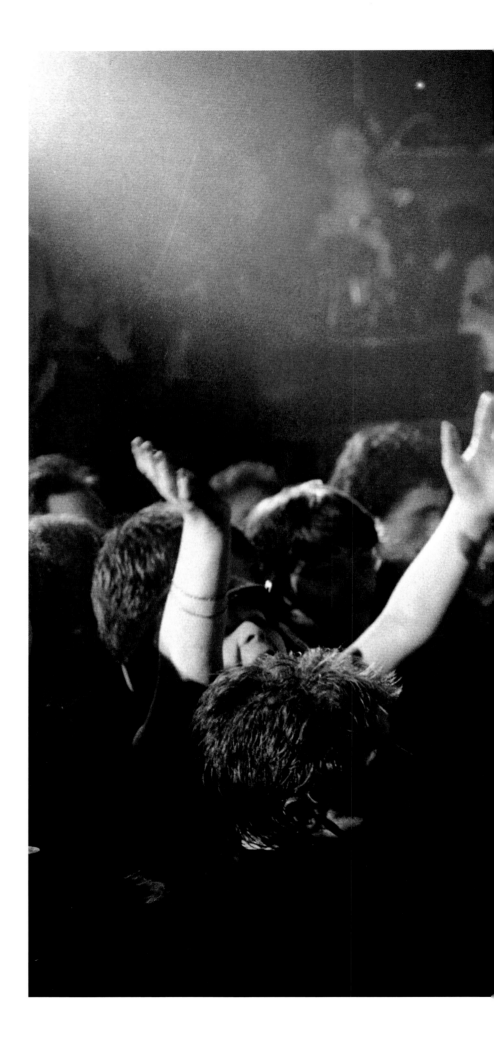

THE SEX PISTOLS

PHOTOGRAPHY KEVIN CUMMINS

The Sex Pistols photograph was taken on Christmas day 1977 at Ivanhoe's club, Huddersfield. The initial batch of tickets for the gig were printed with a phone number to ring on December 22 to find out the date and venue. This was either paranoia or another great marketing ploy from Malcolm. I was the only photographer allowed to shoot what was to be The Sex Pistols' last ever British show with Sid. A few days earlier, I'd seen them at Knickers in Keighley, Yorkshire, where Johnny Rotten performed a low-key show with his back to the audience. The Huddersfield gig was completely different; it was the best, most exuberant live show I'd ever seen them perform. It was a glorious way to signal the end of an era.

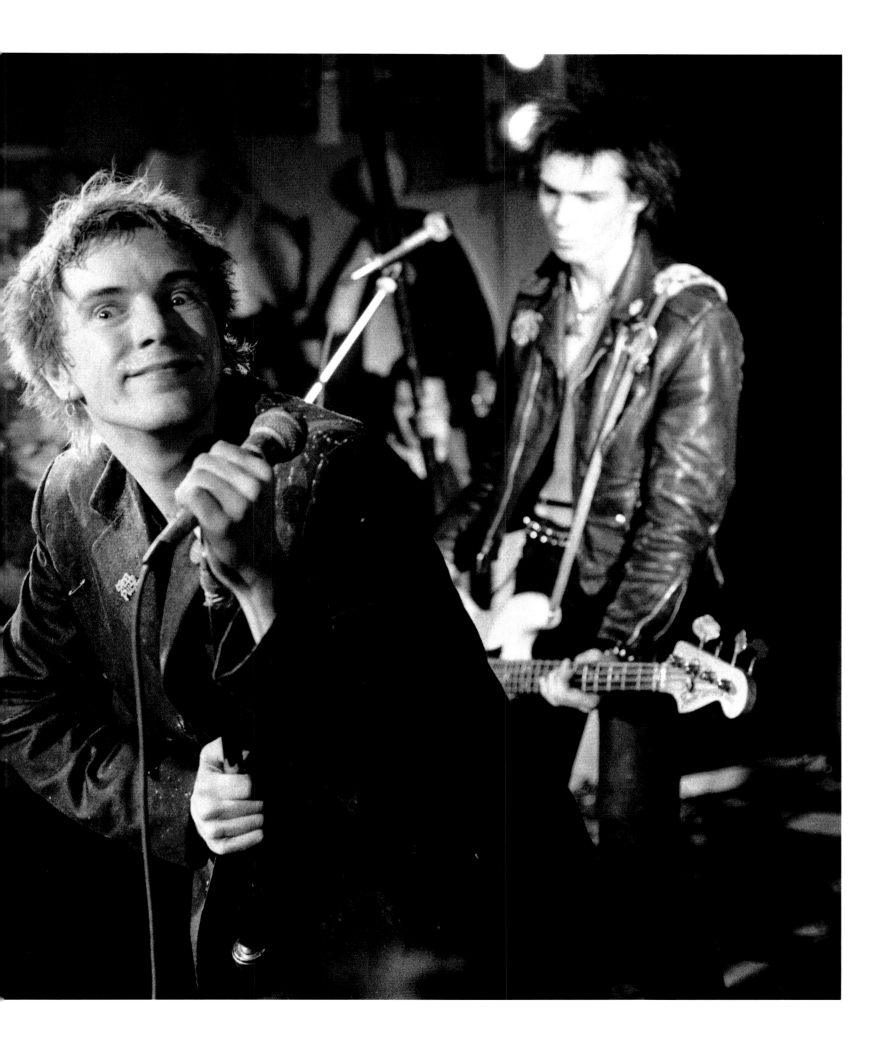

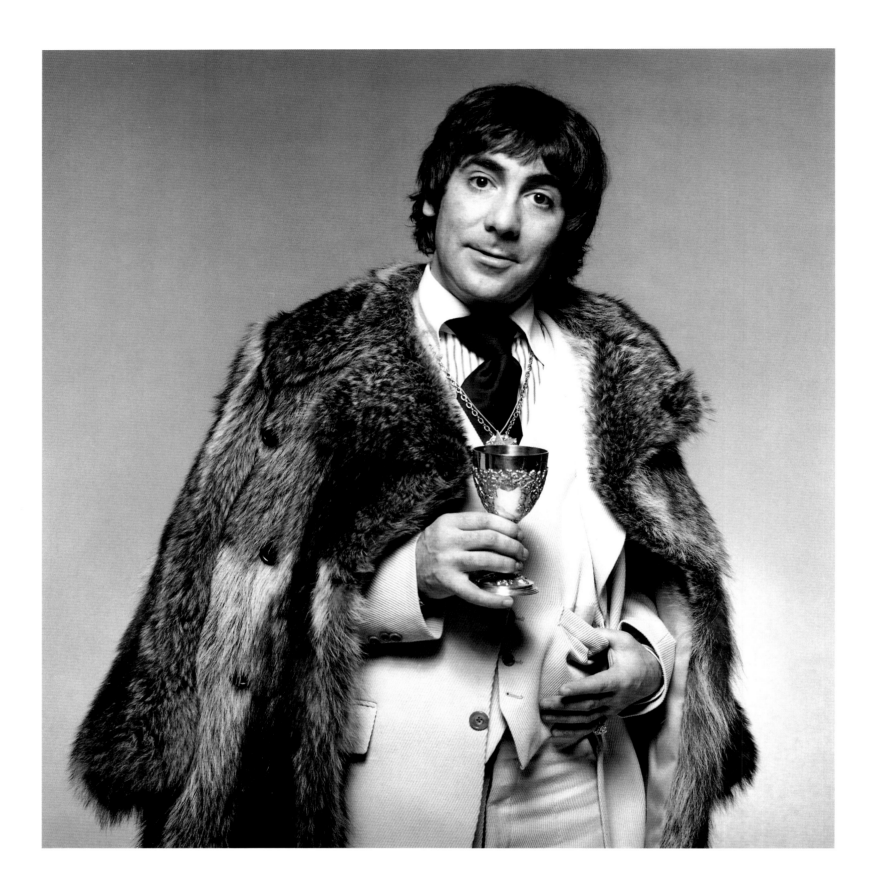

KEITH MOON (THE WHO)
PHOTOGRAPHY TERRY O'NEILL
Taken in London wearing one of his mate Jez's jackets

BRUCE SPRINGSTEEN
PHOTOGRAPHY TERRY O'NEILL
Sunset Strip, LA. Taken to promote the *Born To Run* album

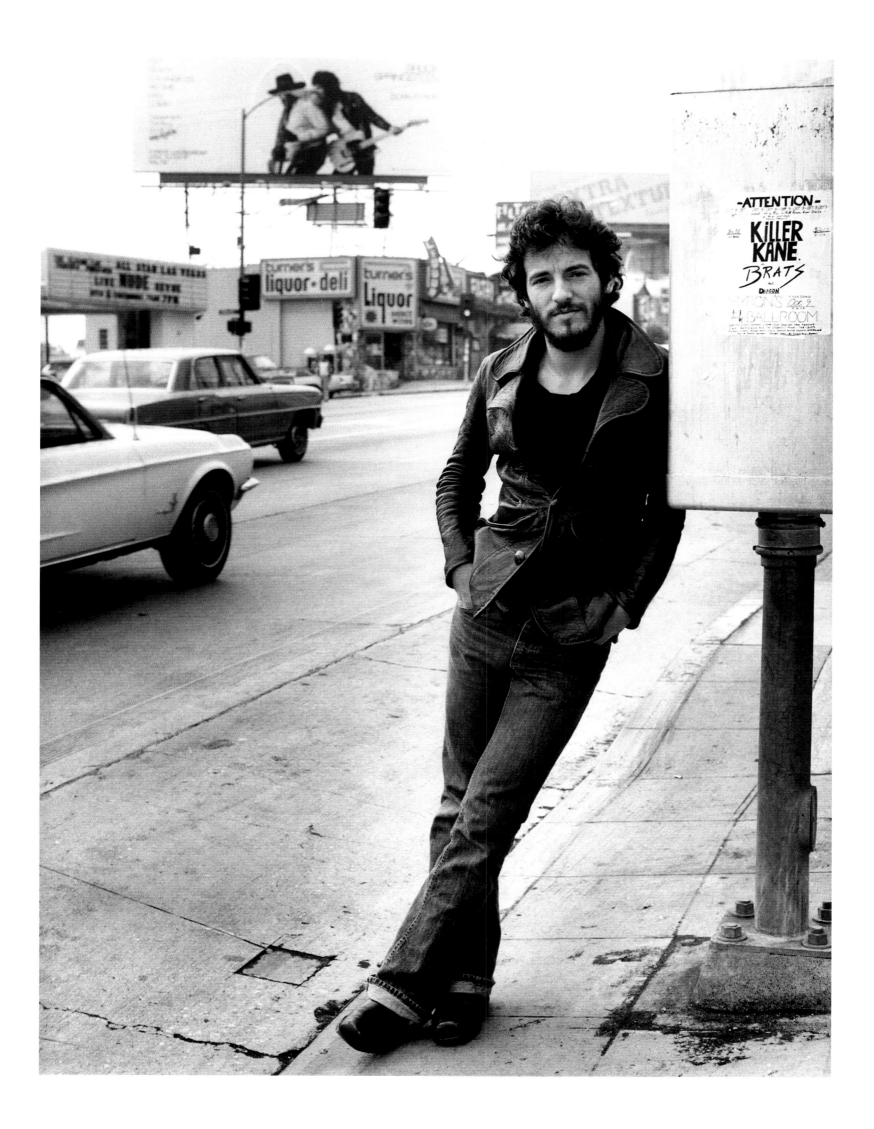

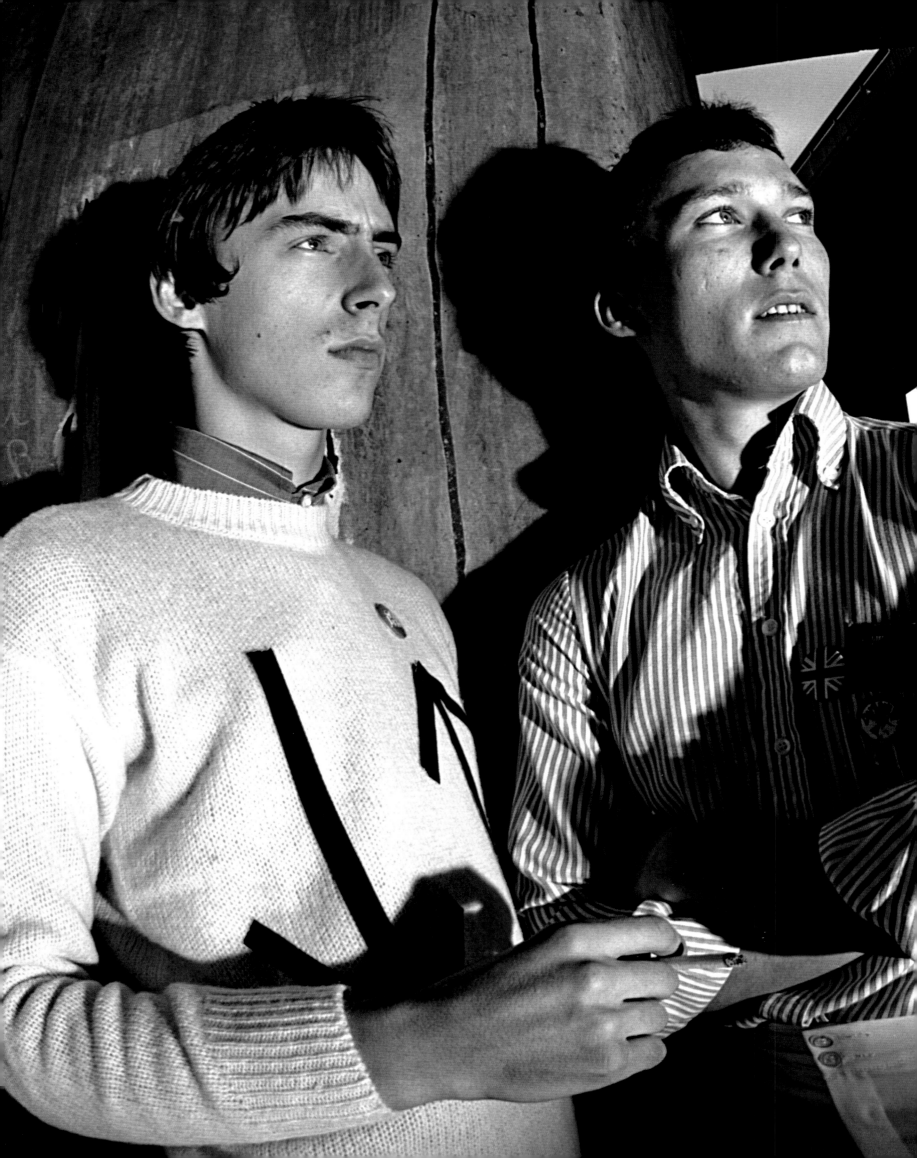

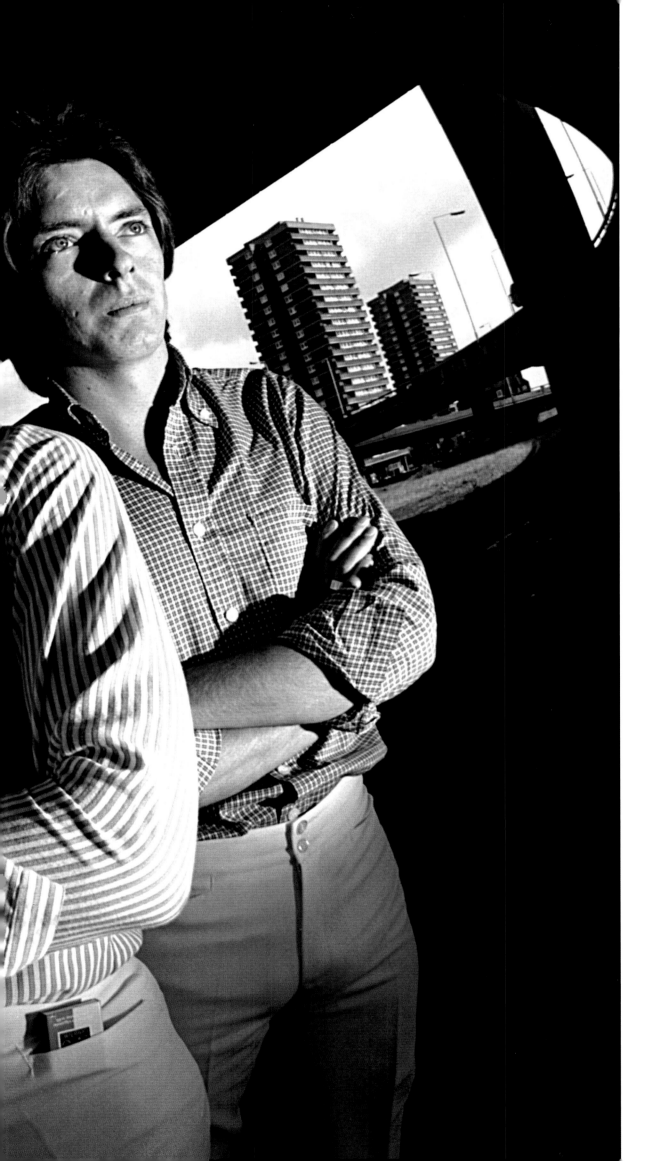

THE JAM
(PAUL WELLER WENT ON TO THE STYLE COUNCIL, NOW SOLO)

PHOTOGRAPHY GERED MANKOWITZ

I shot this under a famous London motorway flyover using a mixed light technique that gave me a lot of control. The band were dressed too conservatively for me, Paul had the inspiration to decorate his jumper with some black gaffer tape

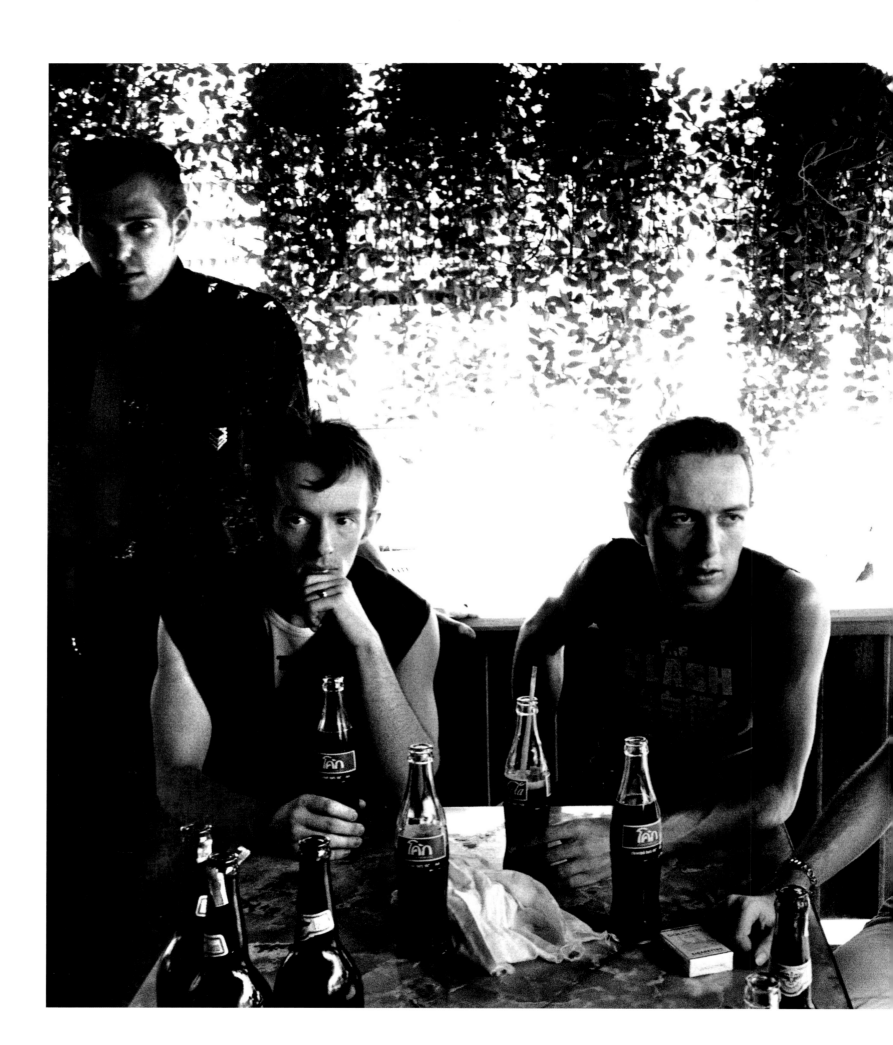

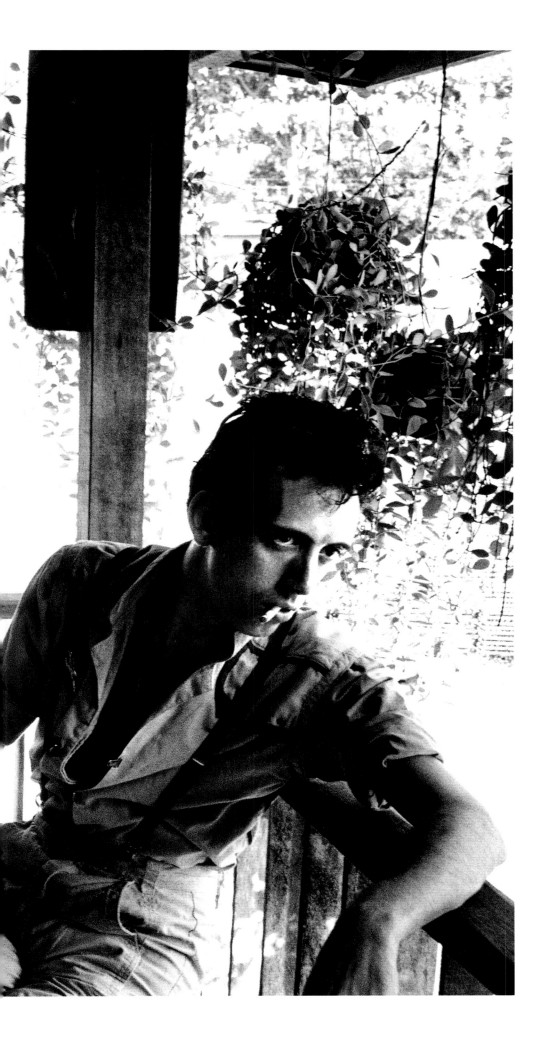

THE CLASH
PHOTOGRAPHY PENNIE SMITH
On a Far East tour. 100°c plus. Taking a break before
shooting on a railroad track for the *Combat Rock* album cover

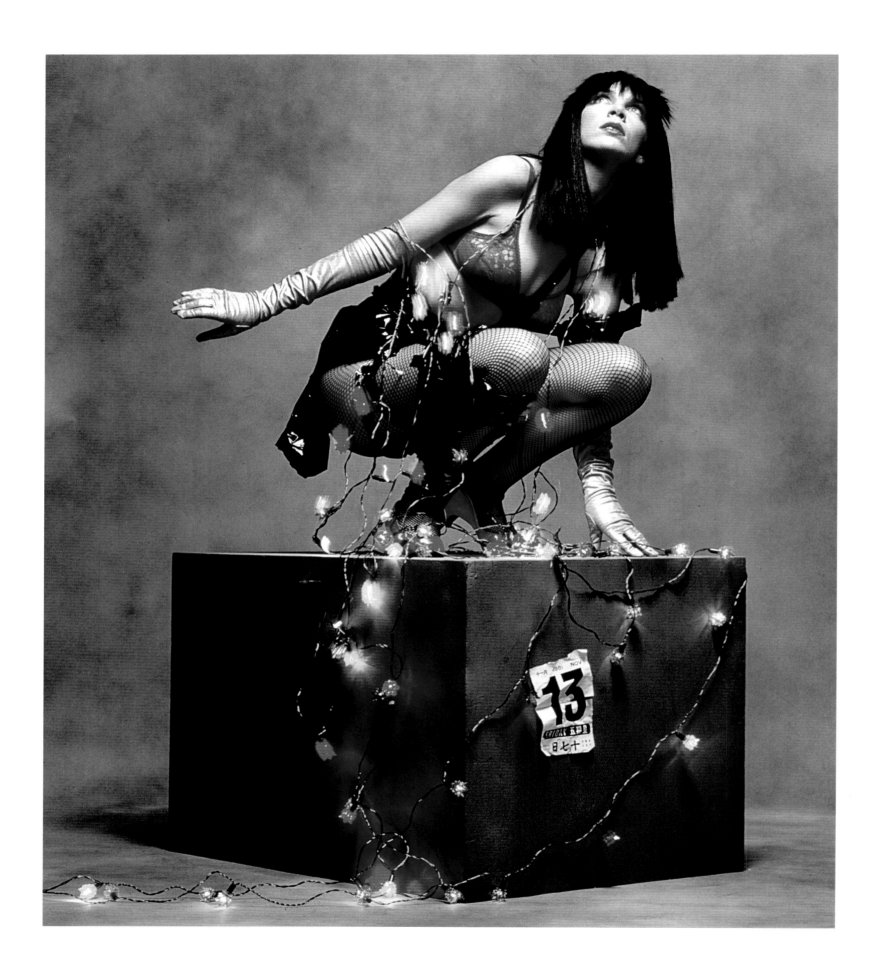

ANNIE LENNOX (THE EURYTHMICS)

PHOTOGRAPHY GERED MANKOWITZ

I started to work with Annie and David in 1979 when they were in the
Tourists and continued to work with them as The Eurythmics for the
following few years up until the *Revenge* cover. This shot of Annie was
taken during one of the several sessions that we did before their careers
really took off and they became mega stars

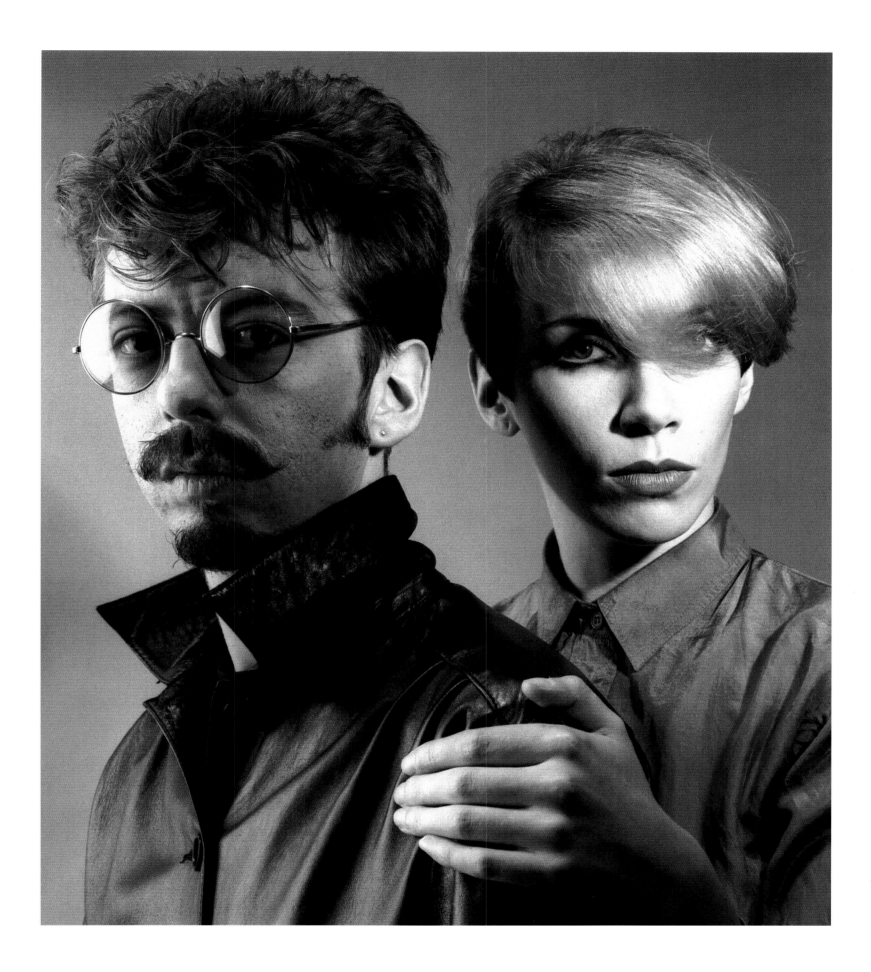

THE EURYTHMICS

PHOTOGRAPHY GERED MANKOWITZ

David and Annie were always inspiring to work with, their endless creativity
was a joy to share and I always loved my time with them

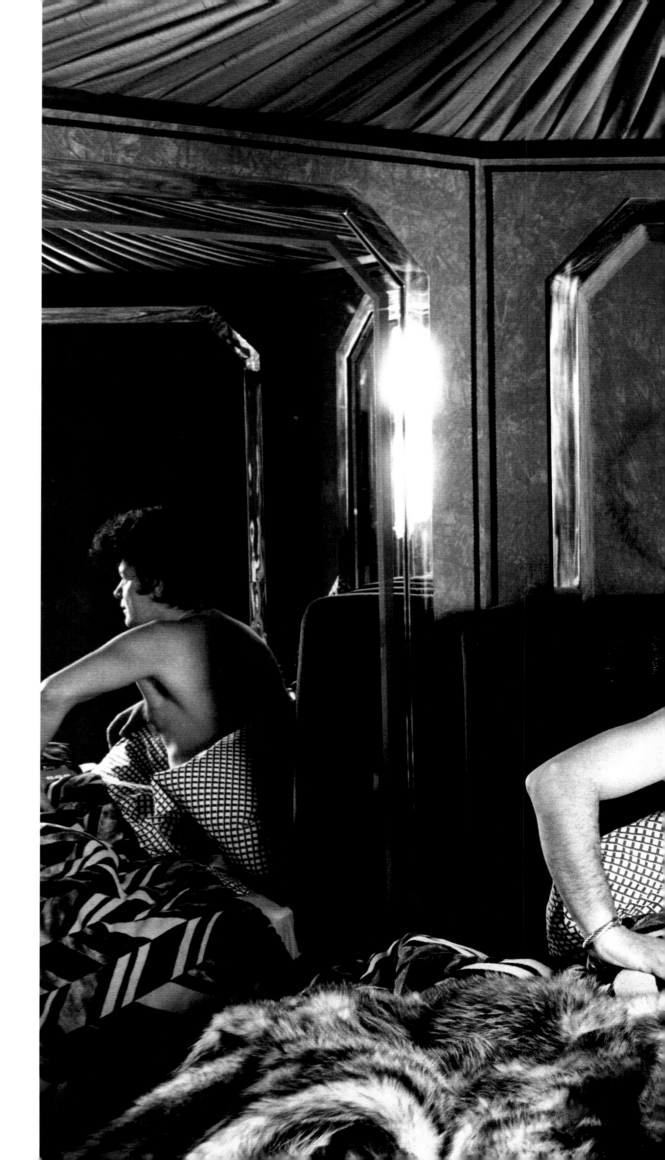

GARY GLITTER
PHOTOGRAPHY ALLAN BALLARD
Gary reclining at home

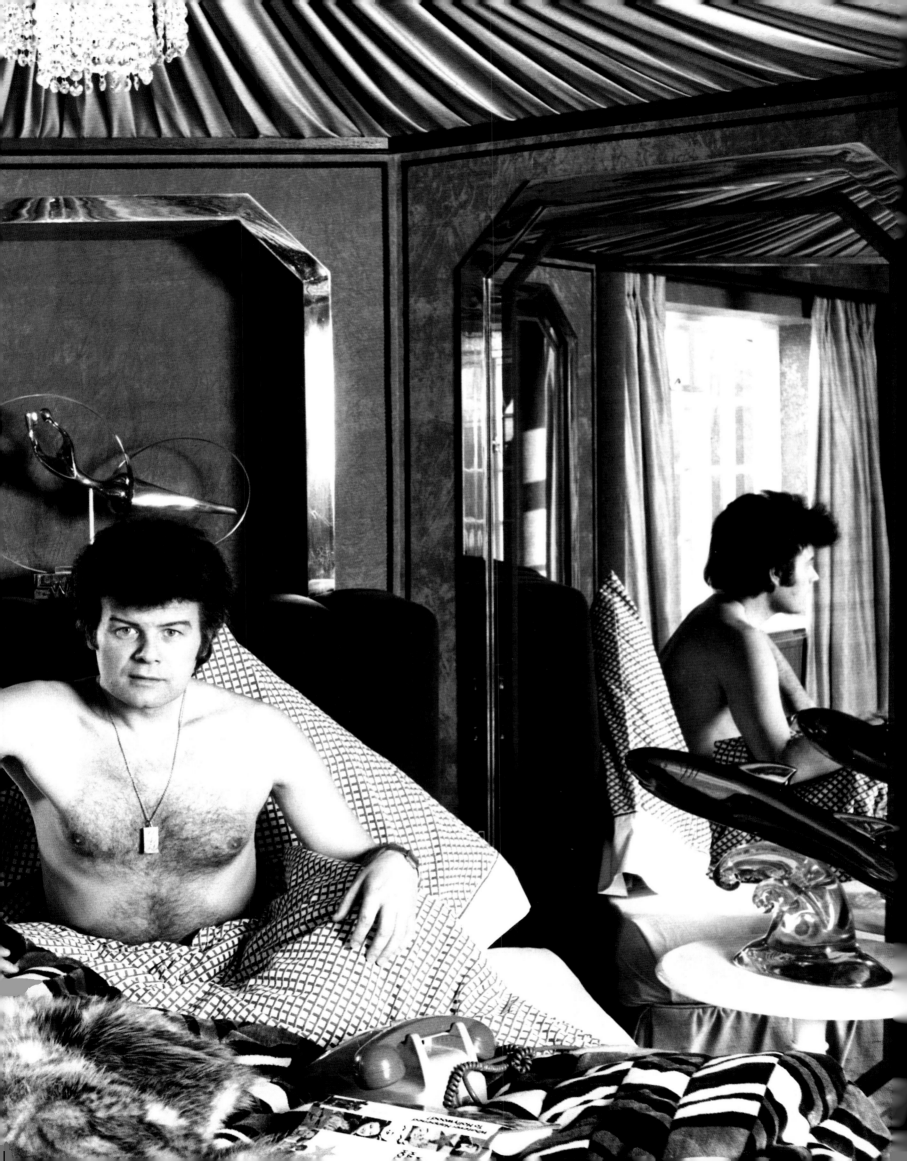

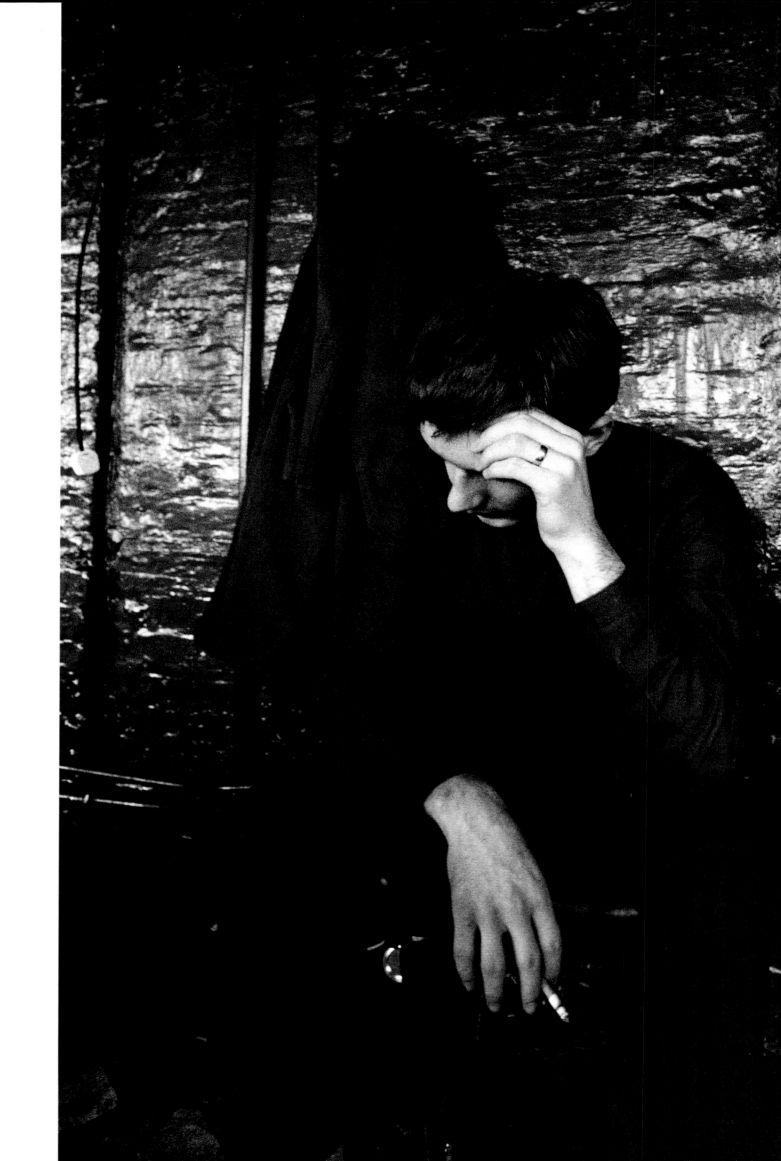

IAN CURTIS
(JOY DIVISION, HE COMMITED SUICIDE. THE REST OF THE BAND WENT ON TO
FORM NEW ORDER)
PHOTOGRAPHY KEVIN CUMMINS

Ian Curtis in rehearsal room. Shot for *NME*. I always released pictures of
Ian Curtis looking serious, it propagated the Manchester miserablists
myth. Journalists would come to Manchester in trepidation. Joy Division
were seen as an enigmatic force, but nothing was further from the truth.
Sorry to disappoint you but Ian Curtis liked a pint. He didn't just sit on
the bus reading Sartre.

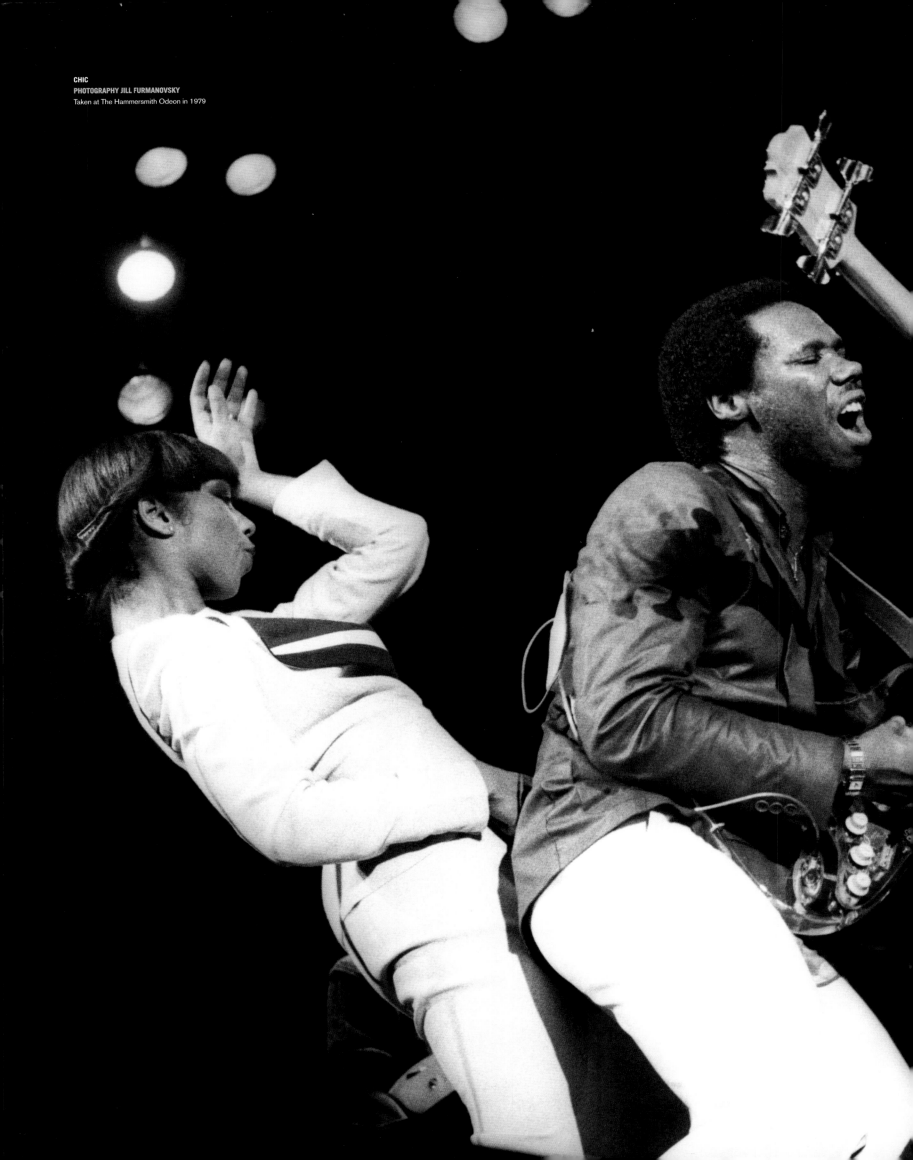

CHIC
PHOTOGRAPHY JILL FURMANOVSKY
Taken at The Hammersmith Odeon in 1979

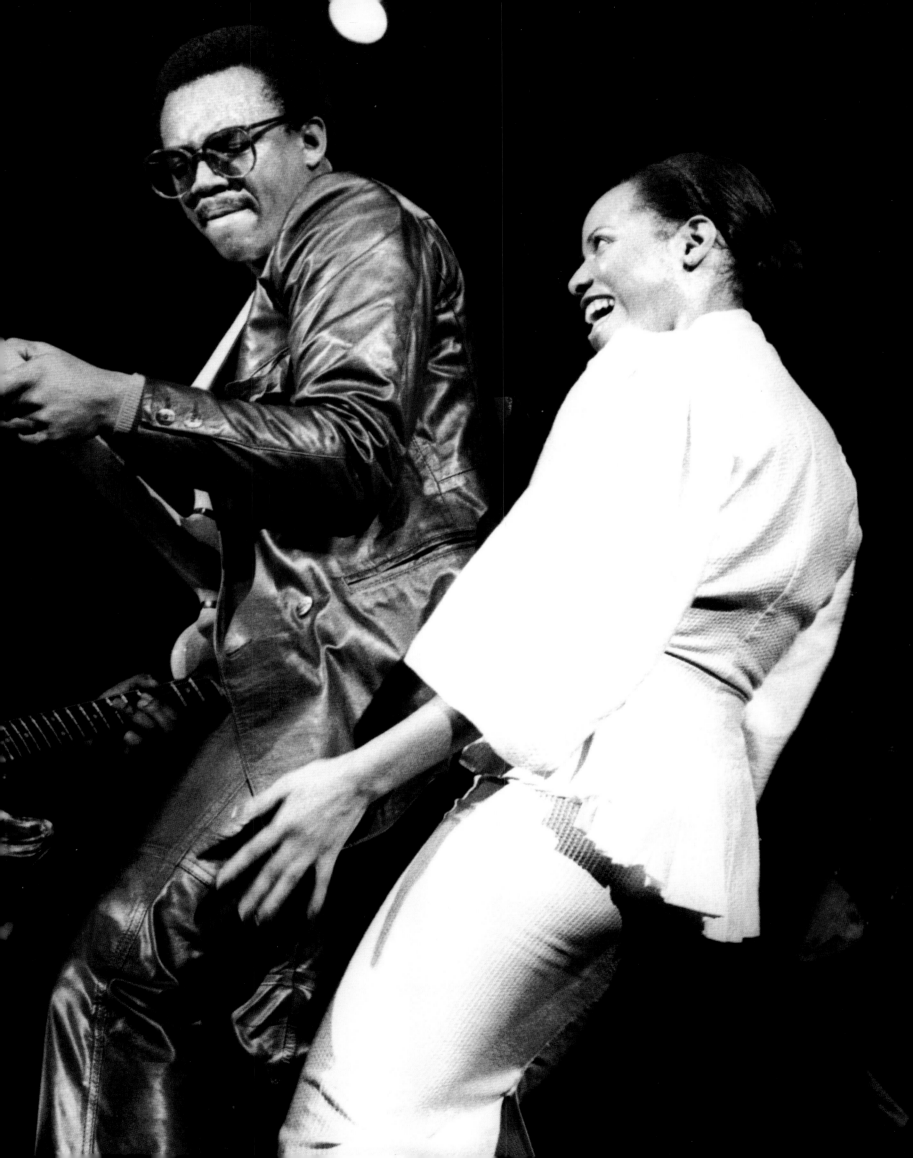

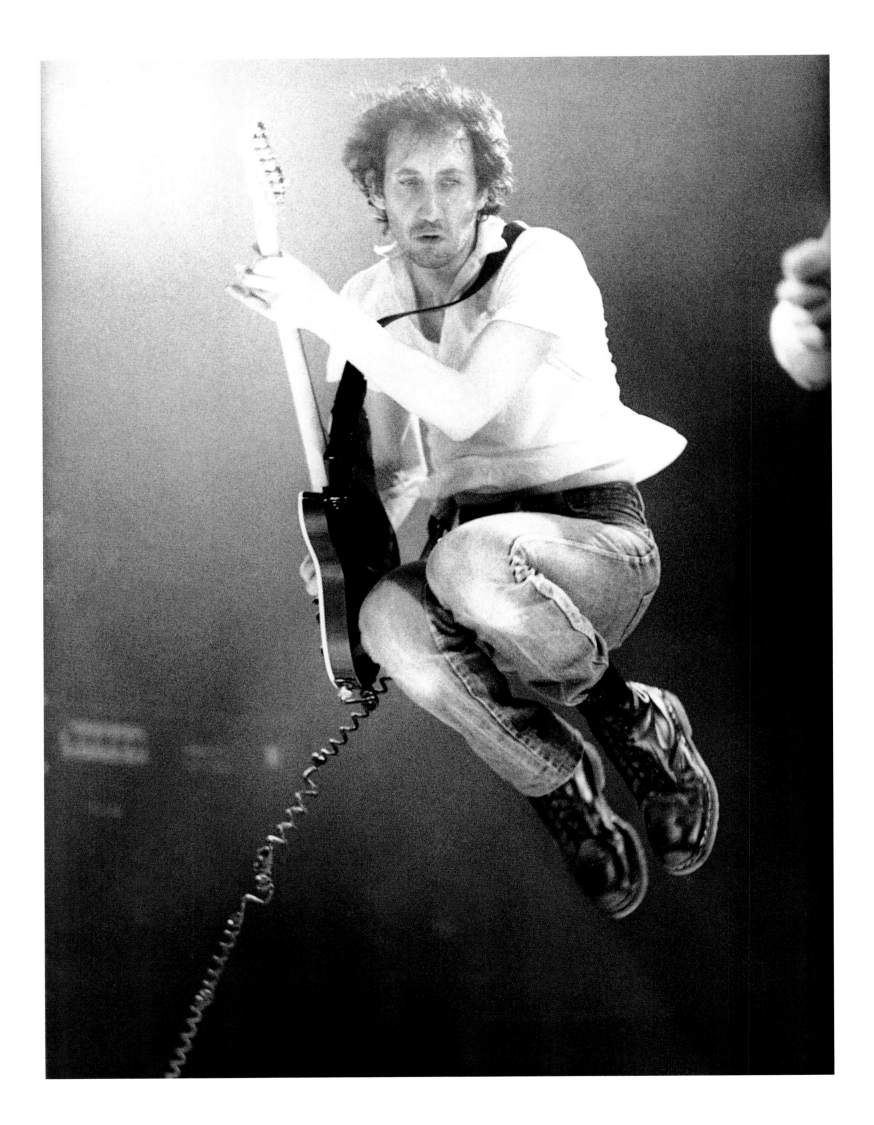

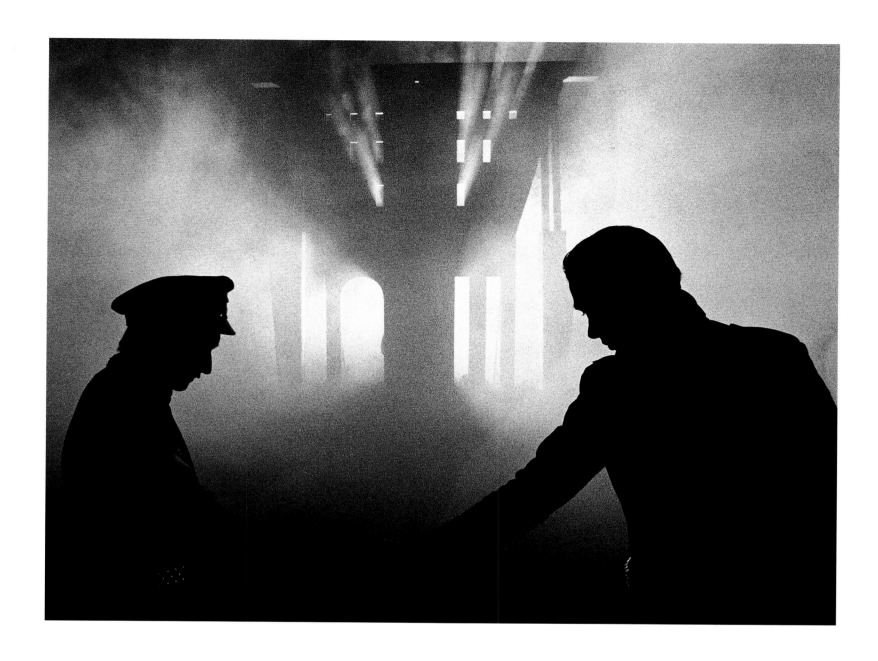

PETE TOWNSHEND (THE WHO)
PHOTOGRAPHY PENNIE SMITH
The picture says it all

ULTRAVOX (MIDGE URE WENT SOLO)
PHOTOGRAPHY BRIAN COOKE
Midge Ure and Chris Cross, photographed at Beachy
Head on September 21, 1982. This was while
shooting the promo for 'Reap The Wild Wind' single.
By this time Ultravox had moved on from using
mainstream directors such as Russell Mulcahy, who
had shot the video for 'Vienna', to shooting their own.
Midge and Chris shared the direction, which relied
heavily on the skills of film cameraman, Nick Nolan.
The shoot was dogged by bad weather and the still of
them shaking hands was taken in torrential rain

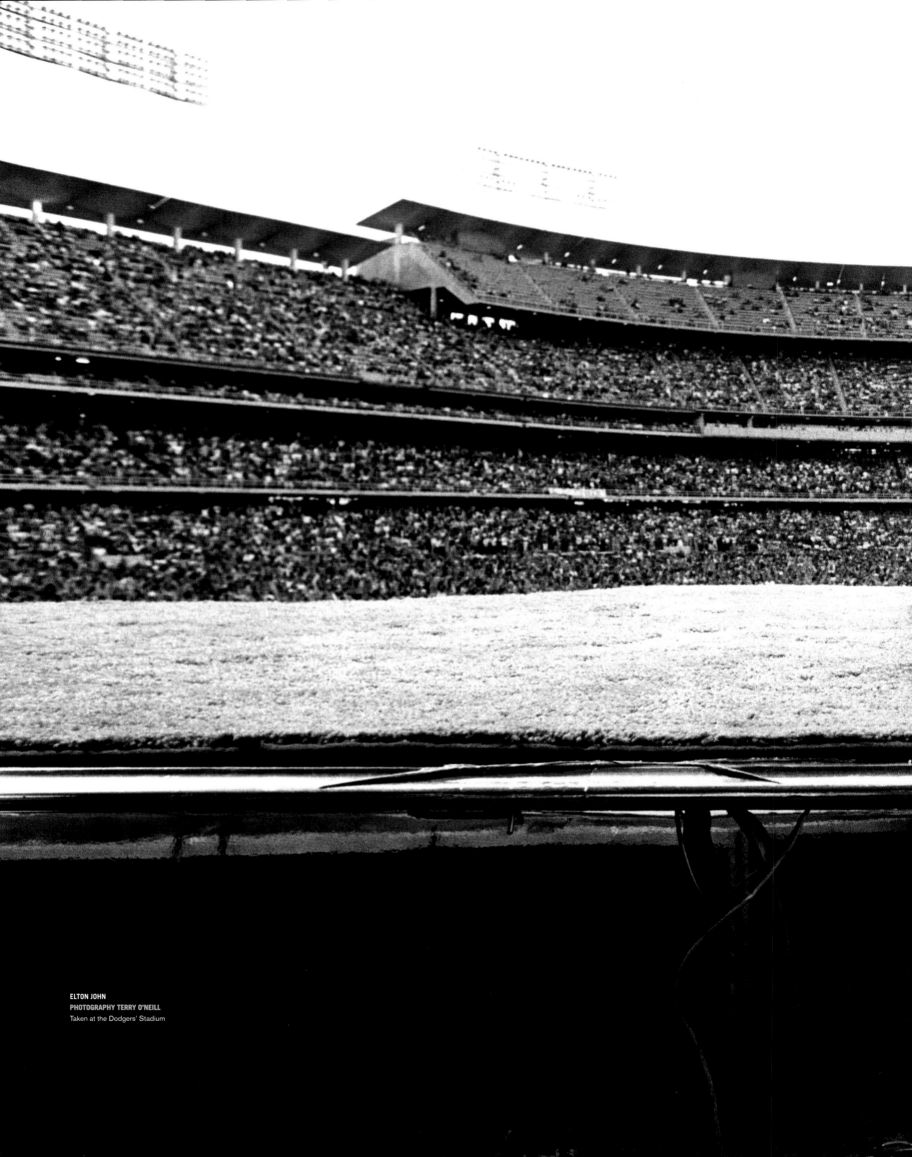

ELTON JOHN
PHOTOGRAPHY TERRY O'NEILL
Taken at the Dodgers' Stadium

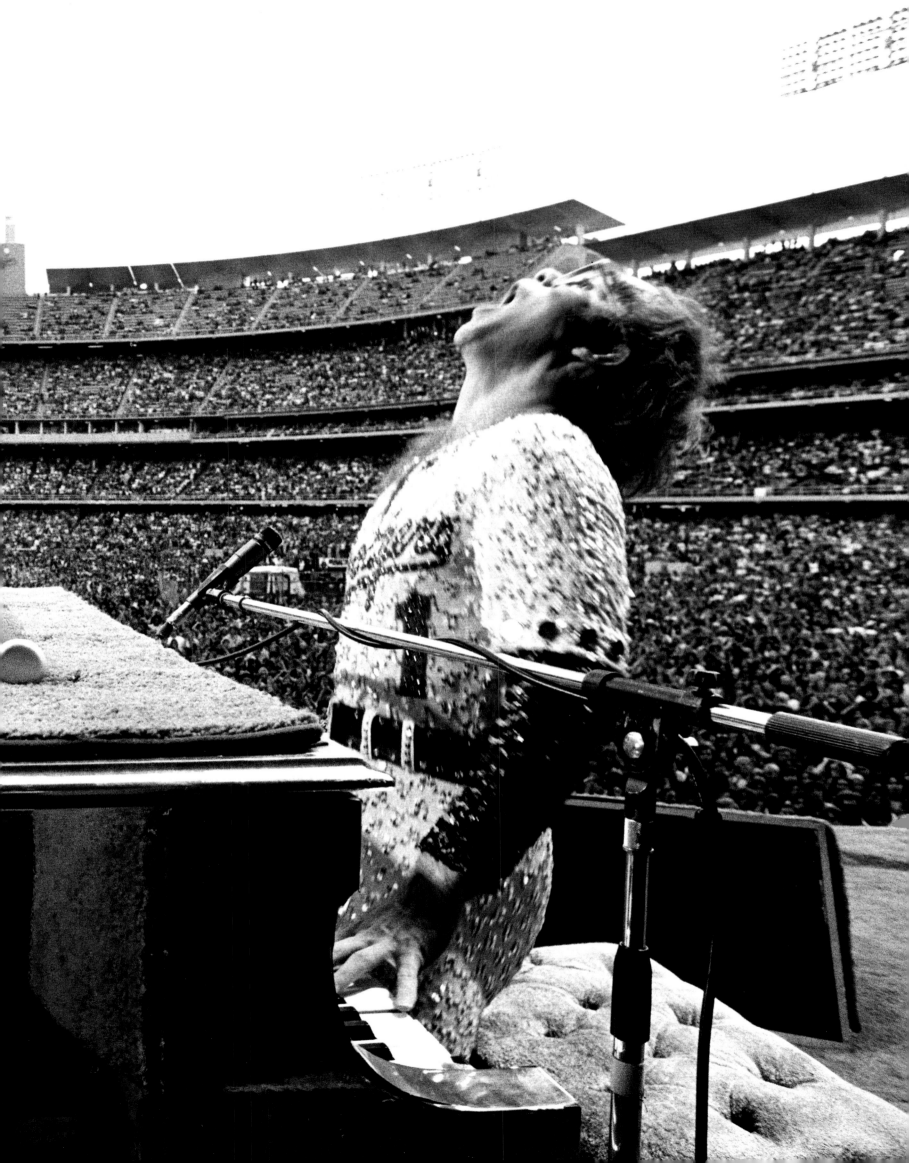

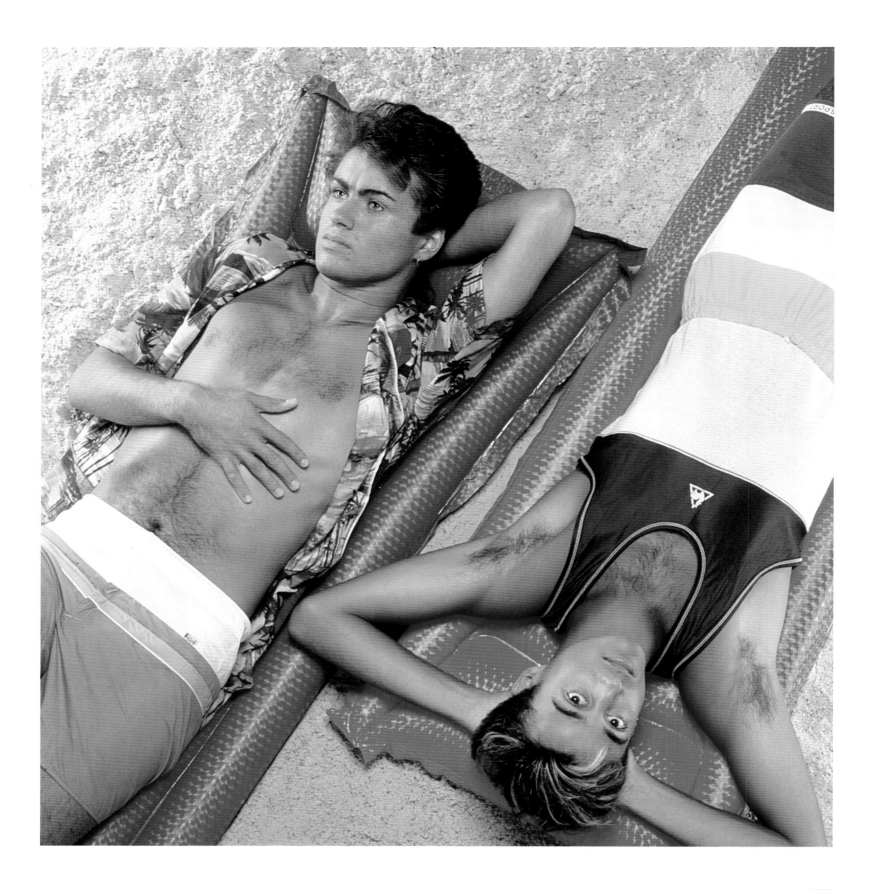

WHAM
PHOTOGRAPHY GERED MANKOWITZ
I did this for *Smash Hits* magazine at the peak of Wham's career.
George has this extraordinary smile that he switched on and off like a
light bulb. It was so phoney and shark-like it was laughable

GEORGE MICHAEL (WHAM, NOW SOLO)
PHOTOGRAPHY ALLAN BALLARD
George on the shoot for the 'Club Tropicana' video

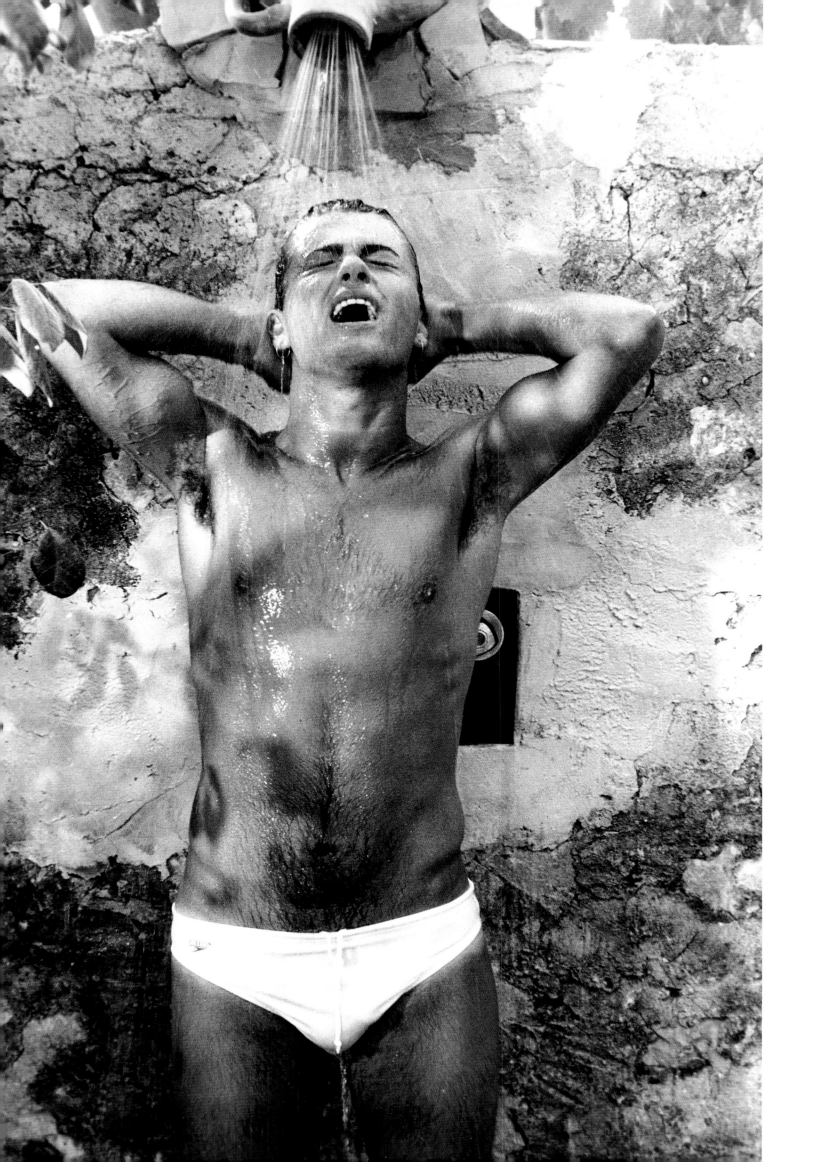

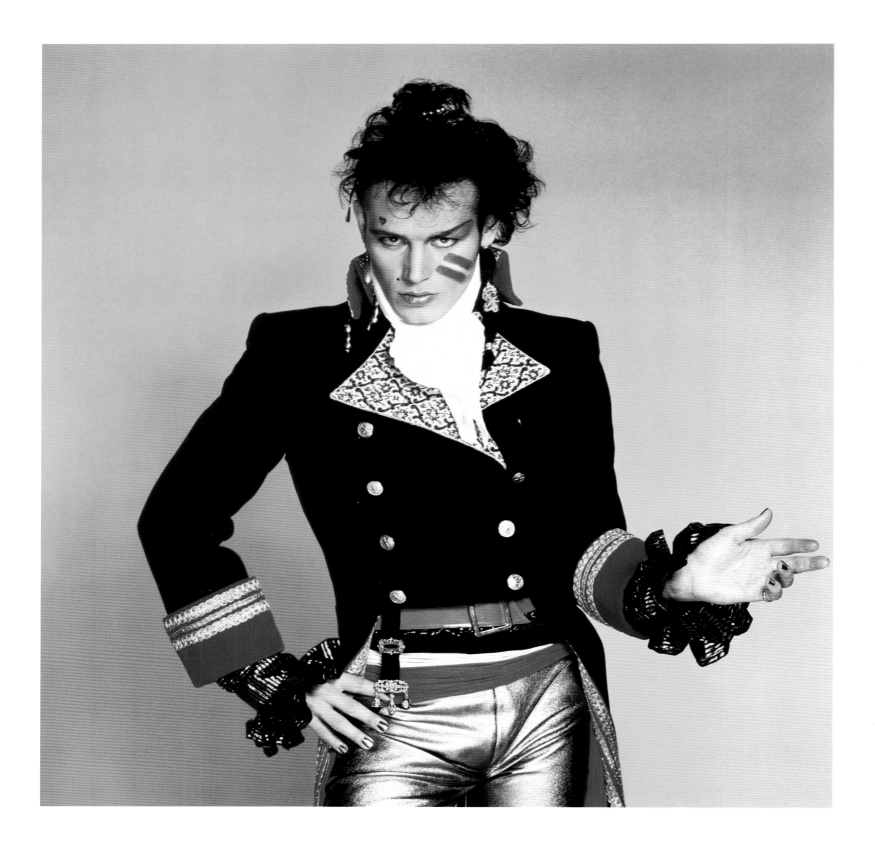

ADAM ANT
PHOTOGRAPHY ALLAN BALLARD
Adam doing publicity shots for 'Prince Charming'

SPANDAU BALLET
PHOTOGRAPHY BRIAN COOKE
This job proved to be the 'beginning of the end' for me as a music business
photographer when Gary Kemp was heard to say, as he caught a glimpse of
me in the shadows, 'Who's that old geezer in the corner?' I was only 33 at
the time and went on to photograph most of their promos, and acted as
photographic consultant on a promo for 'Communication' which was never
used as it was thought to be too violent

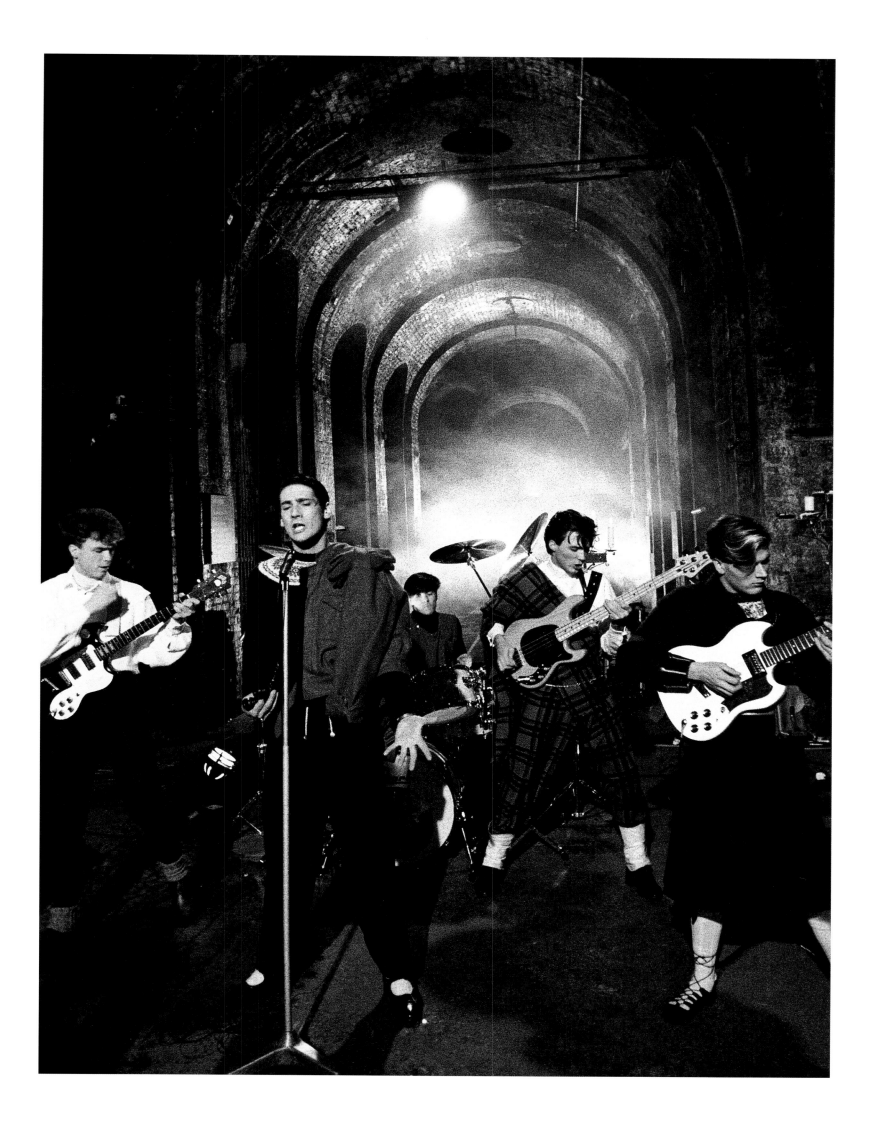

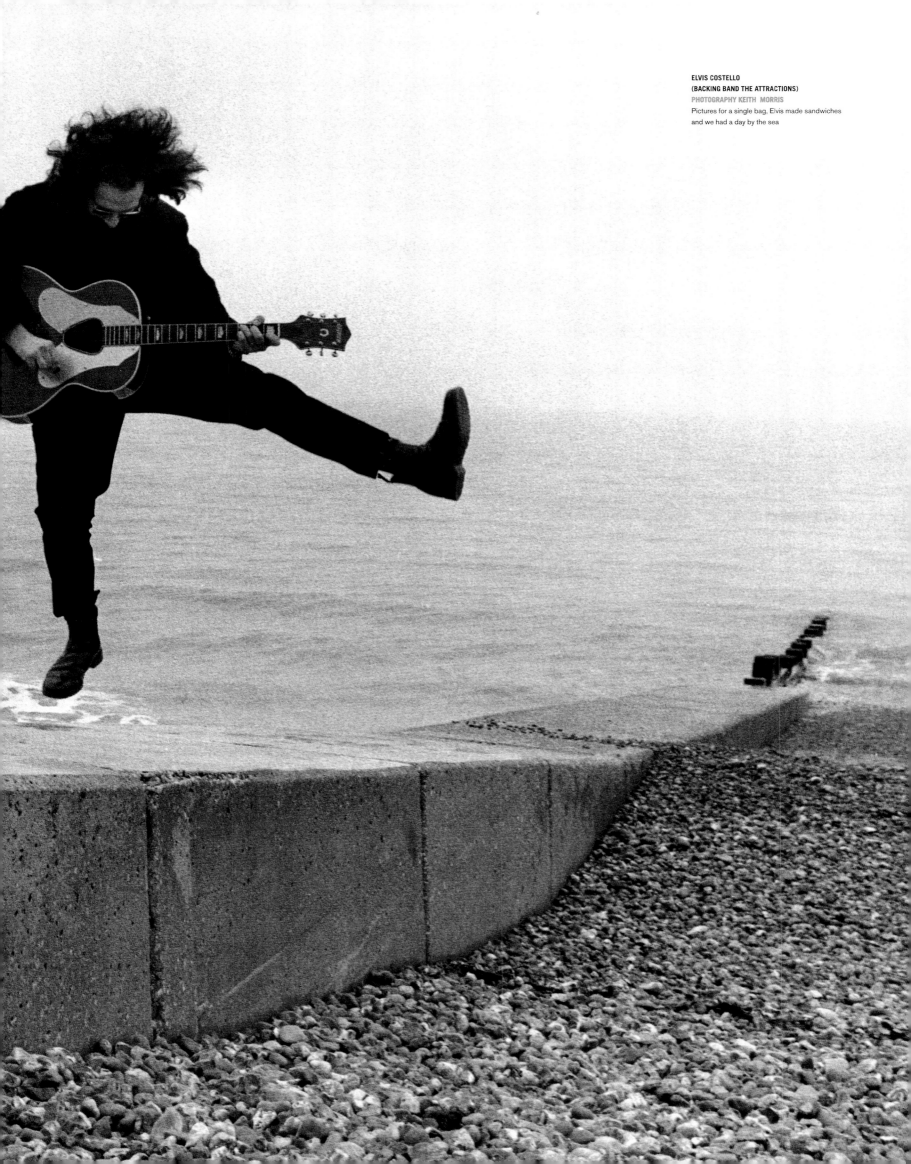

ELVIS COSTELLO
(BACKING BAND THE ATTRACTIONS)
PHOTOGRAPHY KEITH MORRIS
Pictures for a single bag, Elvis made sandwiches
and we had a day by the sea

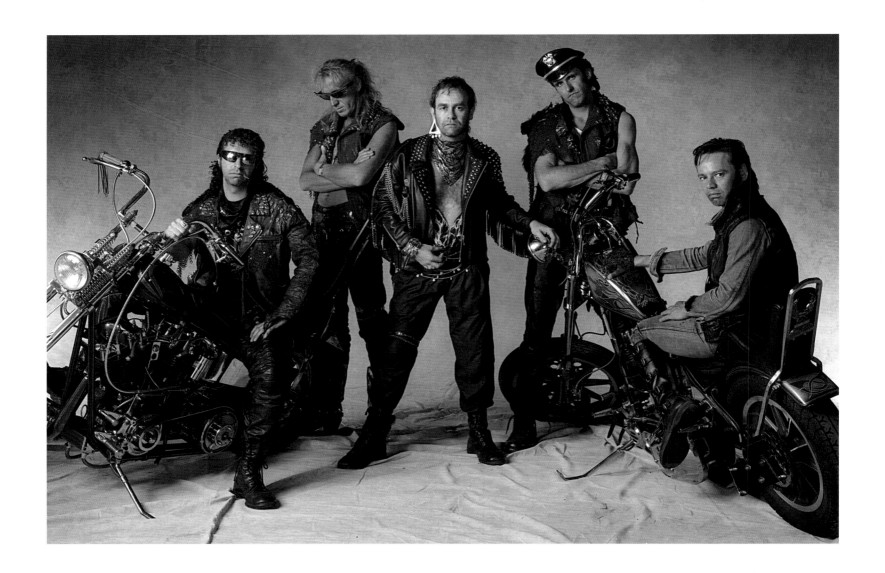

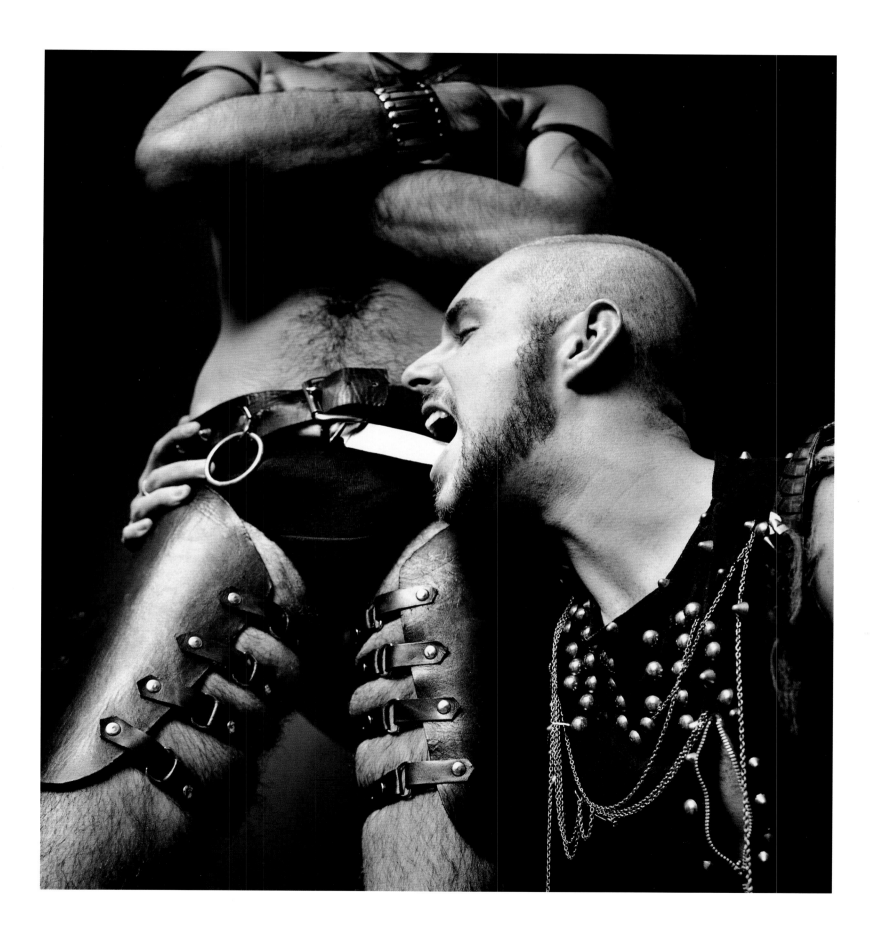

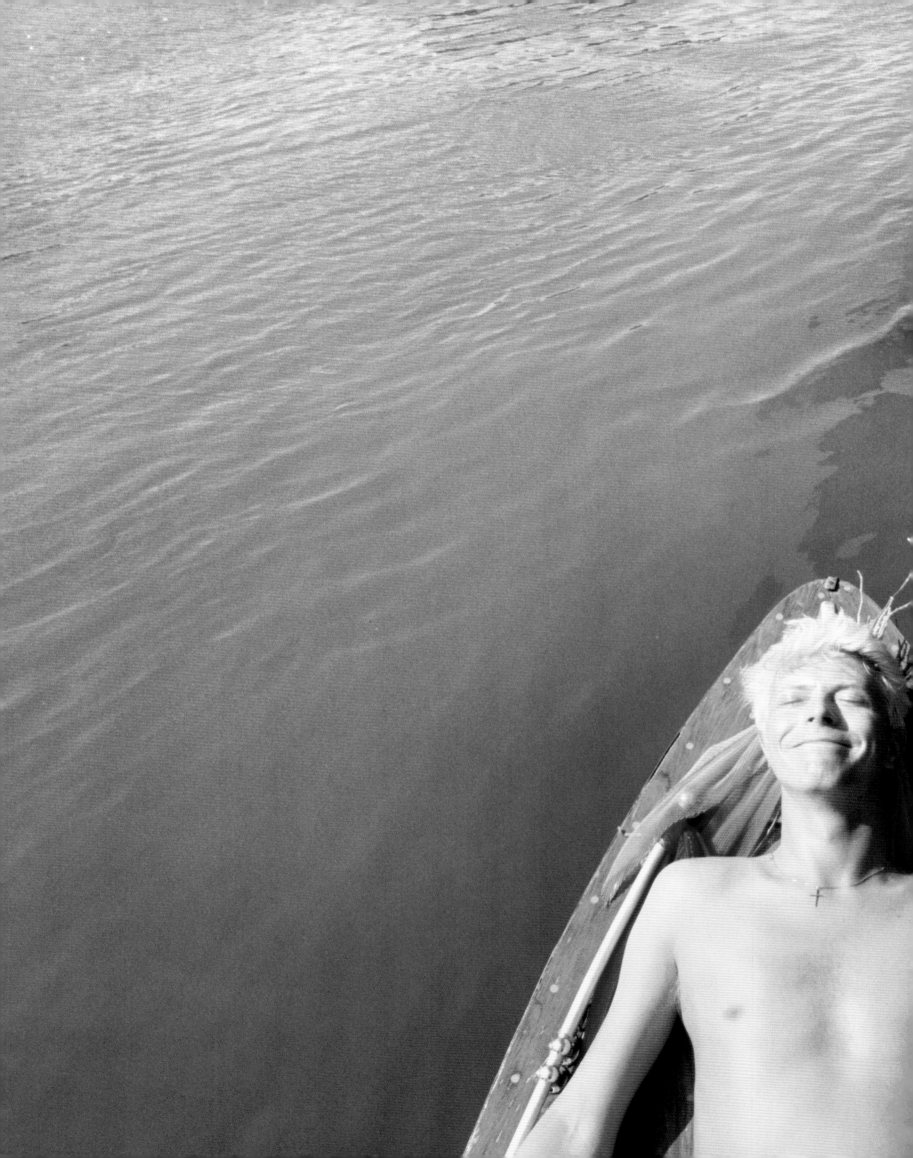

DAVID BOWIE
PHOTOGRAPHY DENIS O'REGAN
Bowie on a terrace at Raffles Hotel in Singapore
at the end of his *Serious Moonlight* tour in 1983

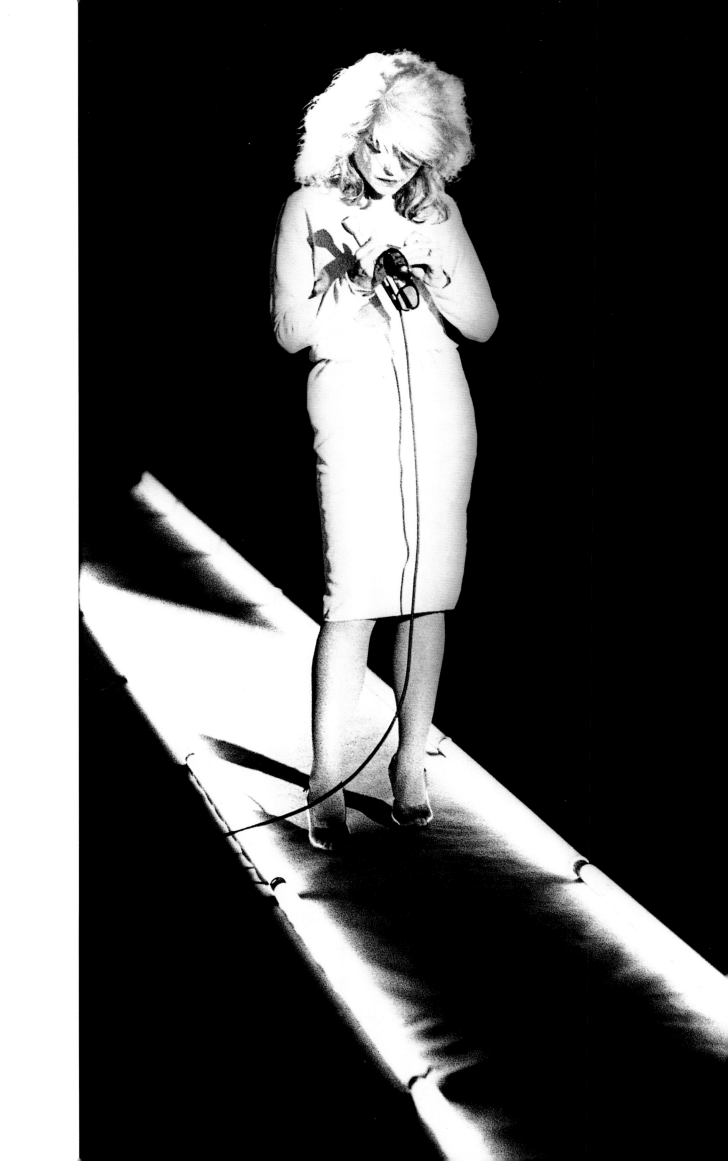

DEBBIE HARRY
(IN BLONDIE, WENT SOLO, THEN BACK TO BLONDIE)
PHOTOGRAPHY PENNIE SMITH
Video shoot, not going well. Photographer arrives,
shoots three frames and runs

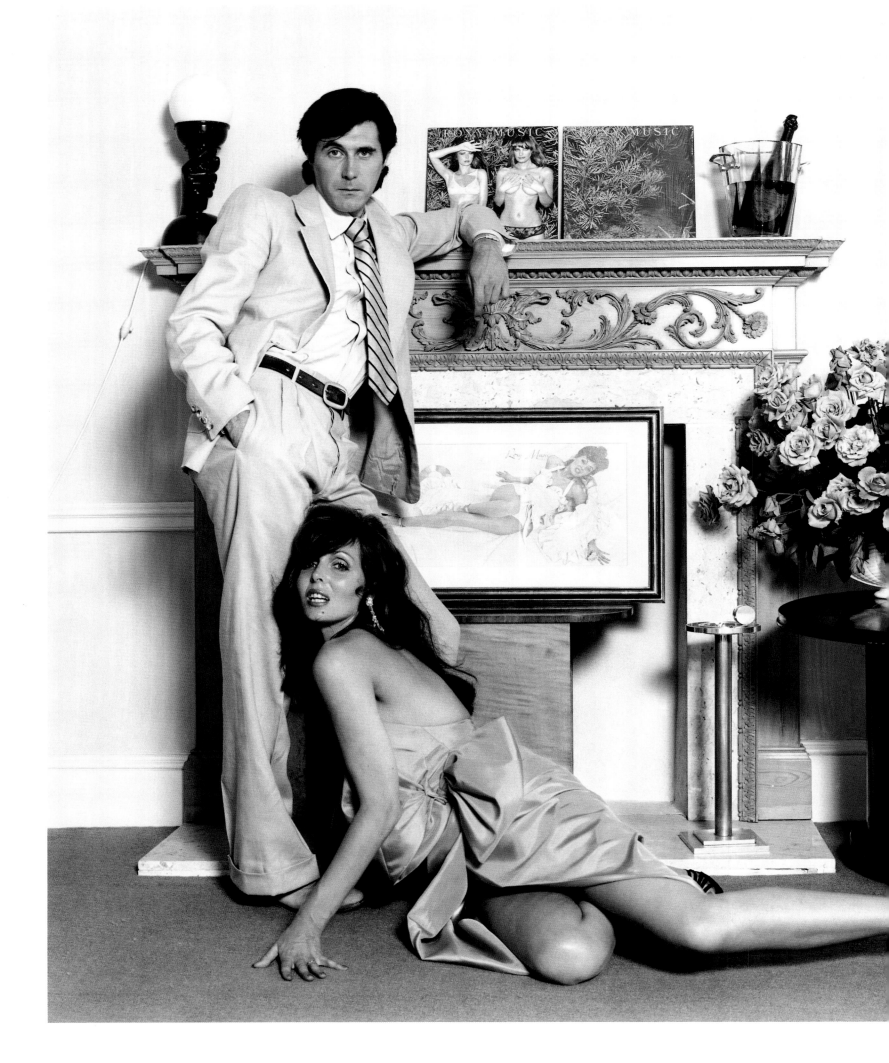

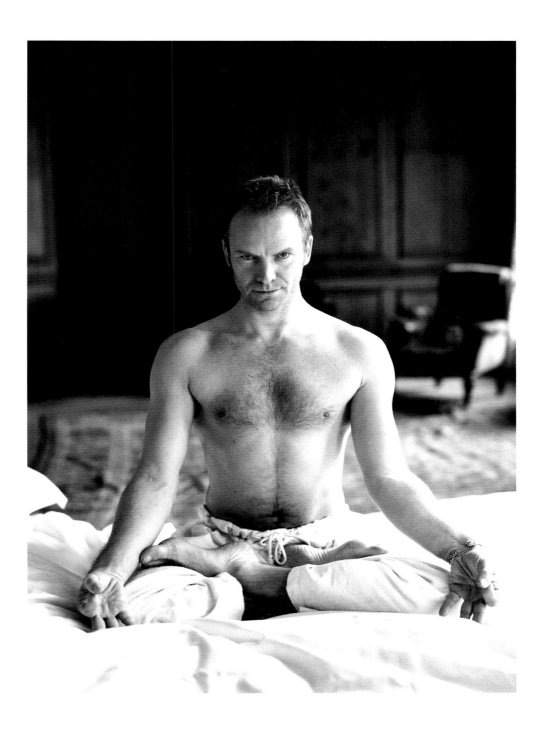

BRYAN FERRY (ROXY MUSIC, NOW SOLO)
PHOTOGRAPHY TERRY O'NEILL
Mmmm...

STING (THE POLICE, NOW SOLO)
PHOTOGRAPHY SHEILA ROCK
The session was for *Cosmopolitan*, I did the
shoot at Sting's home in London. We did a few
yoga asanas together to get the right feeling

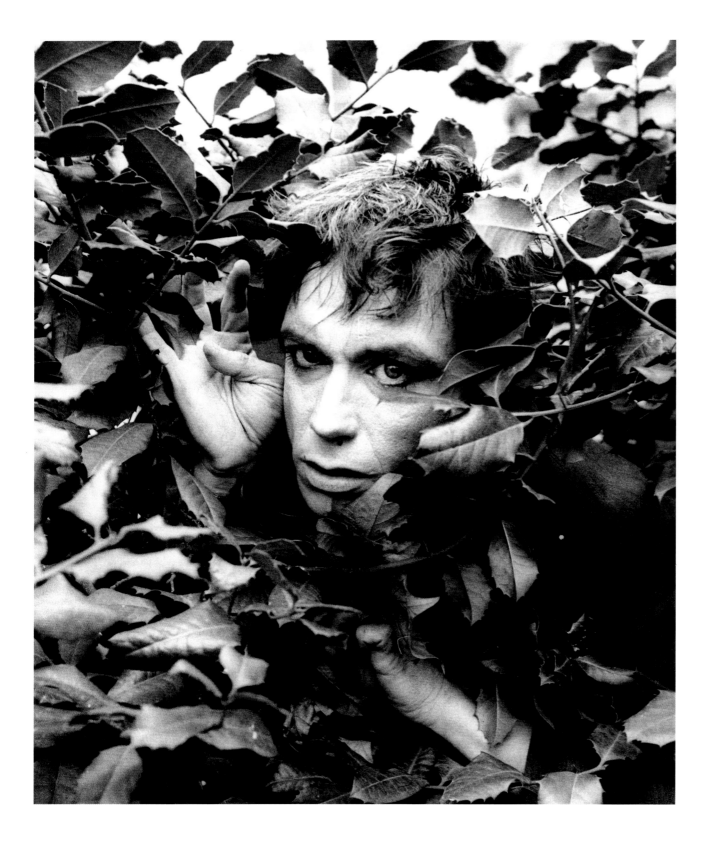

IGGY POP
PHOTOGRAPHY PENNIE SMITH
I've shot loads of Iggy over the years, but no
sessions as off the wall as this. I only remember him
getting himself stuck in a waste bin, then looming
out of the bushes, like The Green Man

PETER GRANT (LED ZEPPELIN'S MANAGER)
PHOTOGRAPHY MARTYN GOODACRE
Taken shortly before his death. When Led Zeppelin
was mentioned a tear came to the big man's eye

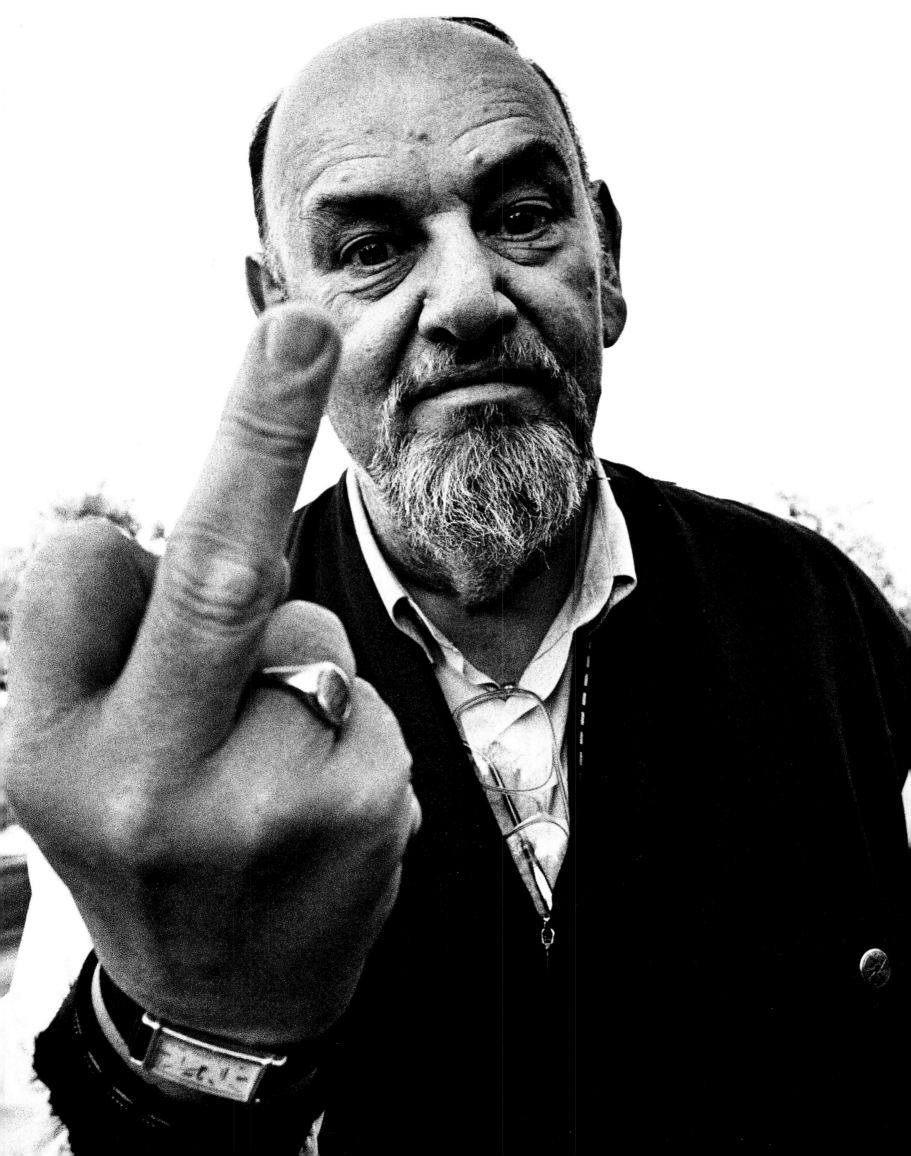

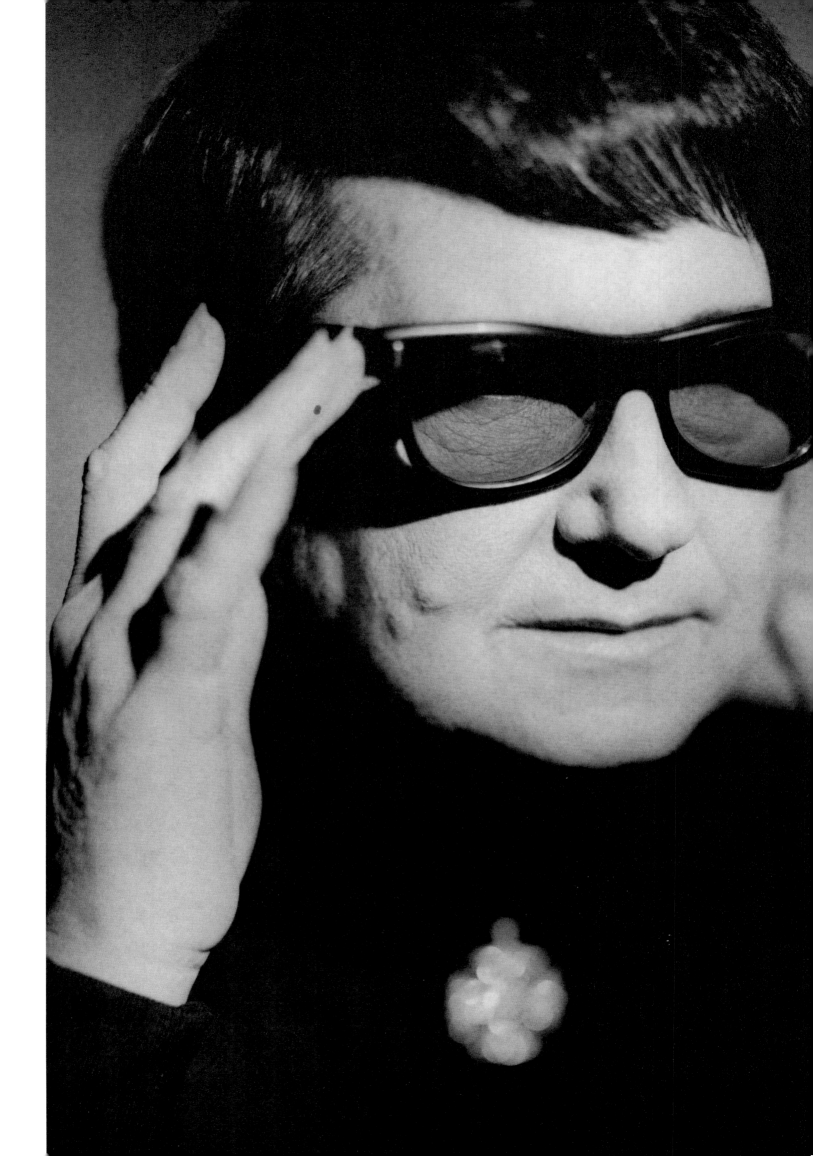

ROY ORBISON

PHOTOGRAPHY SHEILA ROCK

I remember his gentle manner, his Southern
charm and his diamonds. I was told to make him
look like the icon that he is

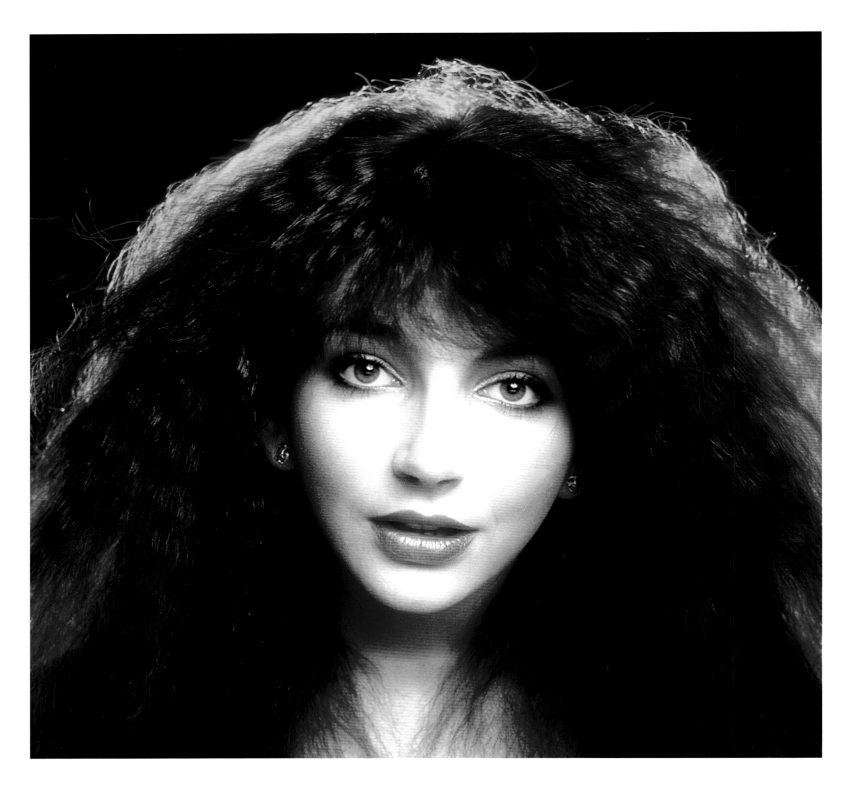

KATE BUSH

PHOTOGRAPHY GERED MANKOWITZ

This is from the back cover session for the
Lionheart album and has always been one of my
favourite portraits of Kate. I did many sessions
with Kate, including the famous portraits for
'Wuthering Heights'. She was always wonderful to
work with, but was also exhausting because of her
frenetic pace and energy

JAMES BROWN

PHOTOGRAPHY JILL FURMANOVSKY

The whole crew, of which I was part, had been
warned to call him 'Mr Brown'. During the
soundcheck he walked on stage in a dressing gown
and Carmen rollers and still maintained his dignity

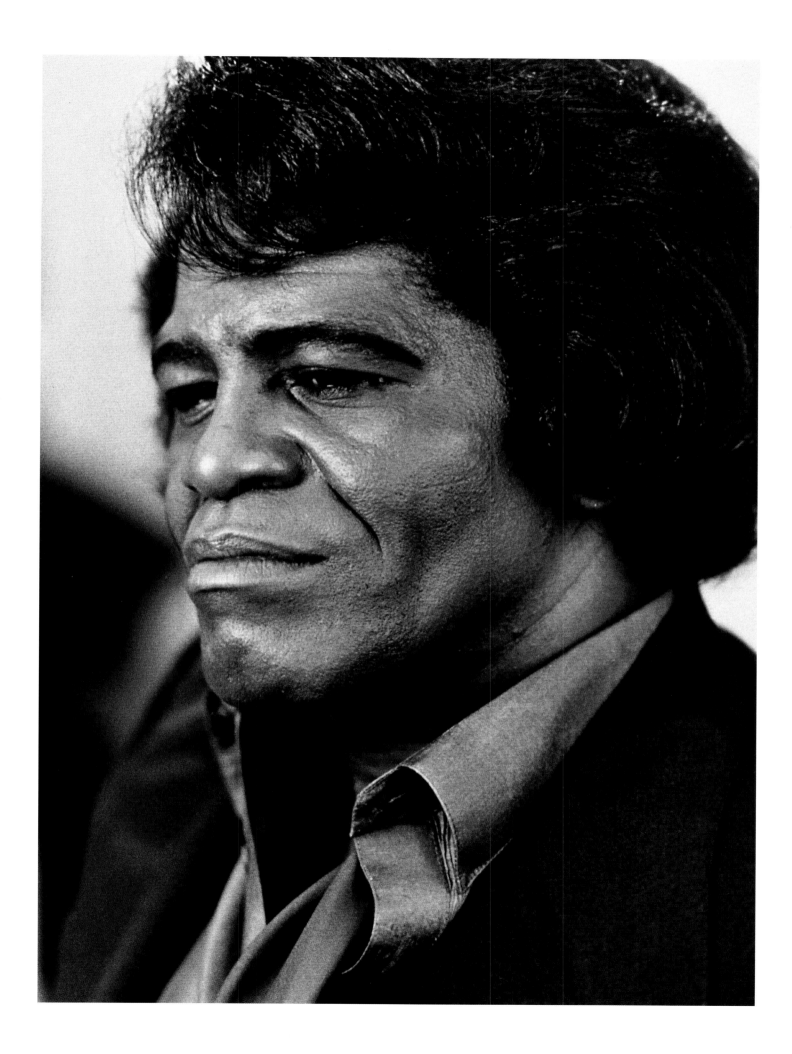

(Next page)

PAUL WELLER (THE JAM, THEN THE STYLE COUNCIL, NOW SOLO)

PHOTOGRAPHY STEVE PYKE

I remember meeting Paul Weller outside Victoria train station in 1984 after a long night out. This was a *Face* commission to travel with his new band (The Style Council) and I'd arrived without a camera. I went into a camera shop just across from the station and bought a second-hand Canon Sureshot, (one of the very early ones) and some film, £65 all in. The first frame I photographed on that camera was this shot of Paul walking out of the hotel to go for the soundcheck. I was walking just ahead of him and passing through a crowd of fans dressed in Mod/Jam guise, I realised the potential for a great photograph. Paul had only recently re-created his musical and visual identity and, walking between these fans, the confusion is apparent. The photograph has been reproduced many times over the years and I've heard is a favourite of his

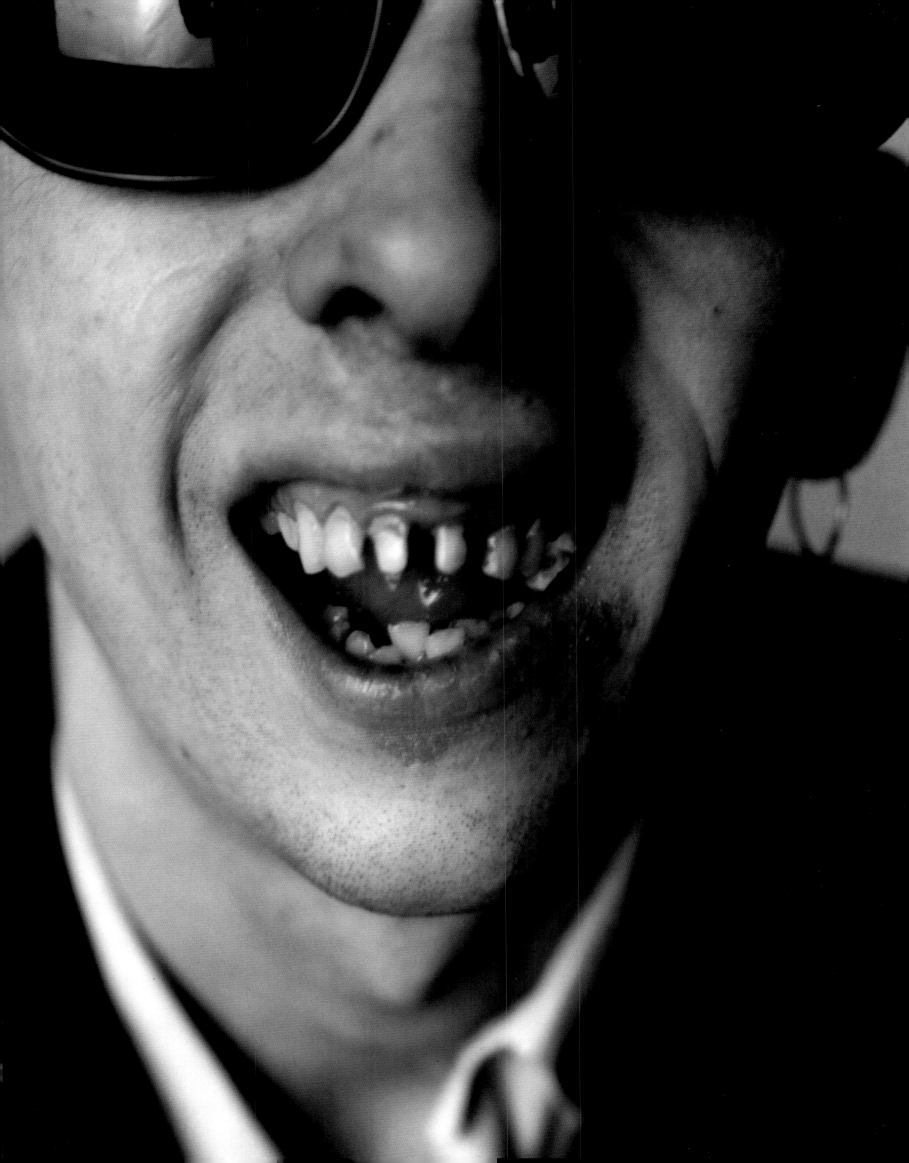

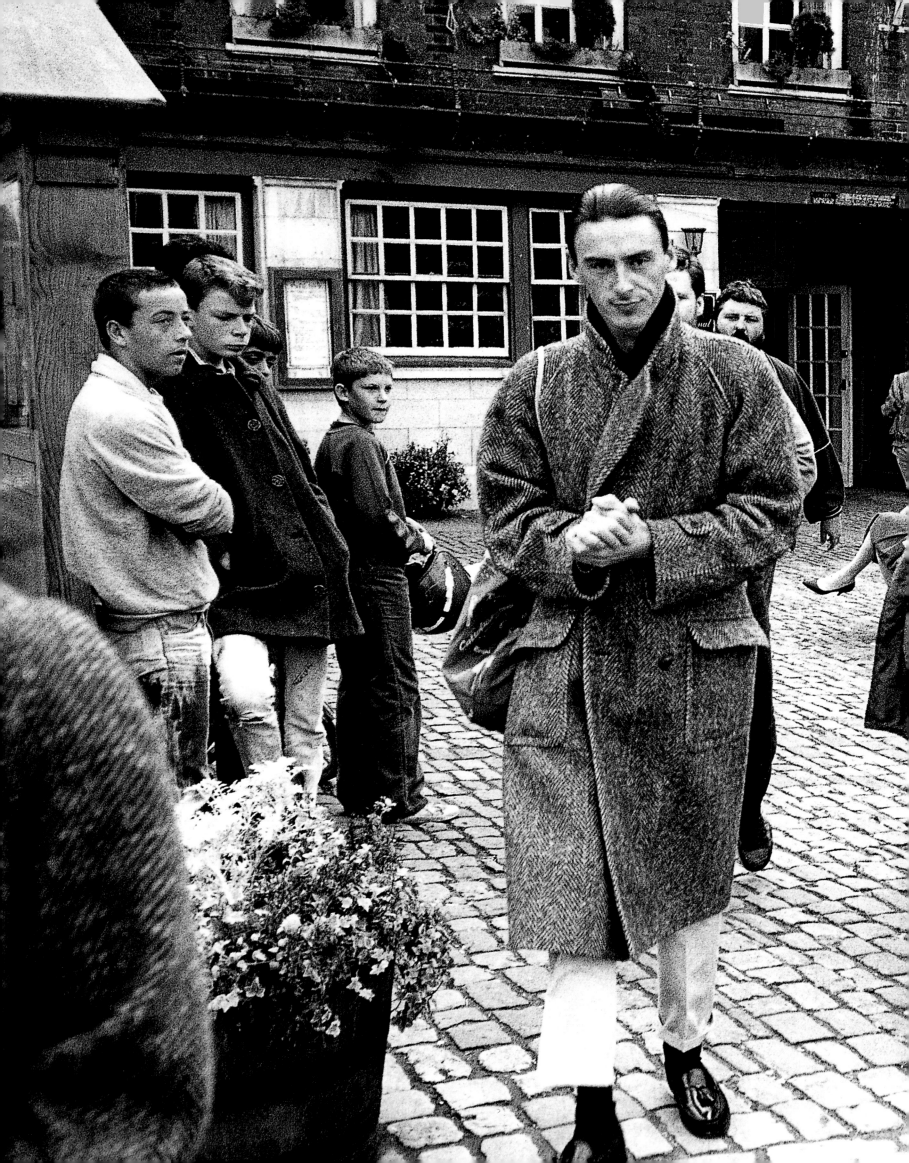

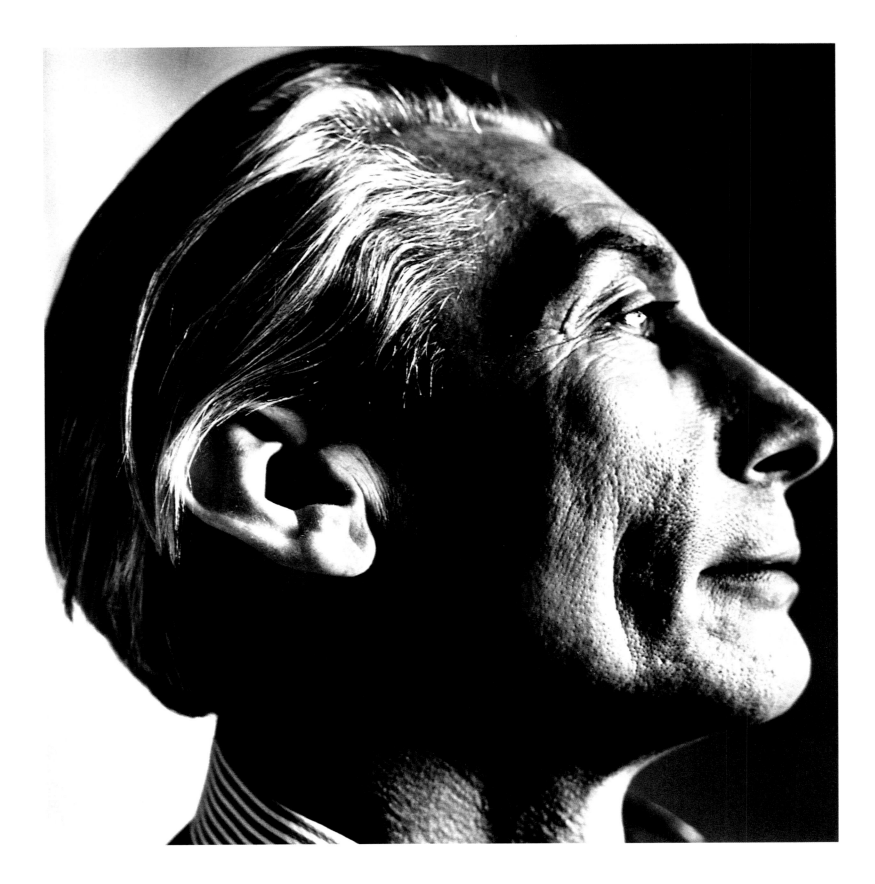

CHARLIE WATTS (THE ROLLING STONES)
PHOTOGRAPHY JILL FURMANOVSKY

This picture was taken for Q magazine but was
only used on the contents page. Feeling it was
worthy of more, this was during a particularly low
time in my career, I entered it into *The Observer*
'Jane Bown portrait awards' and won first prize.
To cap it all, Charlie sent me a hand written letter
of congratulations · his wife liked the portrait

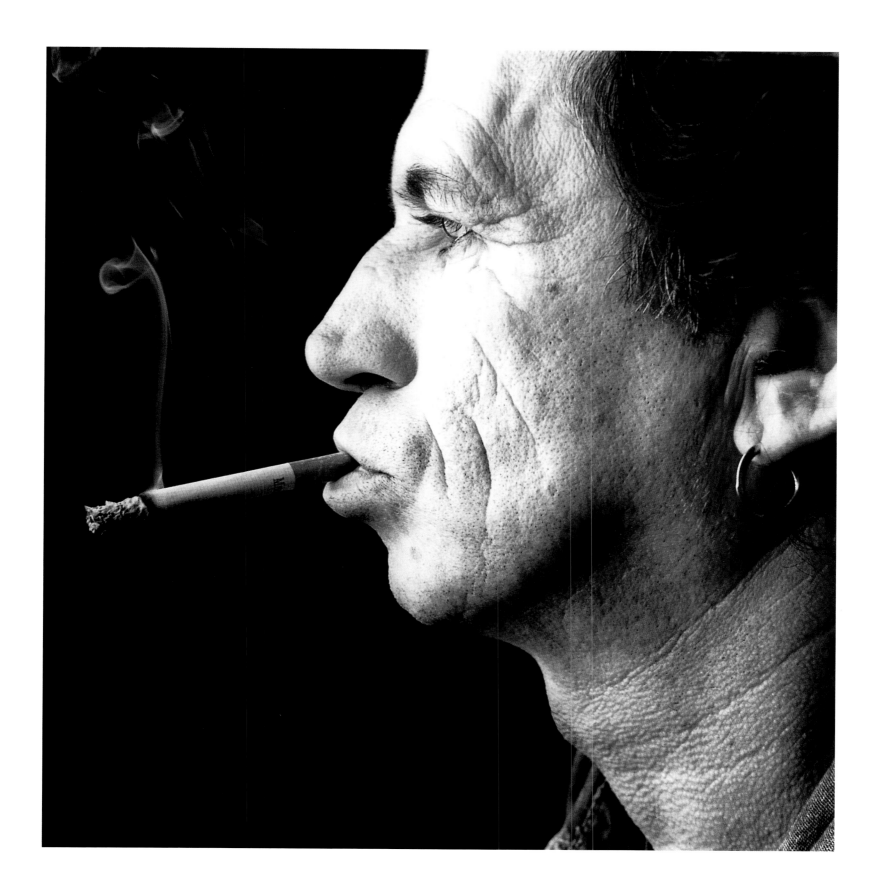

KEITH RICHARDS (THE ROLLING STONES AND THE XPENSIVE WINOS)

PHOTOGRAPHY DENIS O'REGAN

Keith relaxing backstage in Turin during their 1982 stadium tour

THE ROLLING STONES

PHOTOGRAPHY JOHN STODDART

This was the first photo session where they were all together for ten years. There were 50 people in the entourage and as time wore on Keith got through a bottle of vodka and collapsed. Mick just said 'That's the way the Rolling stones finish a photo session'

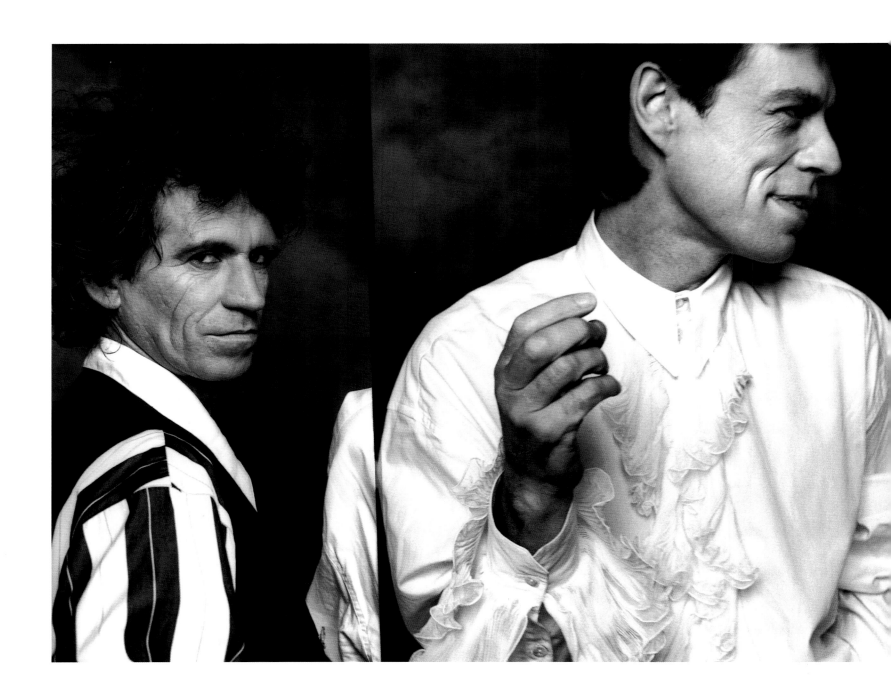

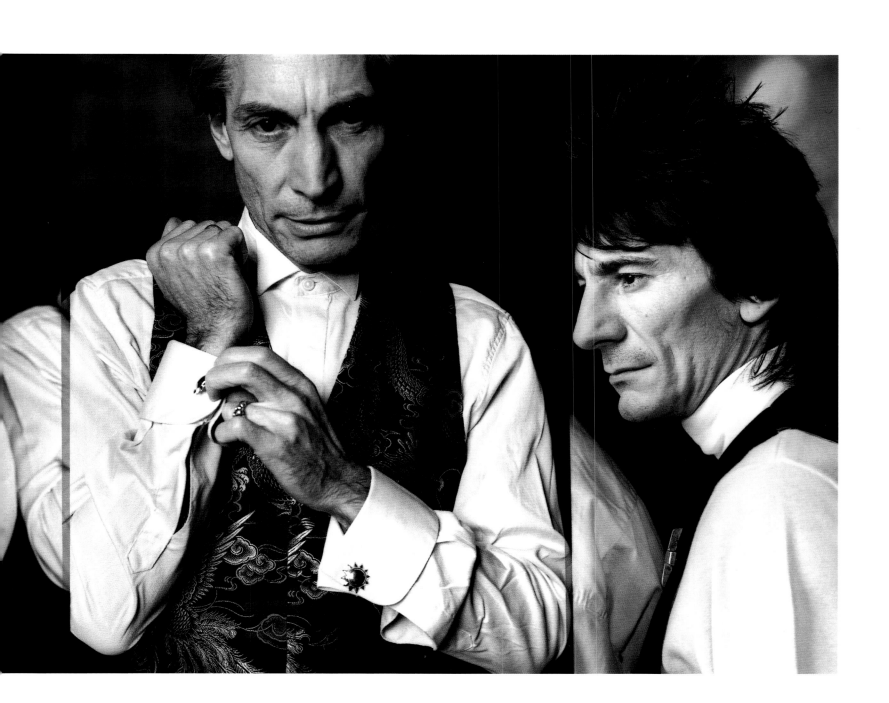

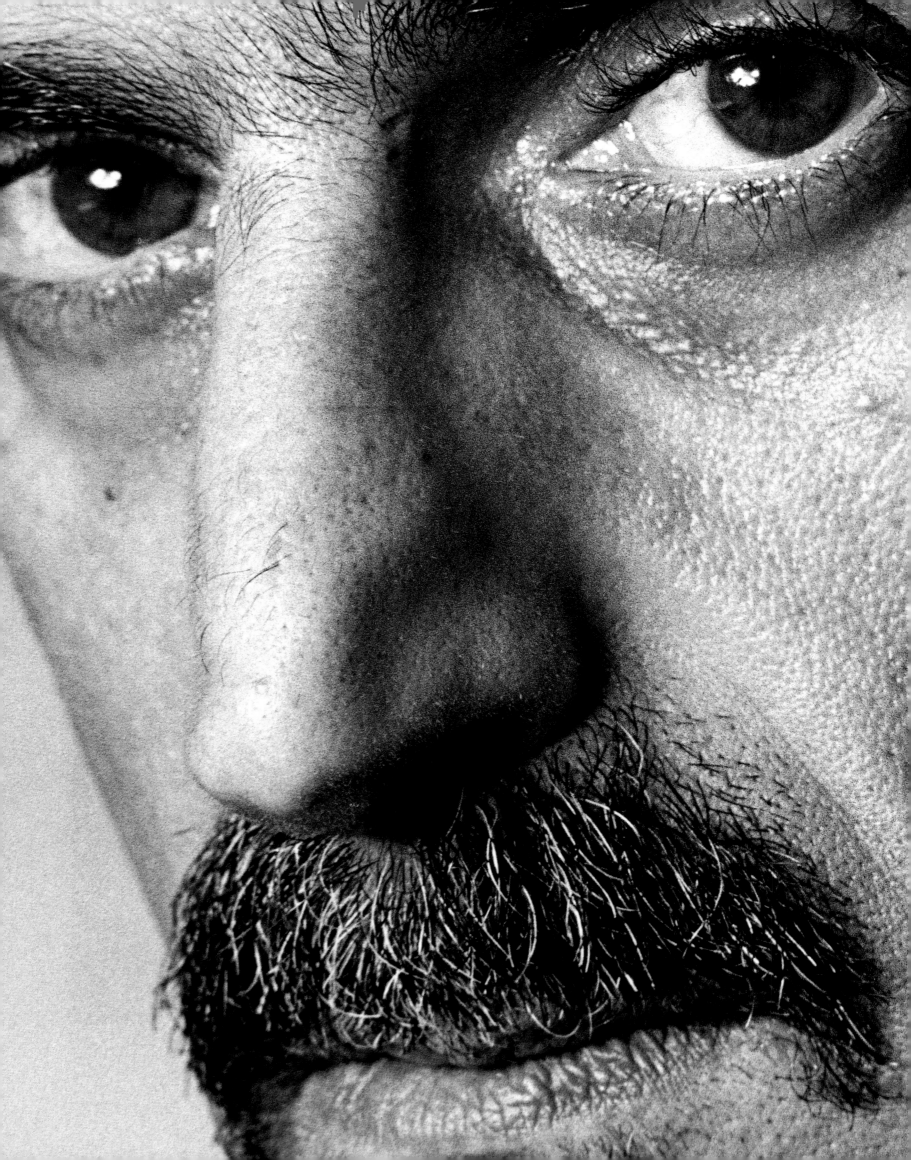

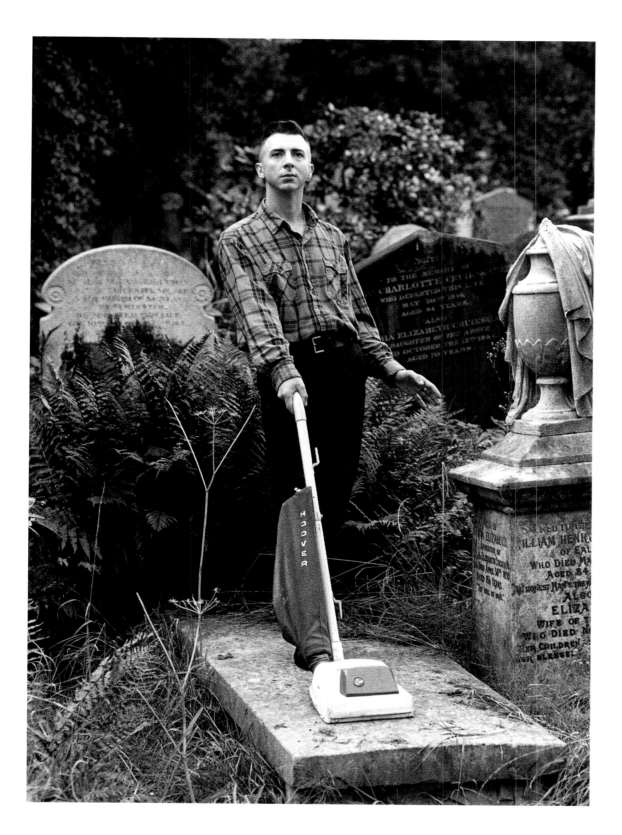

FRANK ZAPPA
(THE MOTHERS OF INVENTION, THEN SOLO)
PHOTOGRAPHY DEREK RIDGERS
No description

MARC ALMOND
(SOFT CELL, THEN SOLO)
PHOTOGRAPHY DEREK RIDGERS
No description

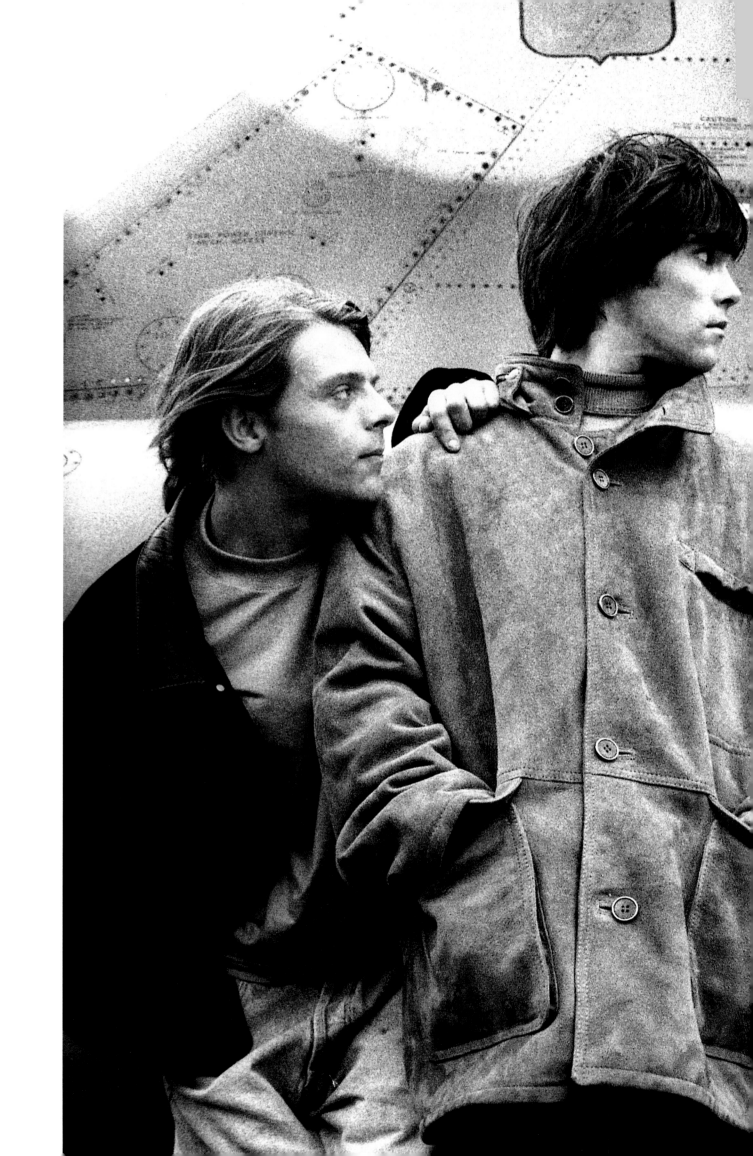

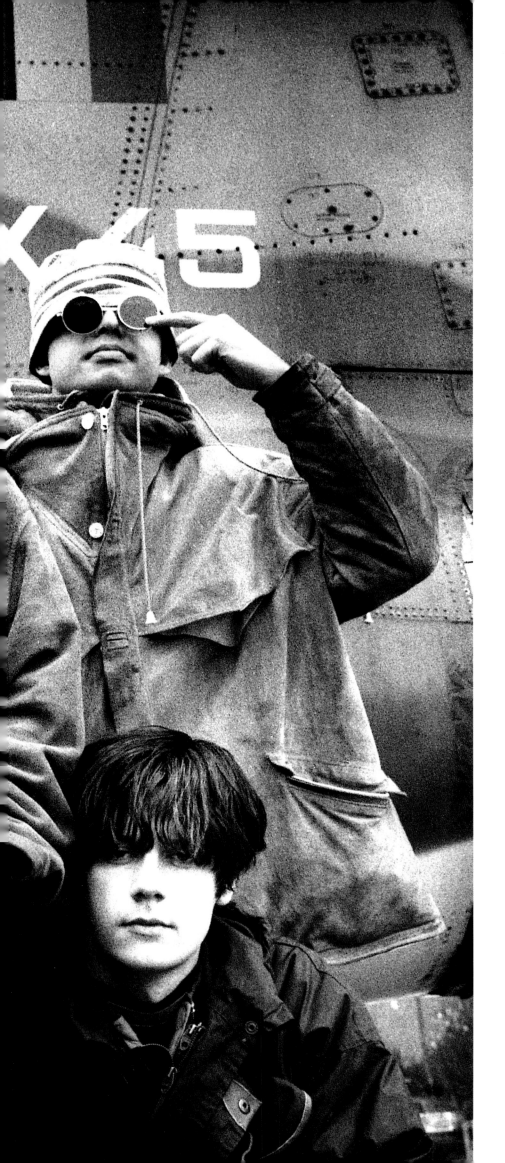

THE STONE ROSES
(LEAD SINGER IAN BROWN WENT SOLO, THE GUITARIST JOHN SQUIRE FORMED
THE SEAHORSES, BASS PLAYER MANI JOINED PRIMAL SCREAM THEN LEFT.
DRUMMER RENI DID NOT STAY IN MUSIC)
PHOTOGRAPHY PENNIE SMITH
We were driving from a soundcheck to the hotel when John Squire
spotted a Second World War plane parked on a roundabout. He wanted
a look, and I got a shot

KURT COBAIN (NIRVANA)

PHOTOGRAPHY MARTYN GOODACRE

Taken before *Nevermind* and after *Bleach*
outside The Dalmacia B&B, Shepherds Bush

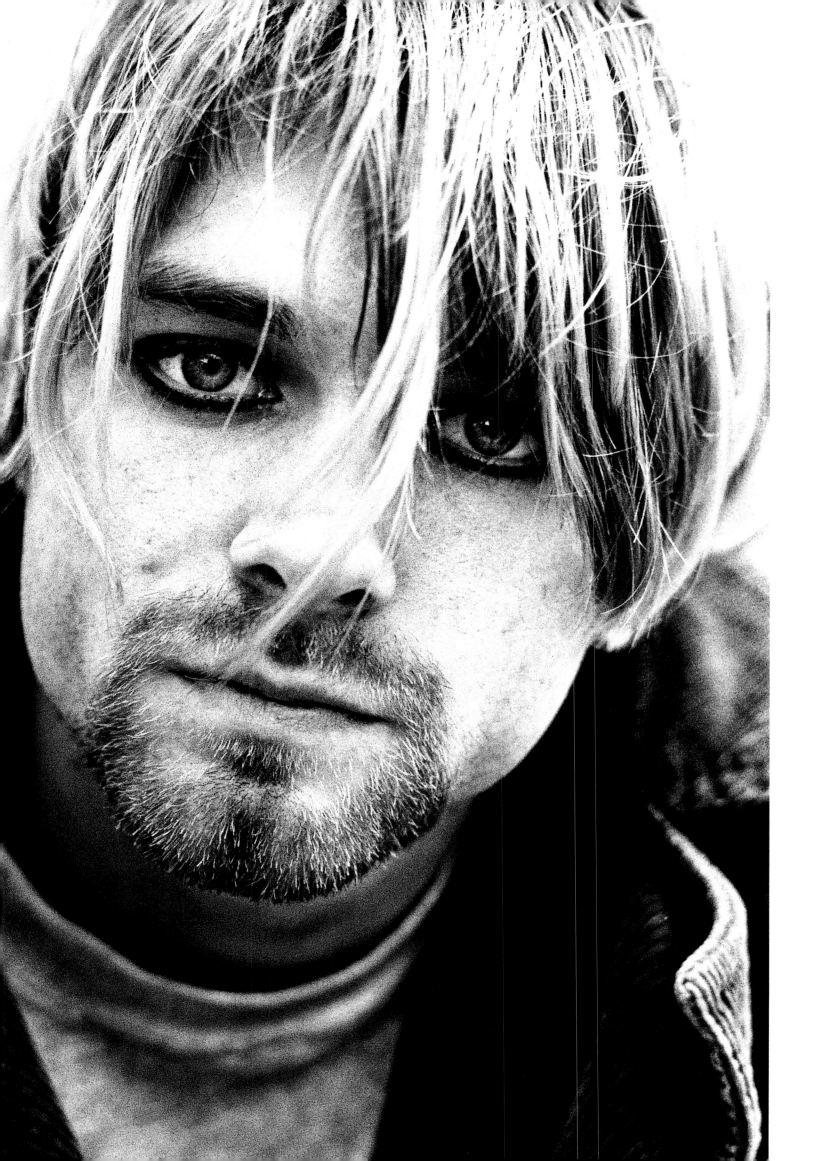

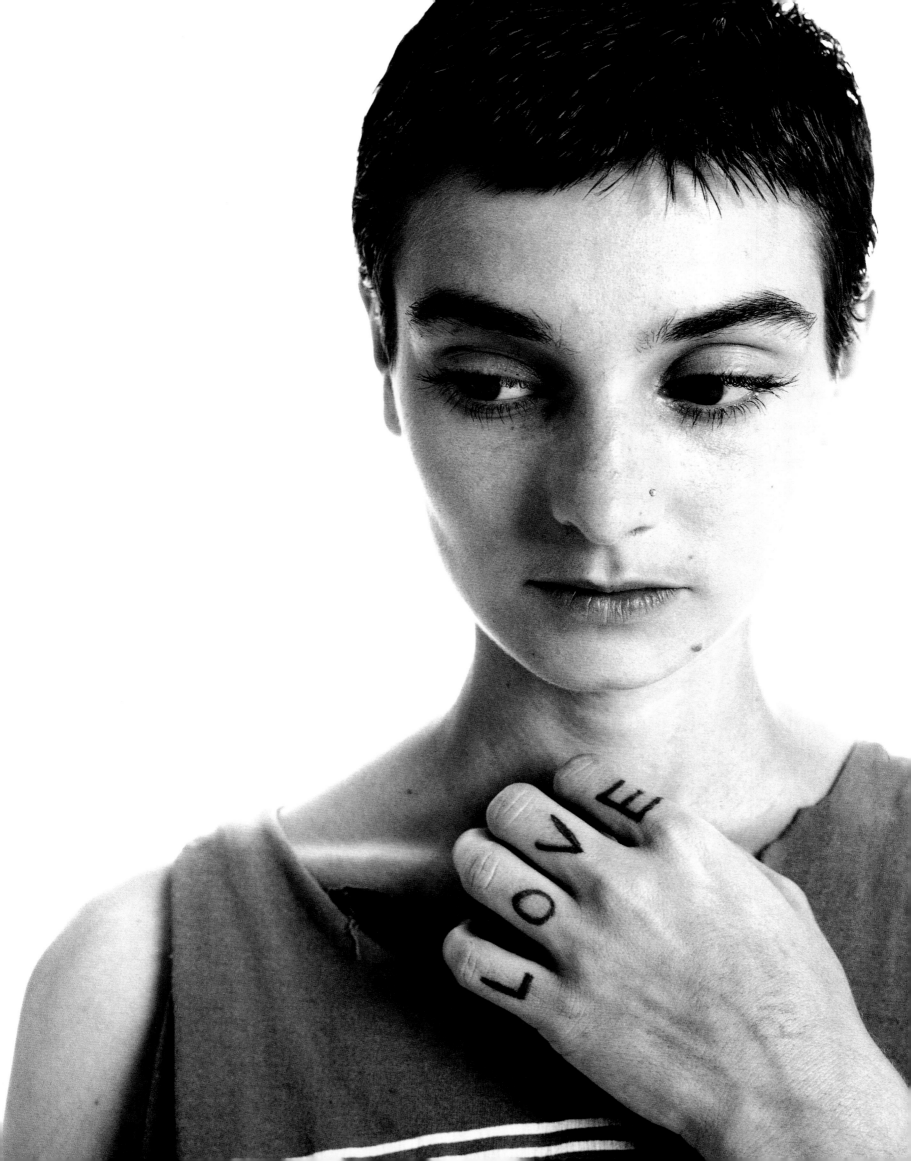

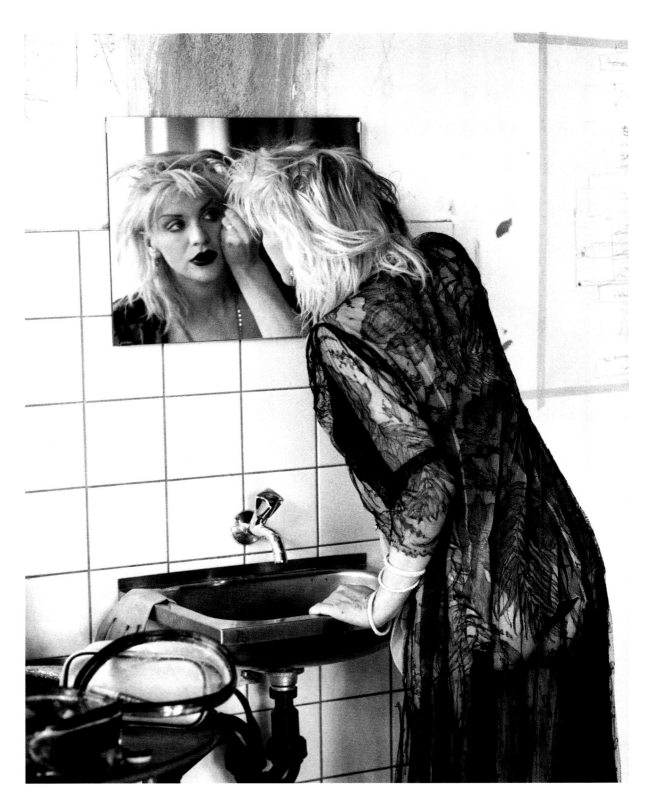

COURTNEY LOVE (HOLE)

PHOTOGRAPHY KEVIN CUMMINS

This was taken in the corner of a photo studio in Zurich. It was taken prior
to a session with her band Hole for the *NME*

RICHEY EDWARDS
(MANIC STREET PREACHERS UNTIL HE DISAPPEARED IN 1995)

PHOTOGRAPHY KEVIN CUMMINS

This was backstage in Bangkok. A fan had sent him a set of ceremonial
knives before the show with a note asking him to cut himself onstage with
them. He refused, thinking this would be too theatrical. However, during a
break in the show when James sang 'Raindrops Keep Falling On My Head',
Richey was backstage carefully slashing his chest. When I asked him why,
he simply said, 'Because he asked me to. I didn't want to disappoint him'

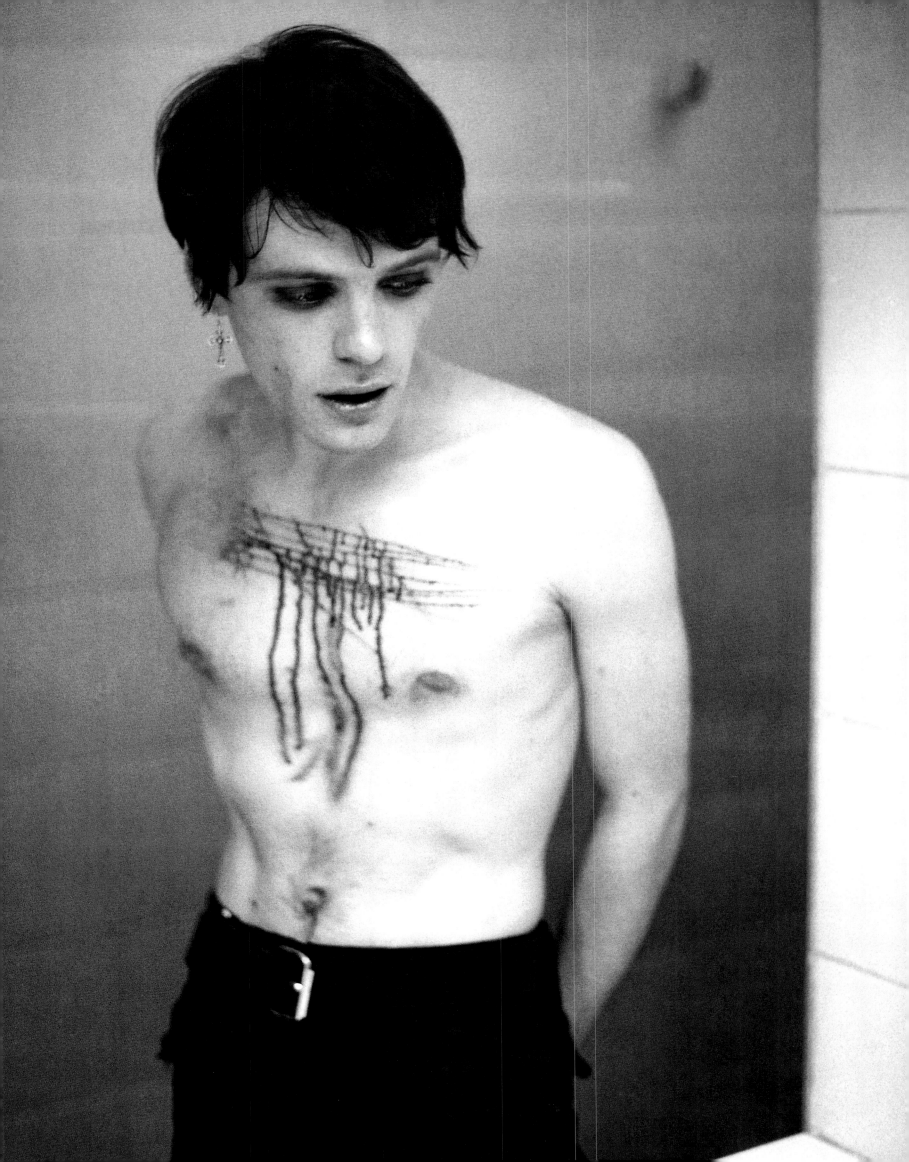

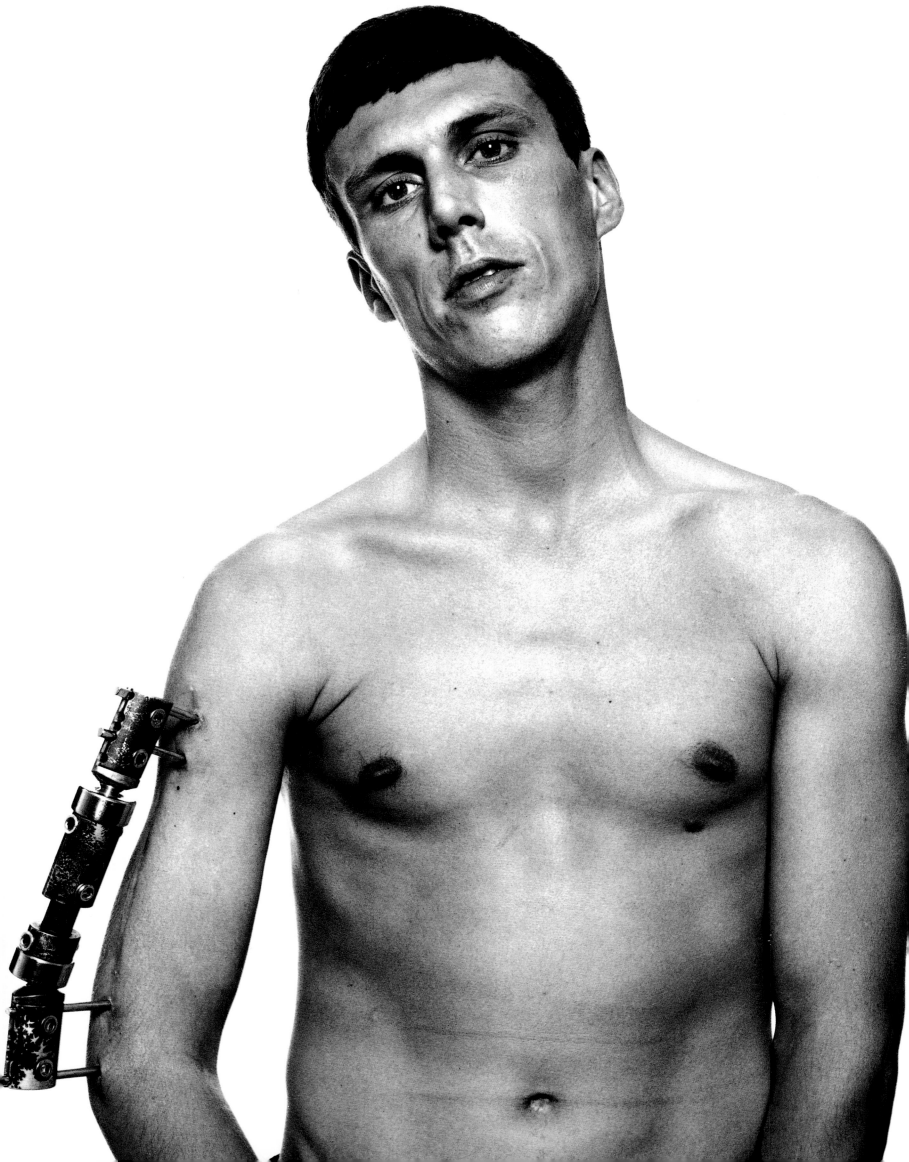

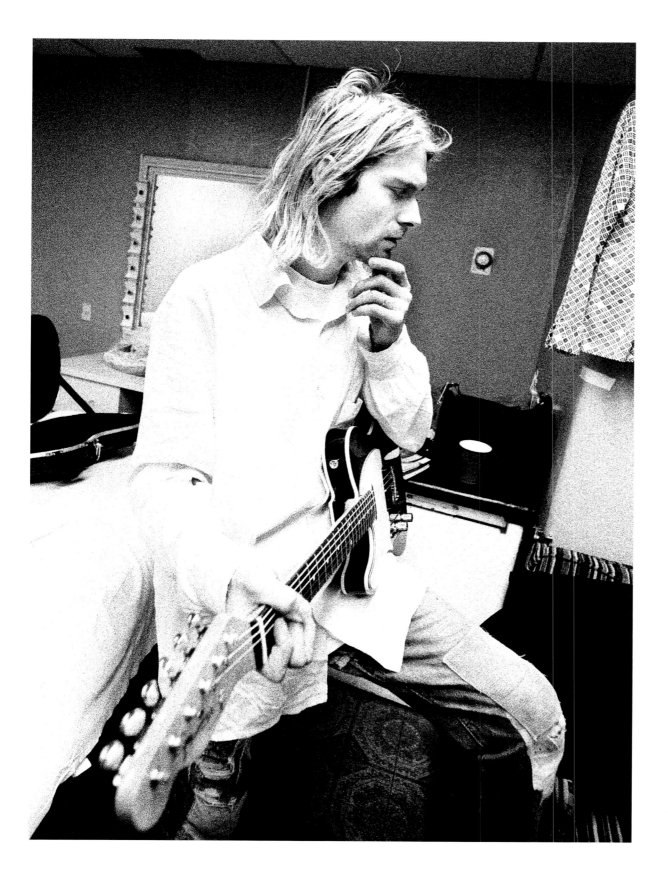

KURT COBAIN (NIRVANA)
PHOTOGRAPHY STEVE GULLICK
Relaxing before going on stage

**BEZ (THE HAPPY MONDAYS, BECAME A
COLUNMIST FOR THE SPORT NEWSPAPER, THEN
REJOINED THE HAPPY MONDAYS)**
PHOTOGRAPHY JOHN STODDART
This was taken during the last session of the
Happy Mondays before they disbanded and
Factory Records went bust. Bez had broken his
arm crashing his Jeep, it had to be re-broken and
set due to the highs of Jamaica

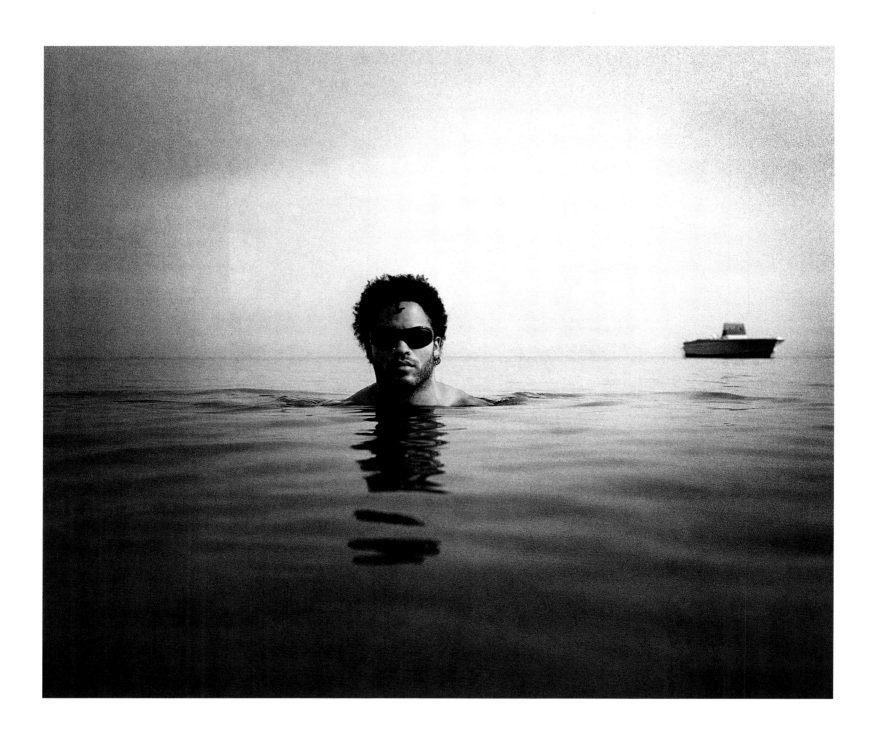

LENNY KRAVITZ
PHOTOGRAPHY HARRY BORDEN
This was taken in the Bahamas. Every morning
whilst waiting for my shoot to happen I would go
swimming in this bay. He was filming a video so
there was a lot of waiting around. Finally, on his day
off I woke him up at 7am (for the light) and got him
in the water. On the last two frames I decided to
have just his head sticking out of the sea with the
boat in the background… very *Dead Calm*

MICHAEL HUTCHENCE (LEAD SINGER INXS)
PHOTOGRAPHY HARRY BORDEN
Overlooking a Paris boulevard

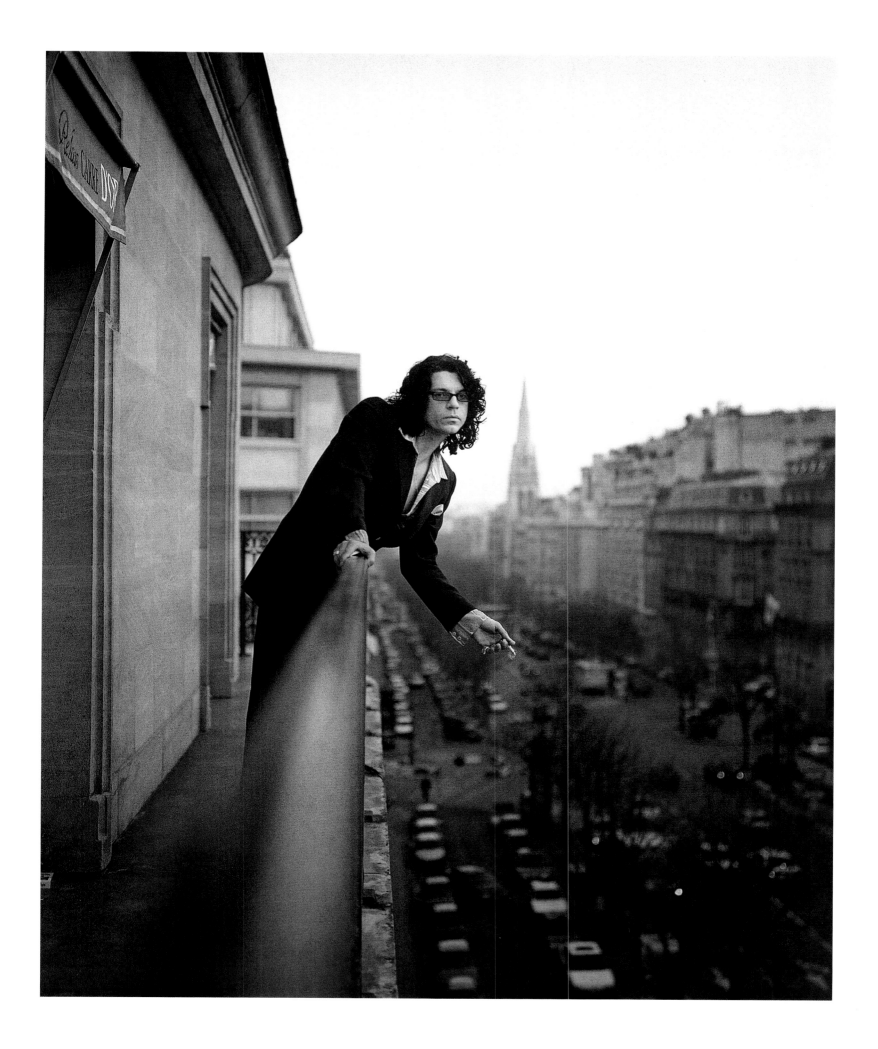

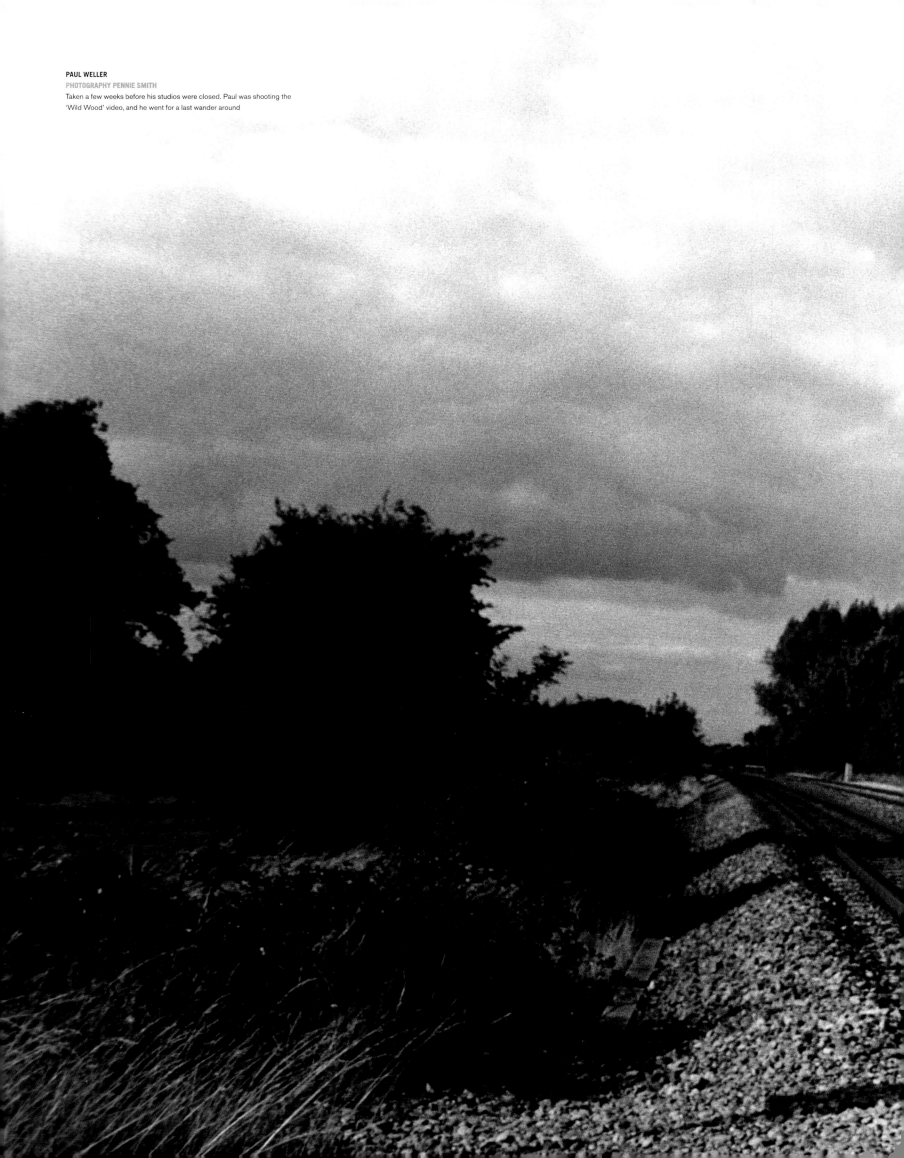

PAUL WELLER
PHOTOGRAPHY PENNIE SMITH
Taken a few weeks before his studios were closed. Paul was shooting the
'Wild Wood' video, and he went for a last wander around

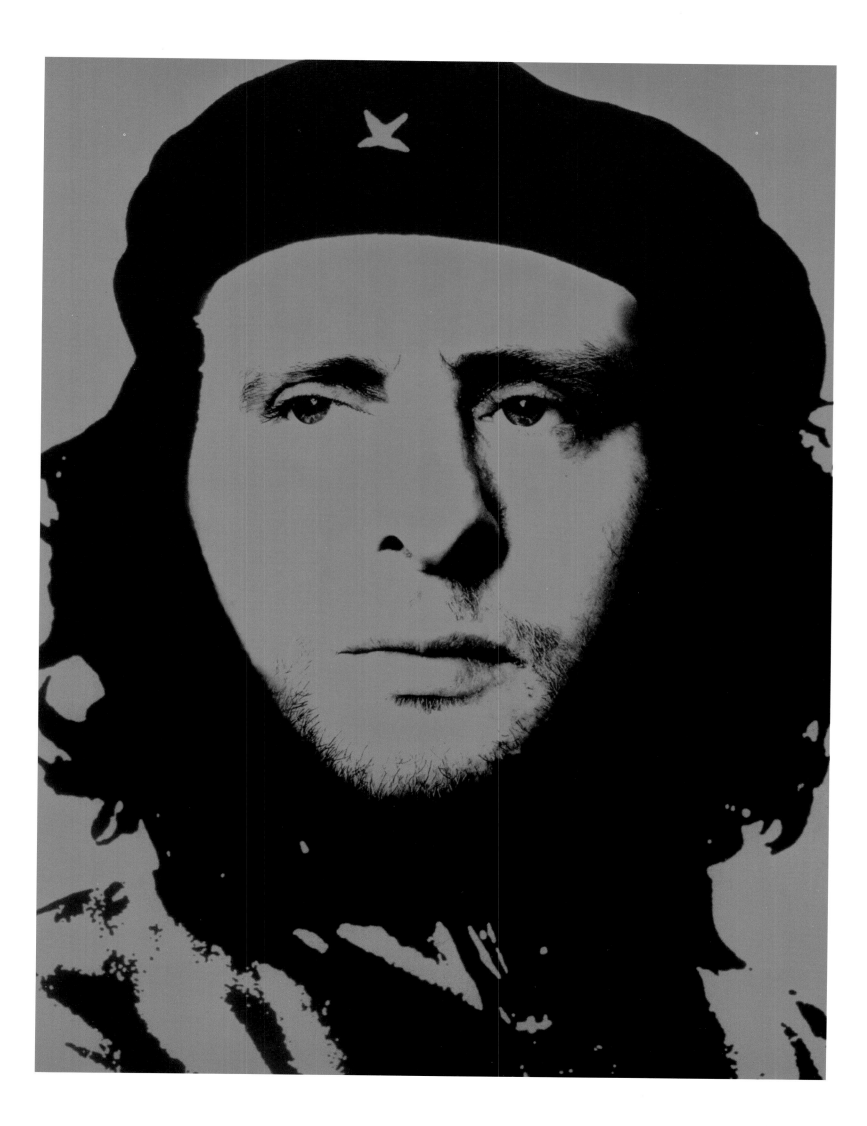

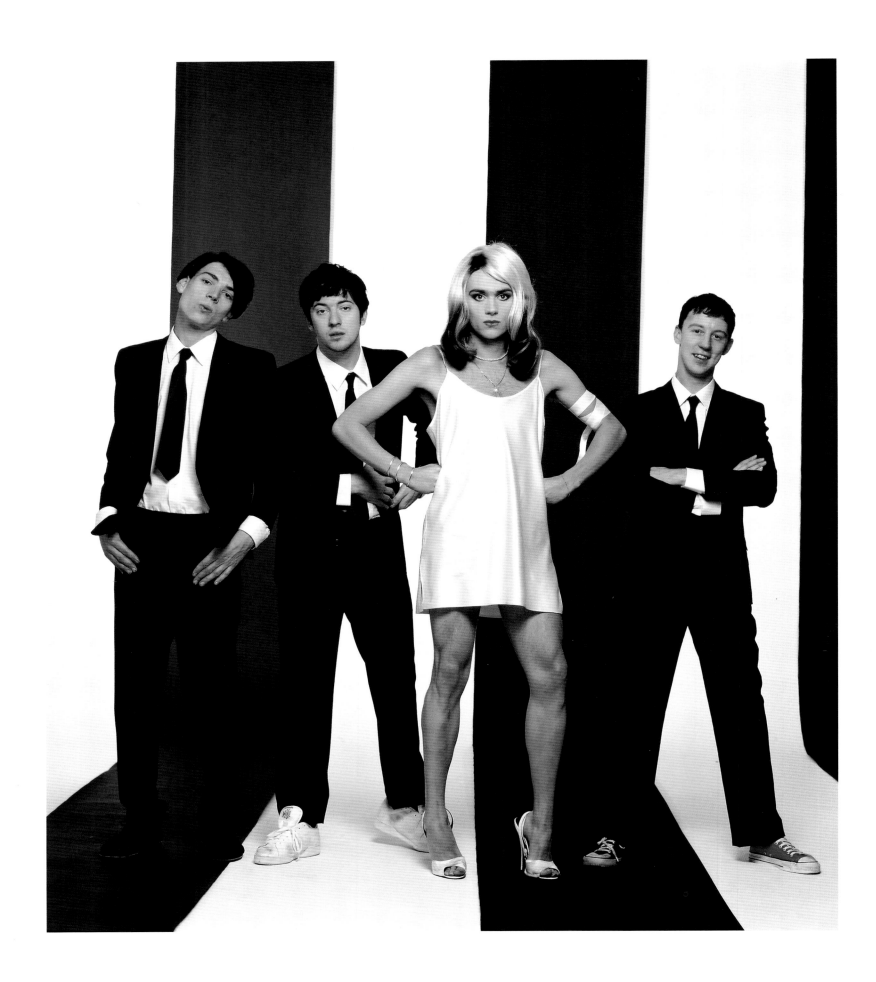

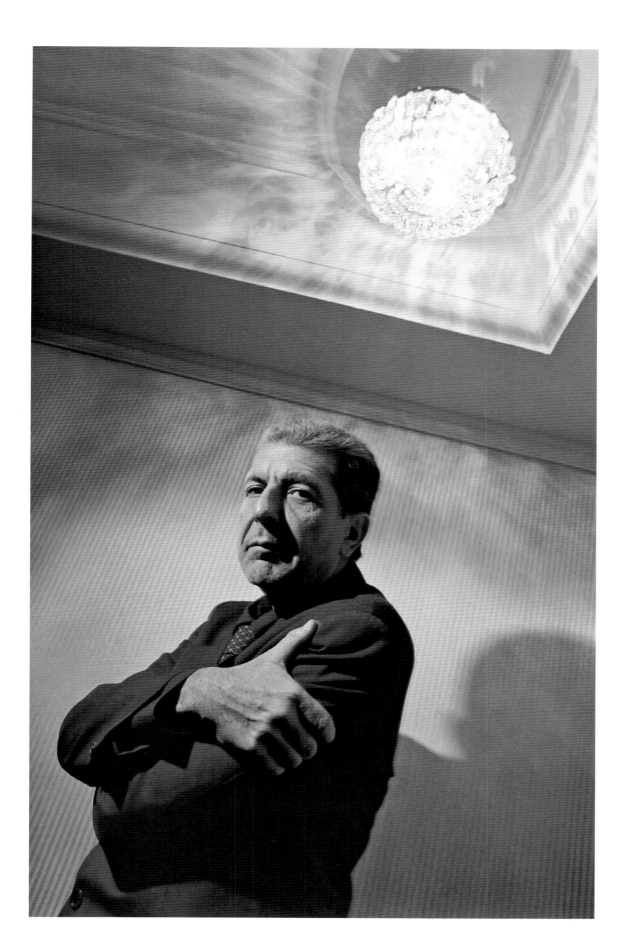

BLUR
PHOTOGRAPHY KEVIN CUMMINS

Every Christmas for the *NME* we would
thematically dress bands up in that British
pantomime tradition. Blur were going to do a
Queen album sleeve but Freddie Mercury died
the week of the shoot. I suggested Blondie's
Parallel Lines as I've always been interested in
that British male obsession with cross-dressing.
Damon would only go as far as shaving his legs
below the knee. I photographed Debbie Harry in
May 1999 and told her this and she said, 'So do
I, I won't go any further either. I guess it's more
authentic than you thought'

LEONARD COHEN
PHOTOGRAPHY BARRY MARSDEN

This was taken in a hotel in London which
unfortunately I've forgotten the name of. I had
been booked to take pictures of Leonard
Cohen for two different publications, *The
Telegraph* and *Vox*. This was the shot used for
The Telegraph, I didn't even have to take the
equipment down to get the shot for *Vox*

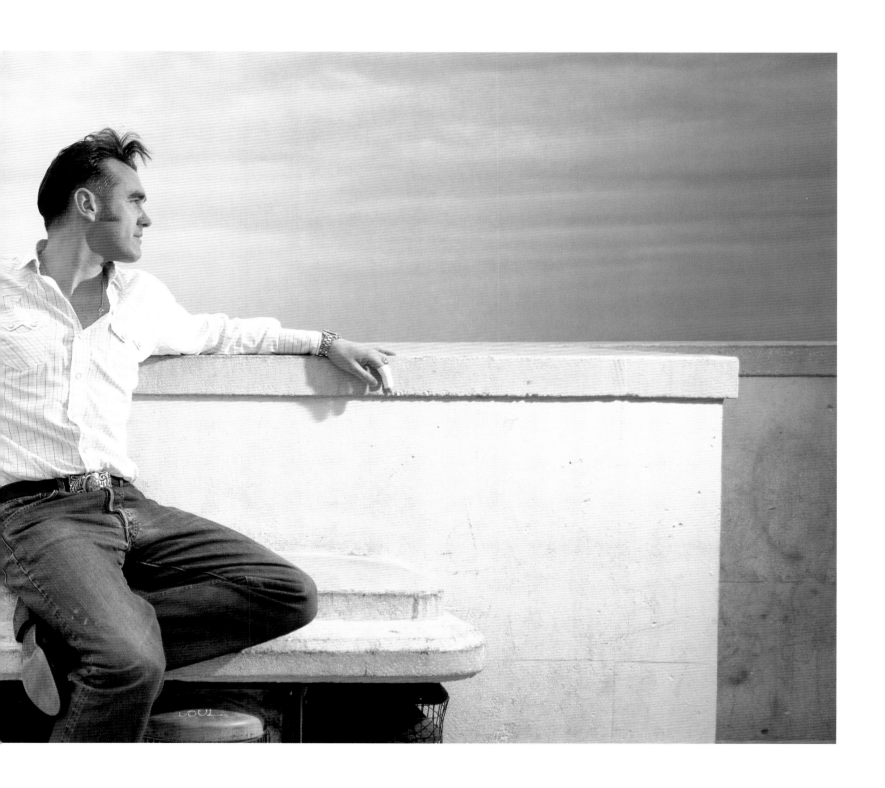

THE SPICE GIRLS
(GERI HALLIWELL (GINGER SPICE) WENT SOLO)
PHOTOGRAPHY HARRY BORDEN
Taken in hotel room in Bangkok on their first
promotional tour of the Far East

BRETT ANDERSON (SUEDE)
PHOTOGRAPHY KEVIN CUMMINS
The body paint took six hours. Every time he
stretched it had to be painted again as cracks
began to show

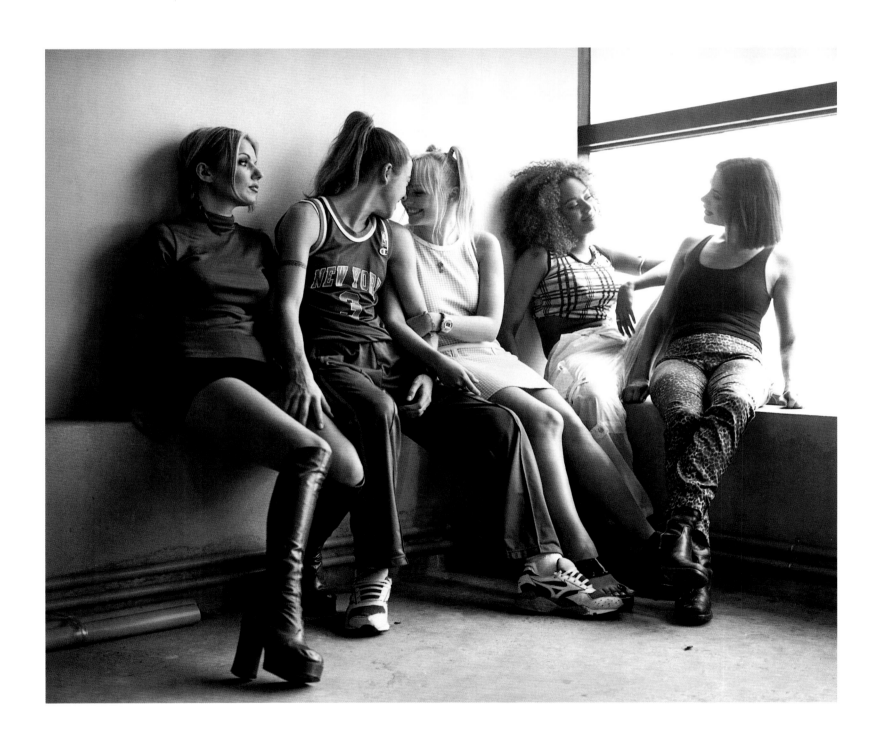

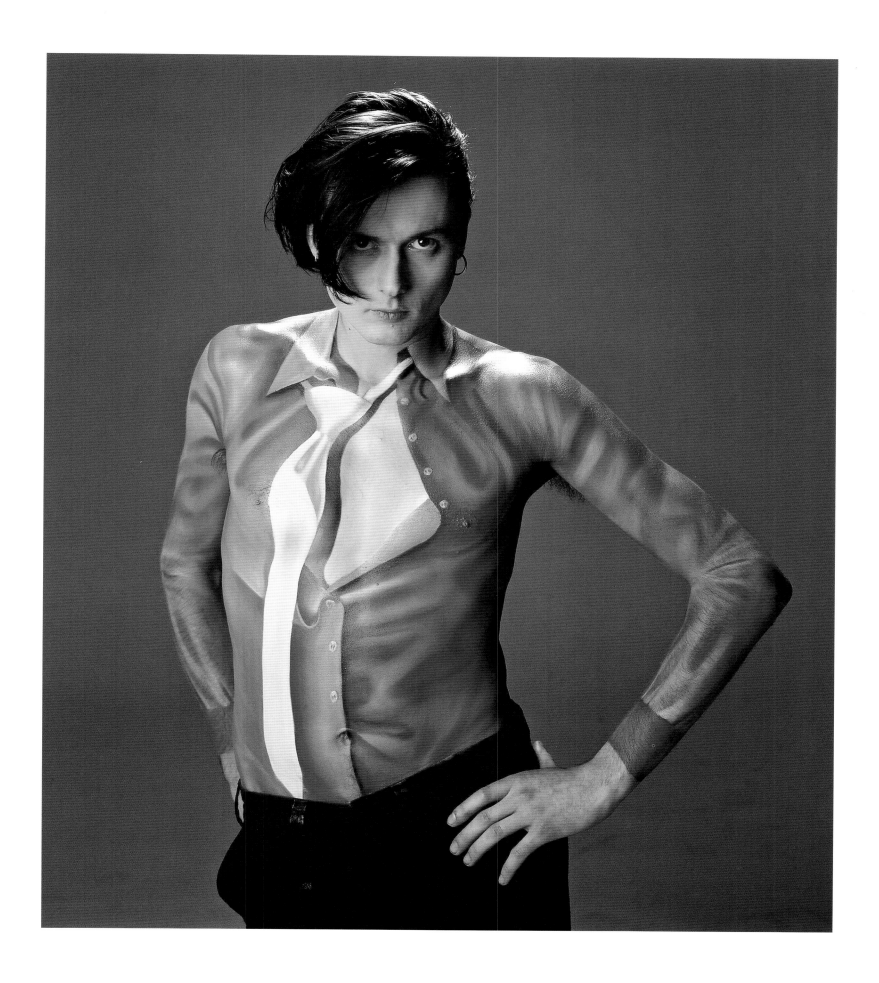

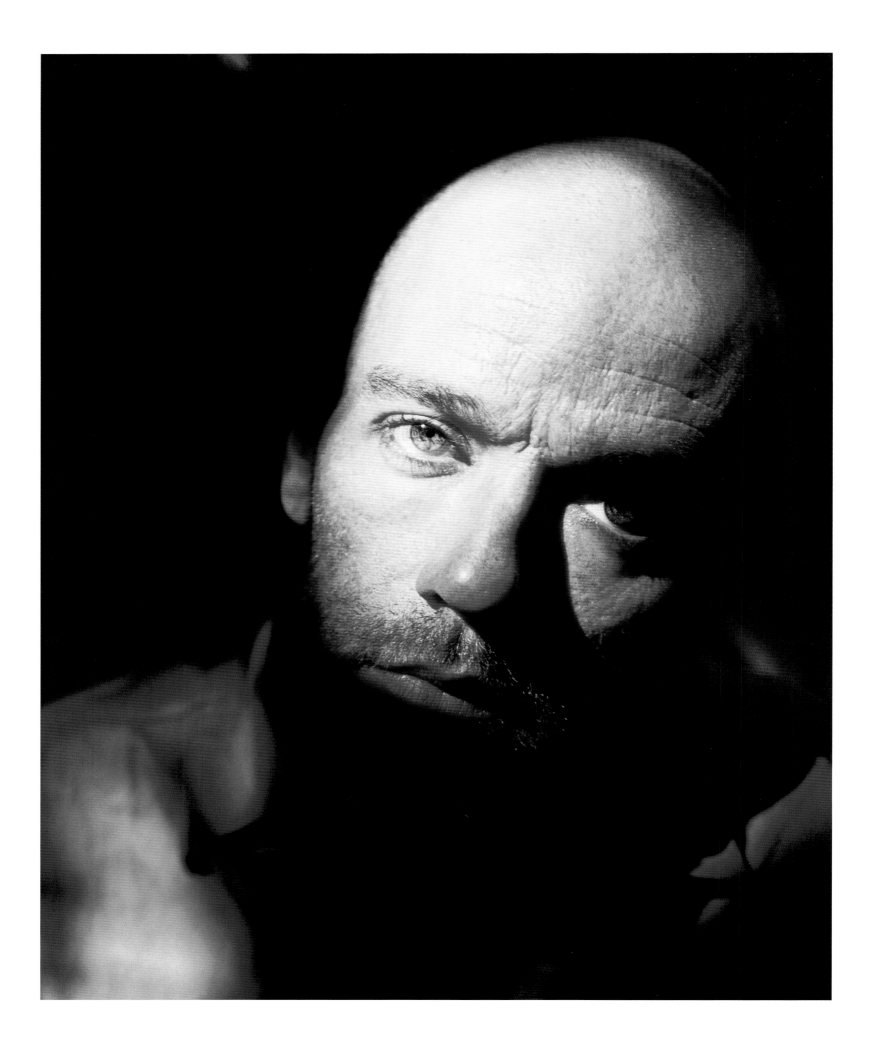

MICHAEL STIPE (LEAD SINGER R.E.M)
PHOTOGRAPHY HAMISH BROWN
Taken in Michael's private hotel garden in LA

PJ HARVEY
PHOTOGRAPHY HARRY BORDEN
This was shot where I lived at the time in Bethnal
Green. The make-up person arrived an hour later
so we'd started without her. A lot of celebrities
would feel exposed without make-up, but I
equally like the shots without. After we finished I
asked if I could come with her and take more
shots... we rode back to her hotel and then we
went shopping in a supermarket. She always
looks so extraordinary that you could shoot her
anywhere and she would stand out... even out of
focus, she's instantly recognisable

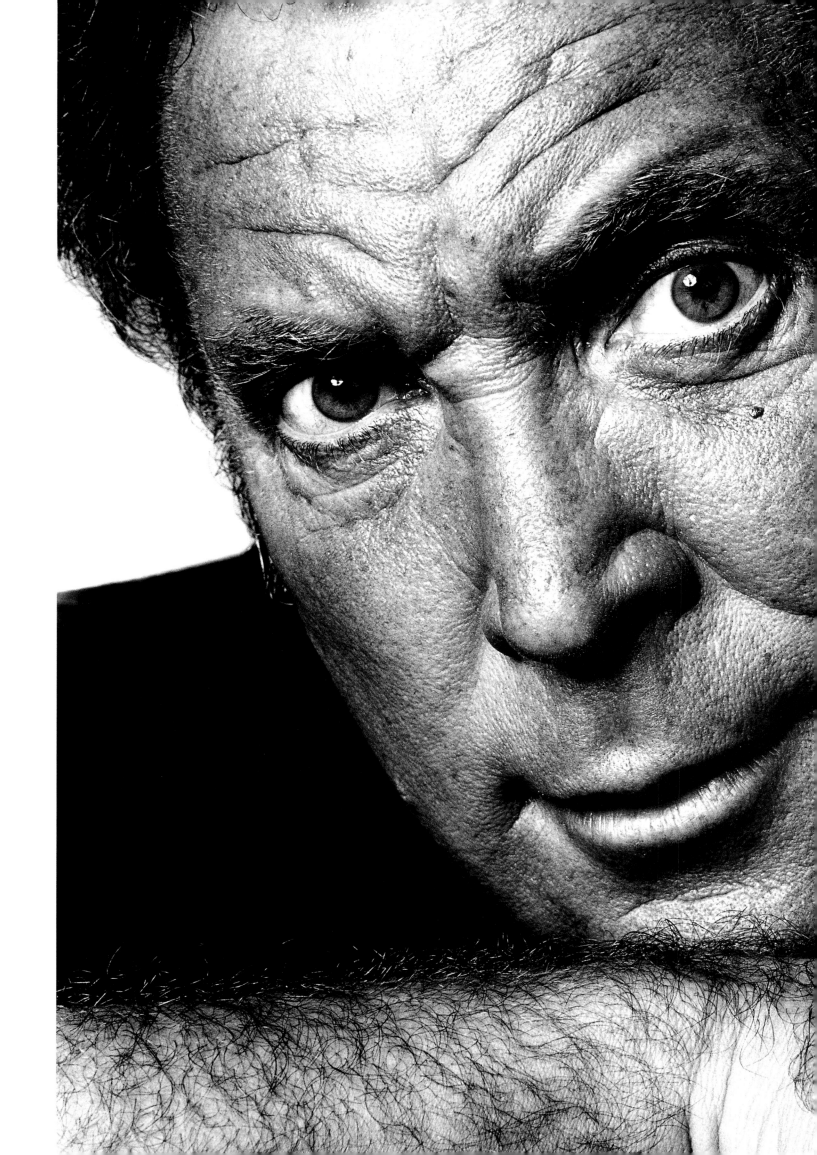

TOM JONES
PHOTOGRAPHY BARRY MARSDEN
Taken over a pool table at a North London recording studio

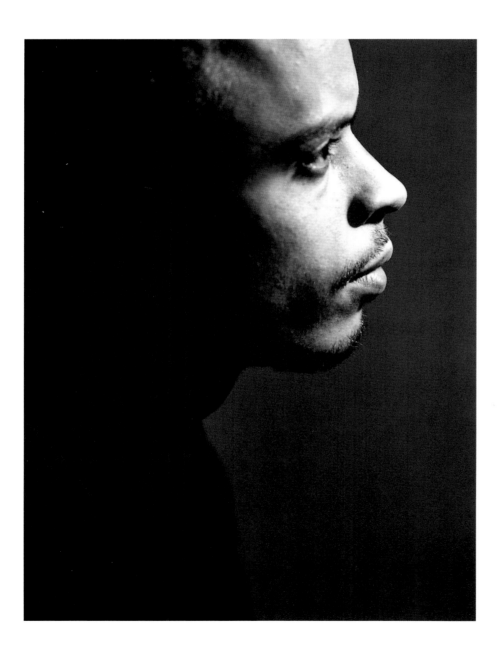

MASSIVE ATTACK (LEFT TO RIGHT: 3D, DADDY G & MUSHROOM)
PHOTOGRAPHY HAMISH BROWN
I shot this in their dressing room after a show in Munich for
an *NME* cover

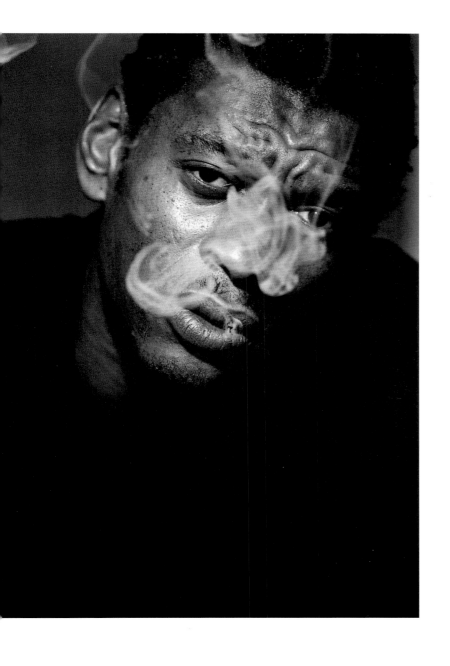
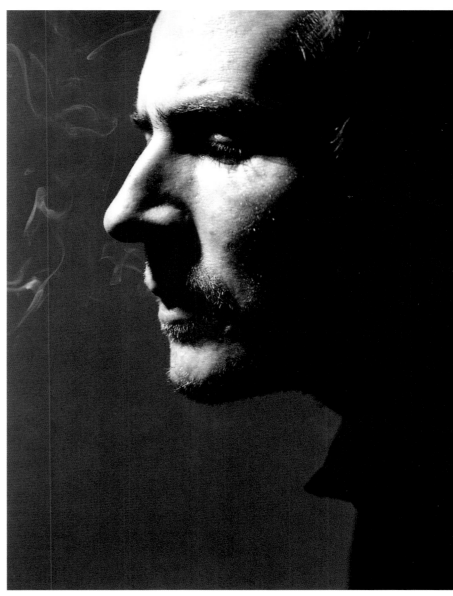

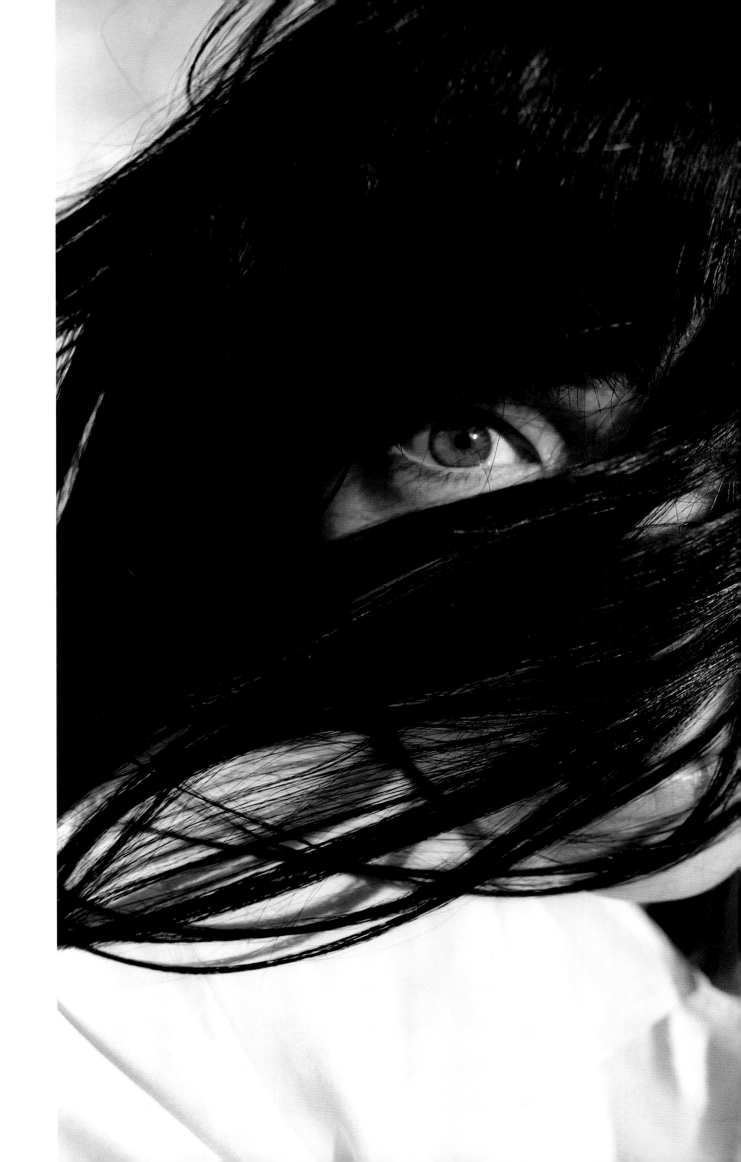

BJÖRK (SUGARCUBES, NOW SOLO)

PHOTOGRAPHY RANKIN

This was taken for a *Dazed & Confused* cover for an issue guest-edited by fashion designer Paul Smith. It was one of the worst journeys I have ever taken to reach a shoot. Björk calmed me down and was lovely as always, but it was so windy I wasn't sure what I'd got on film. When we got the contact sheets back Paul pulled out this shot I hadn't even noticed. From one of the worst sessions of all time... Fluked it again

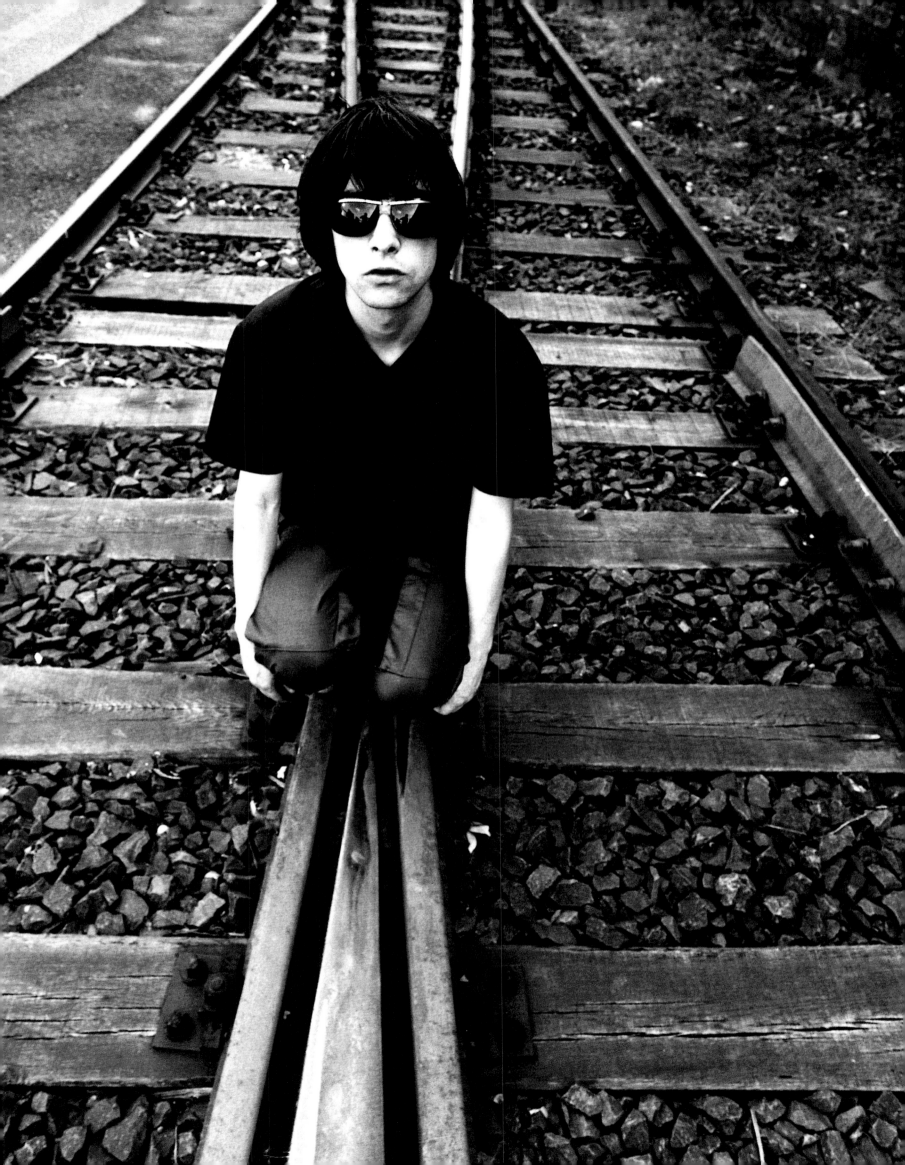

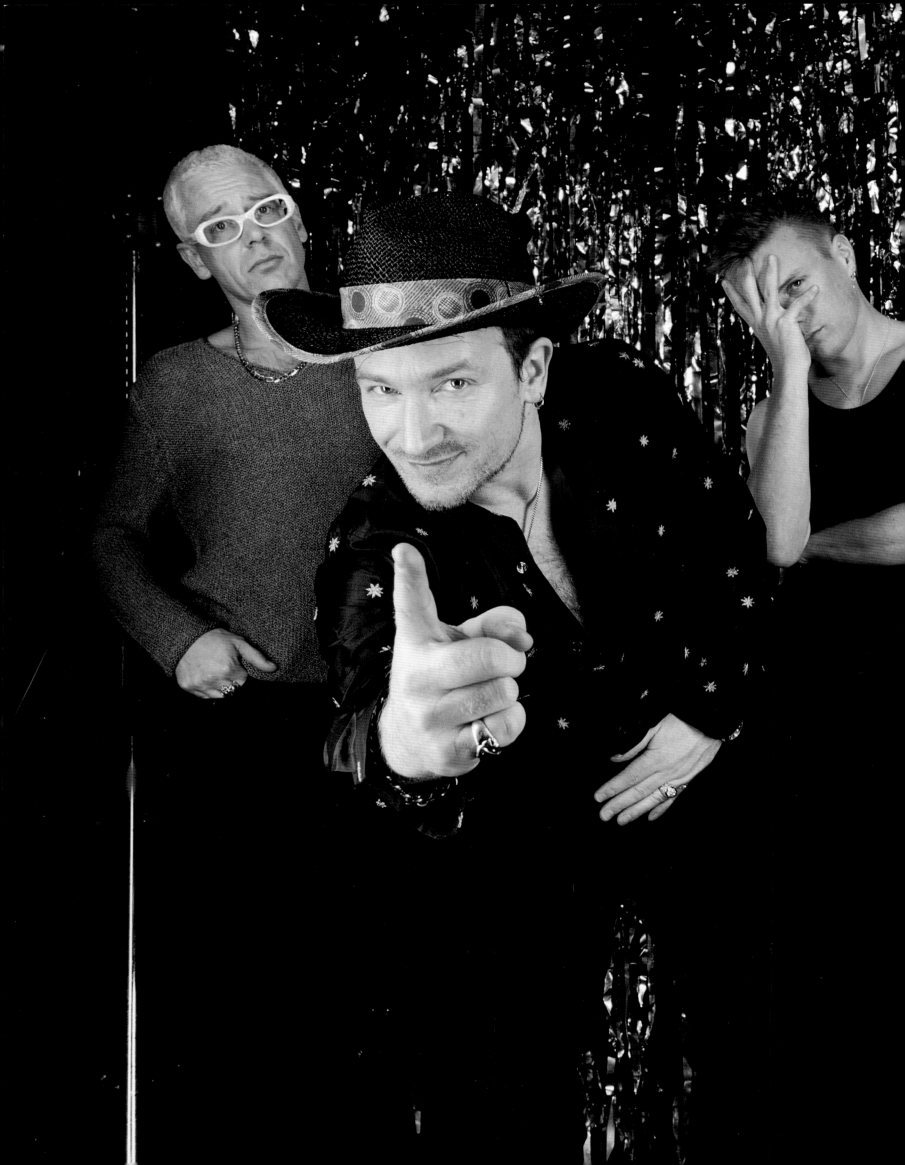

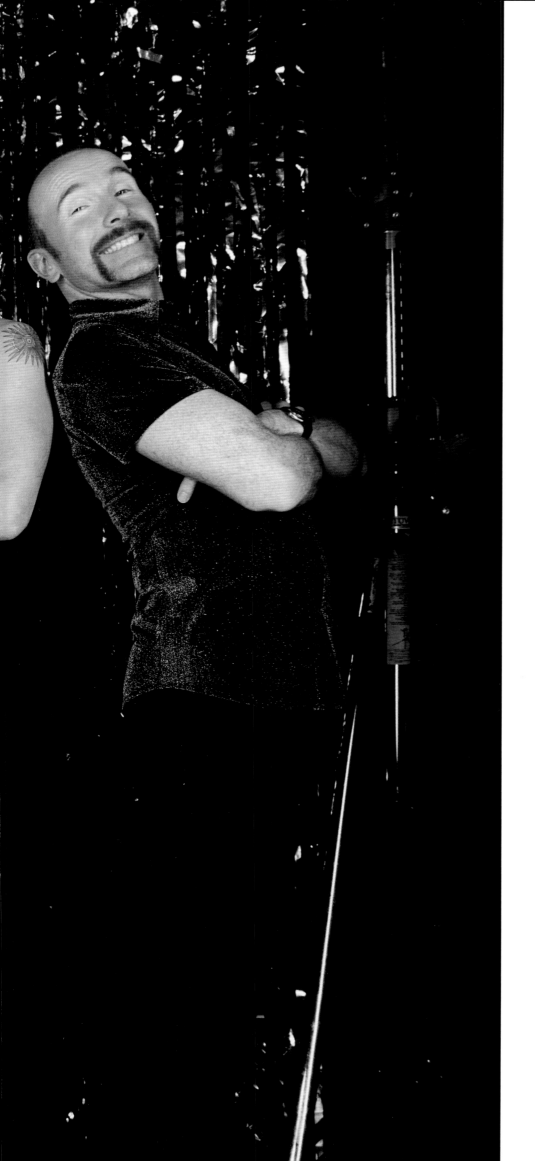

U2

PHOTOGRAPHY RANKIN

Taken during a press session to help promote
the *Pop* album and tour. I have never been
charmed by a man in my life as I was by Bono.
They are still my favourite band to photograph

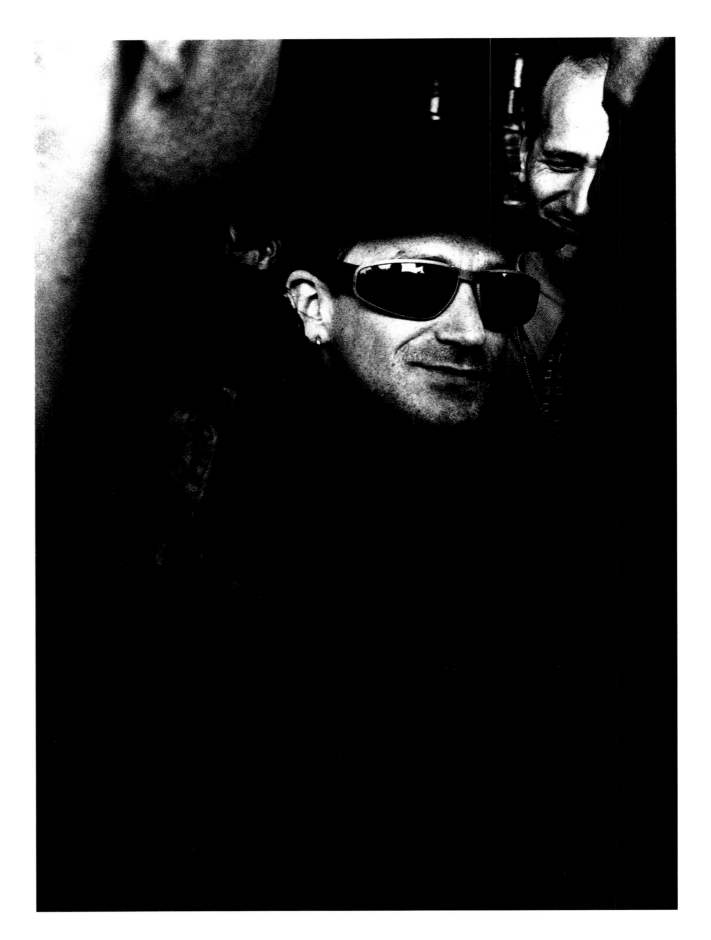

BONO (LEAD SINGER U2)
PHOTOGRAPHY STEVE GULLICK
Bono on the bus on the way to the plane
coming back to Ireland from Sarajevo

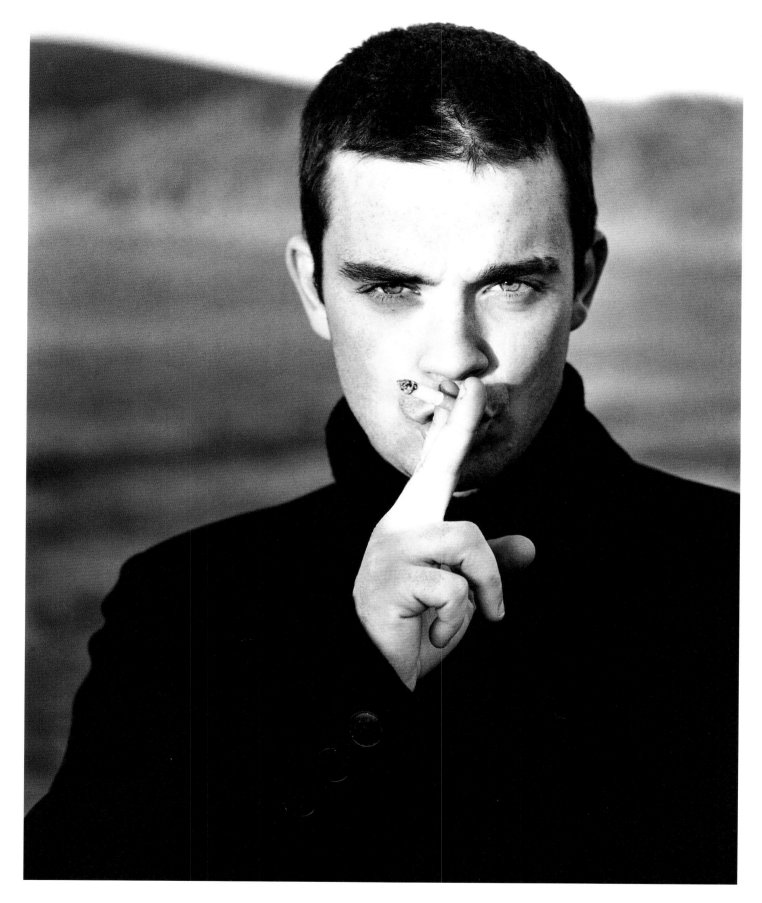

ROBBIE WILLIAMS (TAKE THAT, NOW SOLO)
PHOTOGRAPHY HAMISH BROWN
Taken on the beach in Devon on the set of the
'Angels' video. The shots I took were for the single's
artwork and publicity

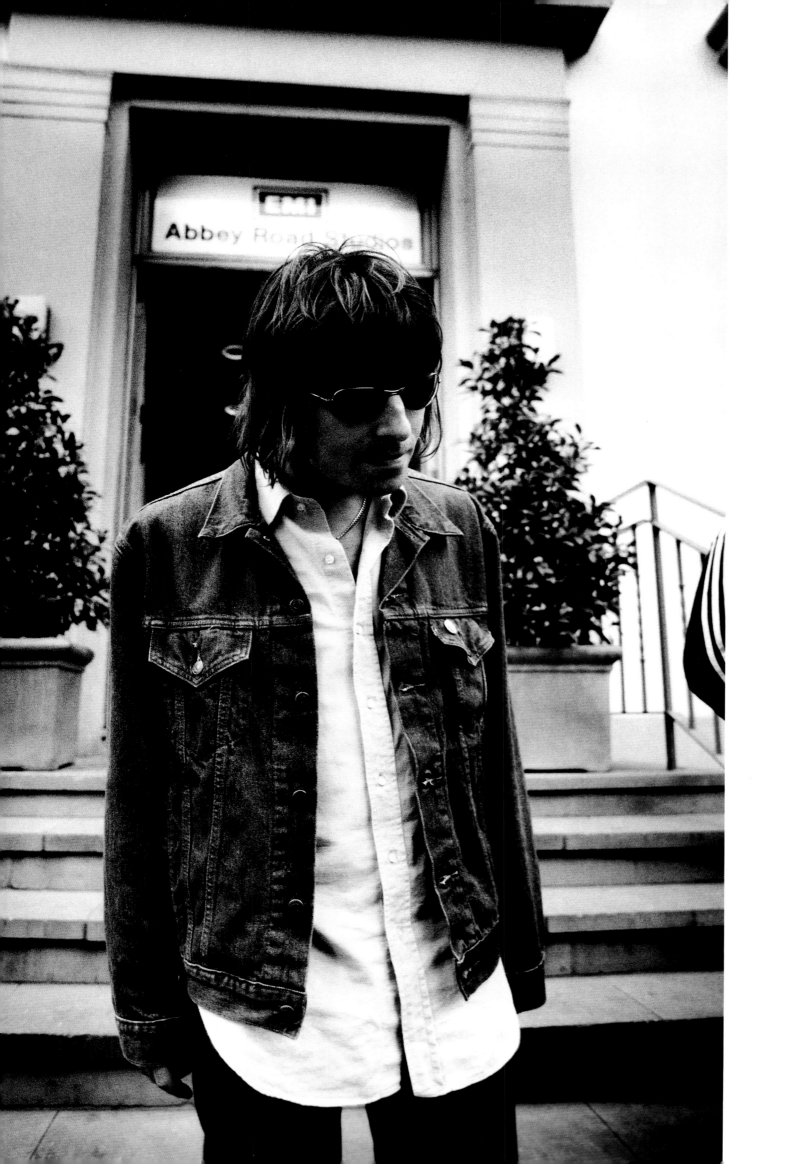

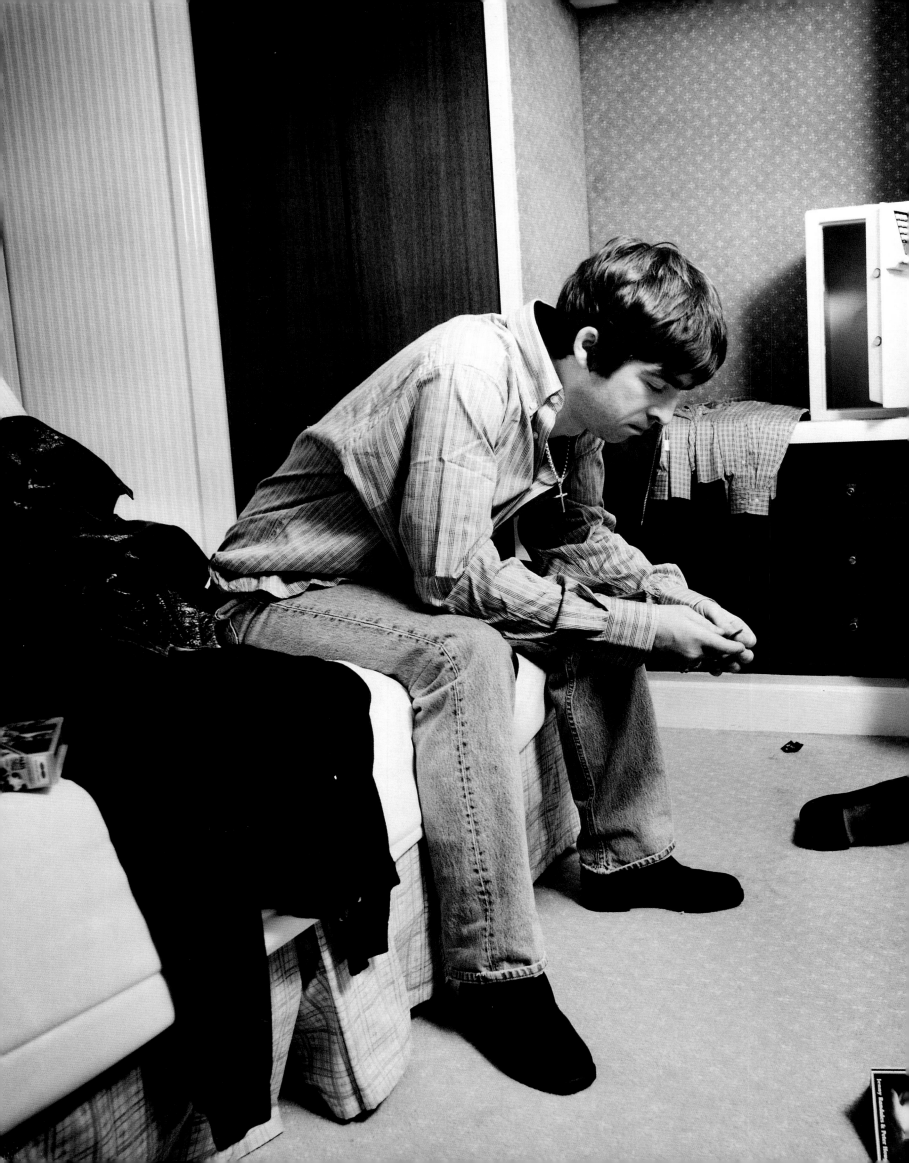

NOEL GALLAGHER (OASIS)
PHOTOGRAPHY JILL FURMANOVASKY
Taken in his hotel room in Paris the morning before an Oasis photo shoot,
this picture preceded a day of conflict for the Gallagher brothers who
were at loggerheads with each other. Although difficult for all concerned,
the day's shooting produced an extraordinary series of portraits

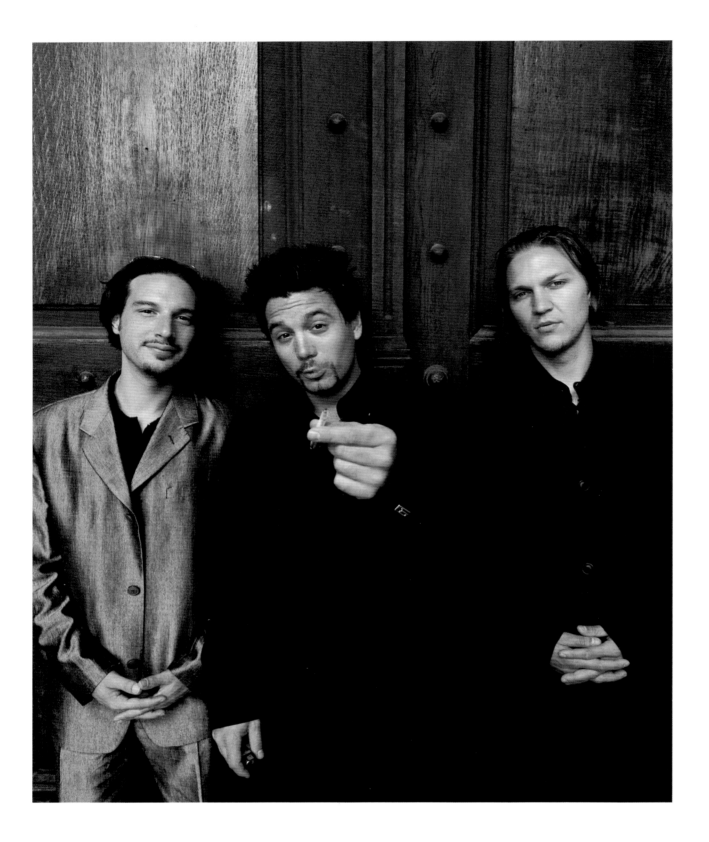

FUN LOVIN' CRIMINALS
PHOTOGRAPHY HAMISH BROWN
Shot at the Beverley Hills Hotel, LA, October
'98. From an *NME* cover shoot

THOM YORKE
PHOTOGRAPHY STEVE GULLICK
Taken for the *Melody Maker*

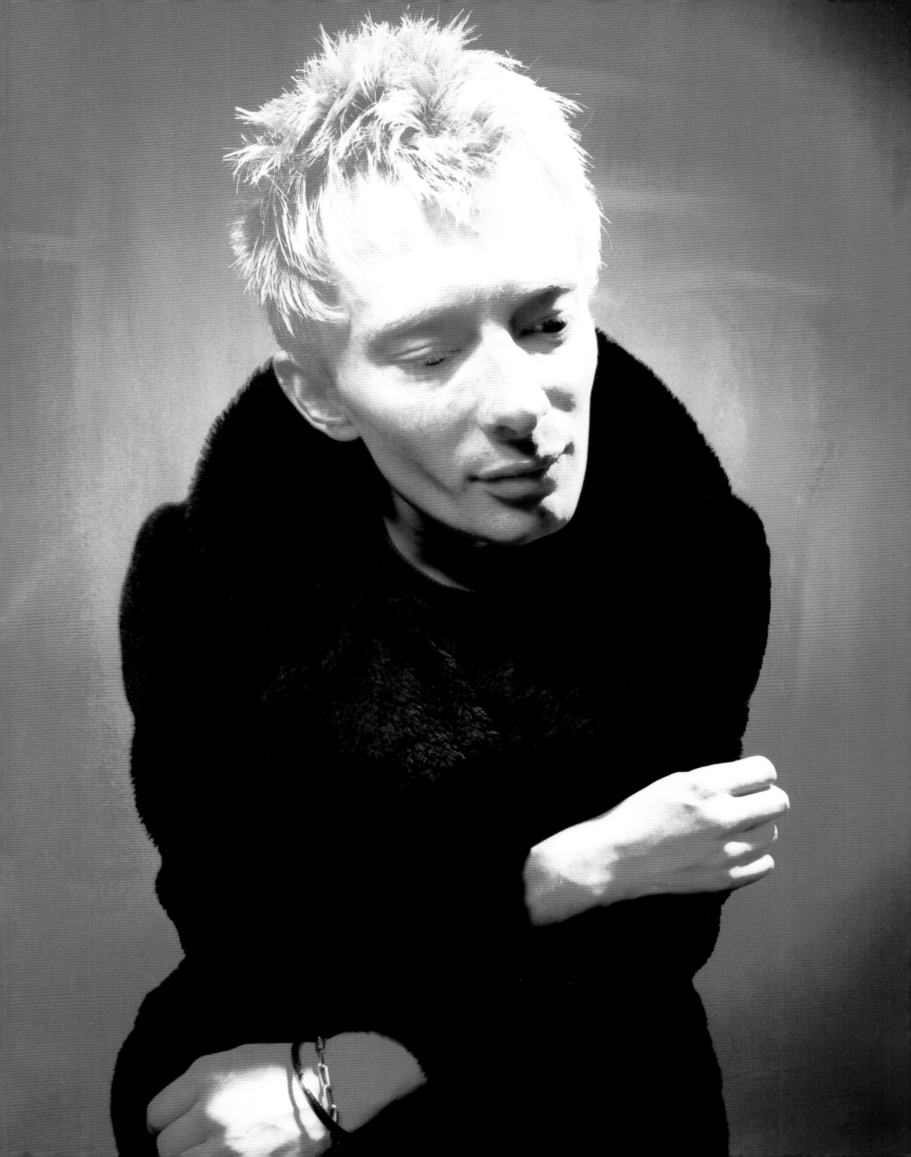

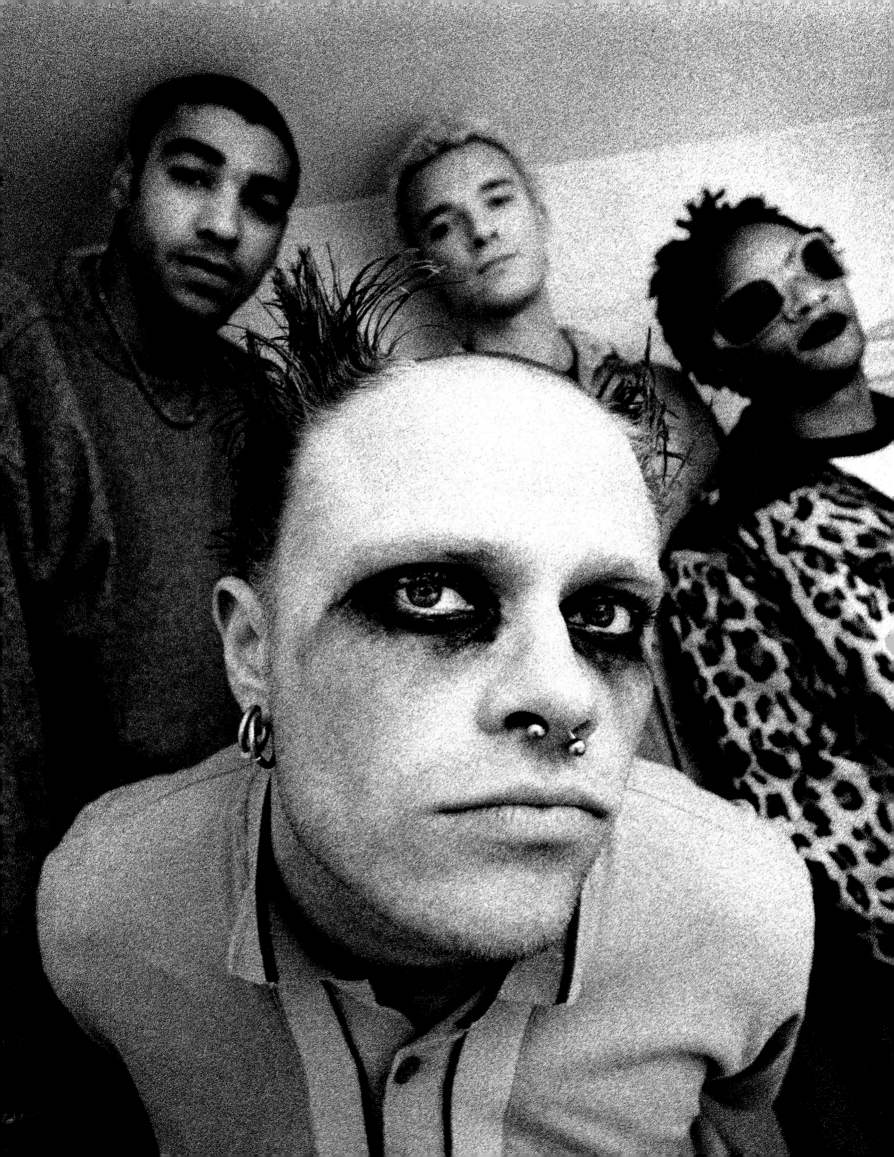

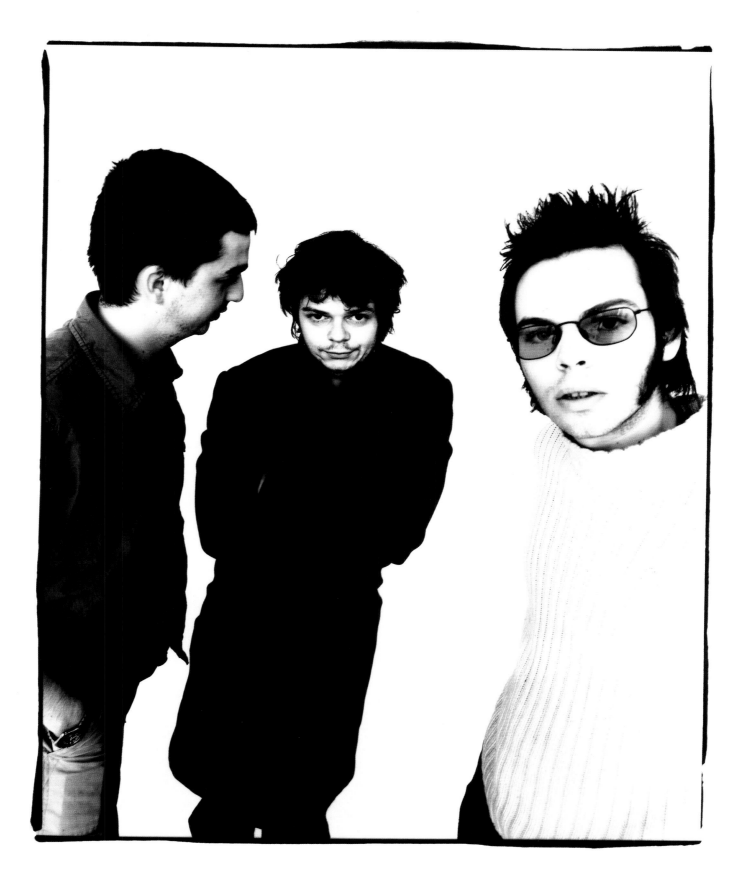

THE PRODIGY

PHOTOGRAPHY STEVE GULLICK

Taken for the *Melody Maker*. I had done a
session with them some months before which
they didn't like so I did another one

SUPERGRASS

PHOTOGRAPHY STEVE GULLICK

Taken at the time of the last General Election:
New Supergrass, New Danger

RICHARD ASHCROFT
(LEAD SINGER THE VERVE, NOW SOLO)
PHOTOGRAPHY RANKIN

Taken for the cover of *Dazed & Confused* just
before the band split up the first time round in
'95. It is the picture I get the most compliments
for, mainly from women, who all ask me for a print

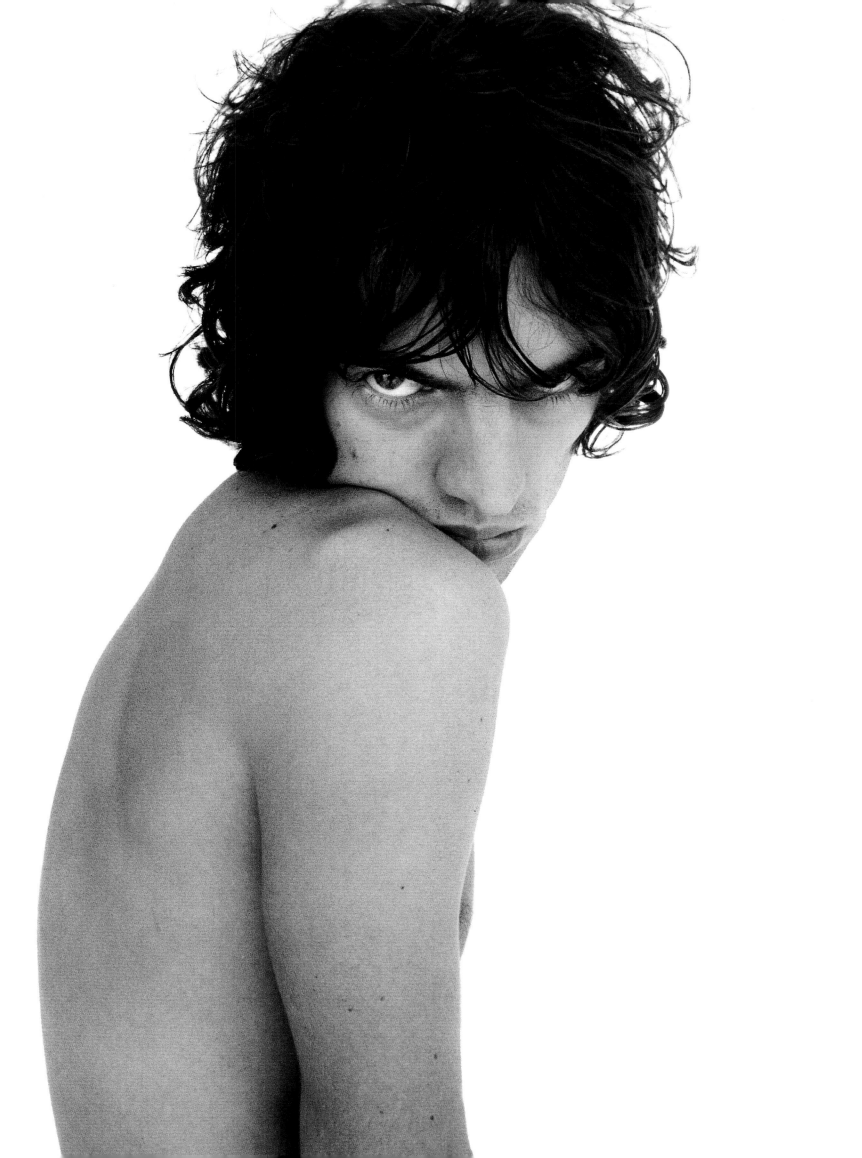

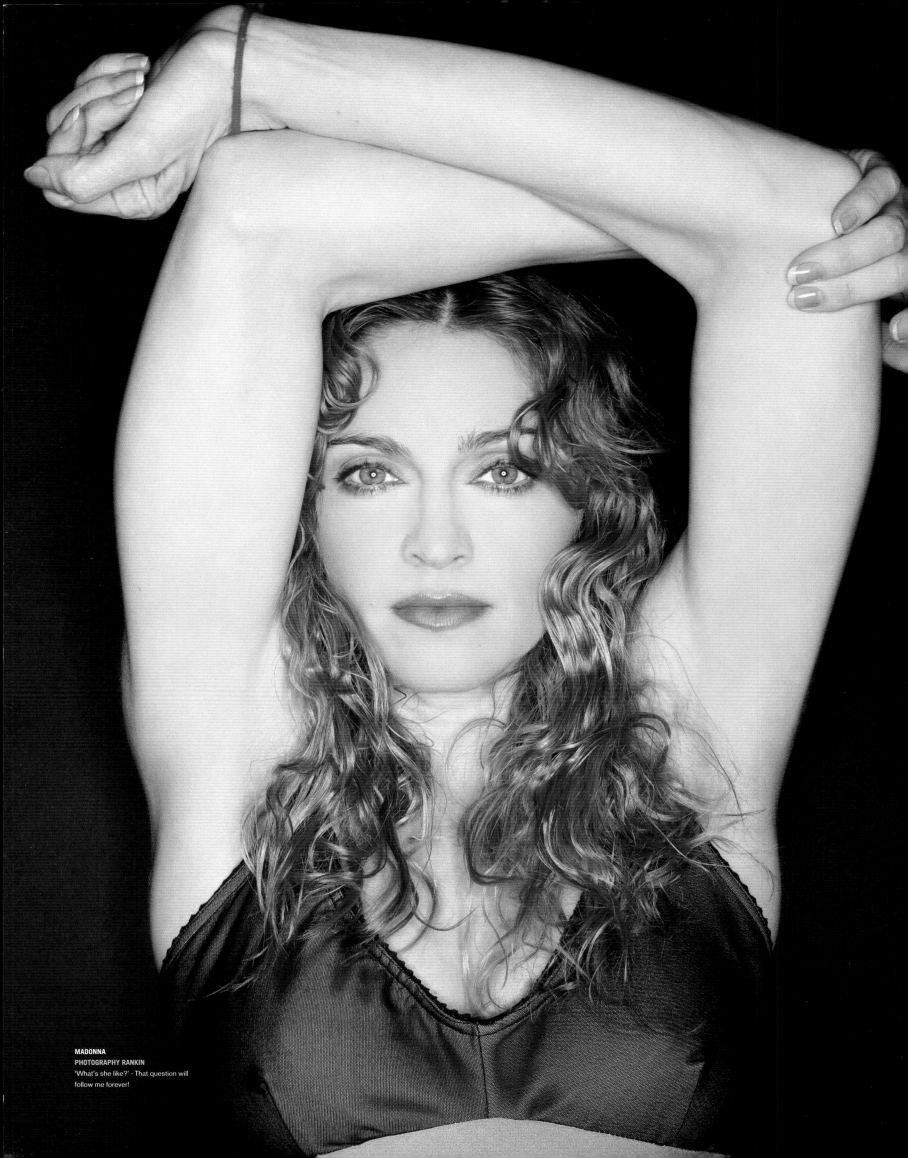

MADONNA
PHOTOGRAPHY RANKIN
'What's she like?' - That question will
follow me forever!

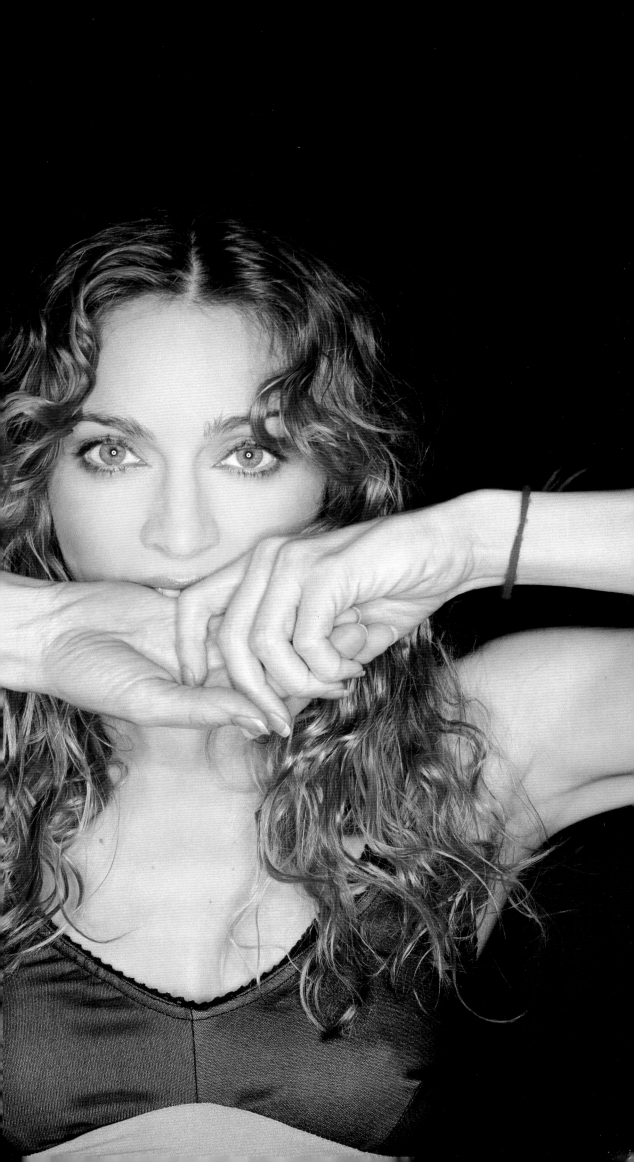

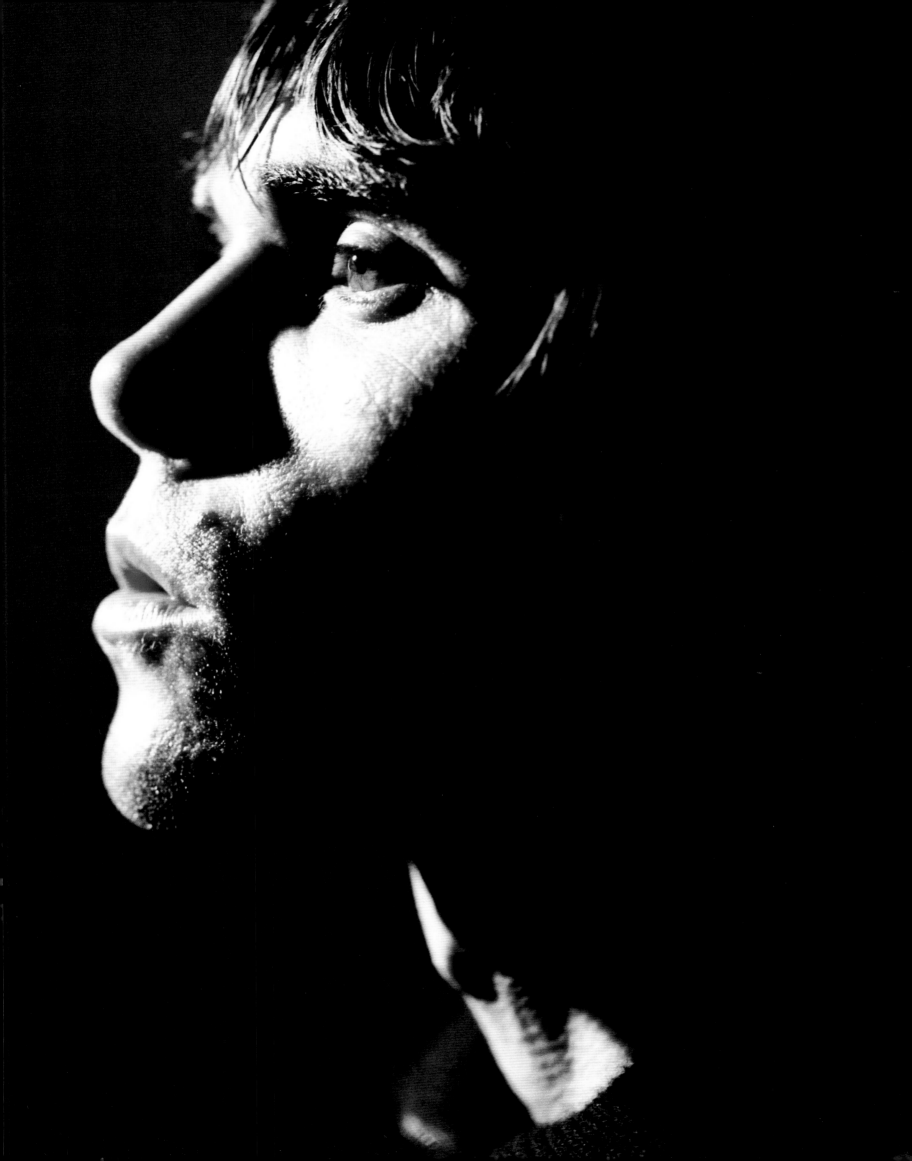

THE CARDIGANS
PHOTOGRAPHY HAMISH BROWN
Swedish cool

UNDERWORLD
PHOTOGRAPHY HAMISH BROWN
From a press session for their album, *Beaucoup
Fish* for Junior Boys Own. Shot in Bow, East
London, March '98

FAT BOY SLIM (AKA NORMAN COOK)
PHOTOGRAPHY HAMISH BROWN
From a press session for his current album
You've Come A Long Way Baby. This was shot
at Norman's house in Brighton

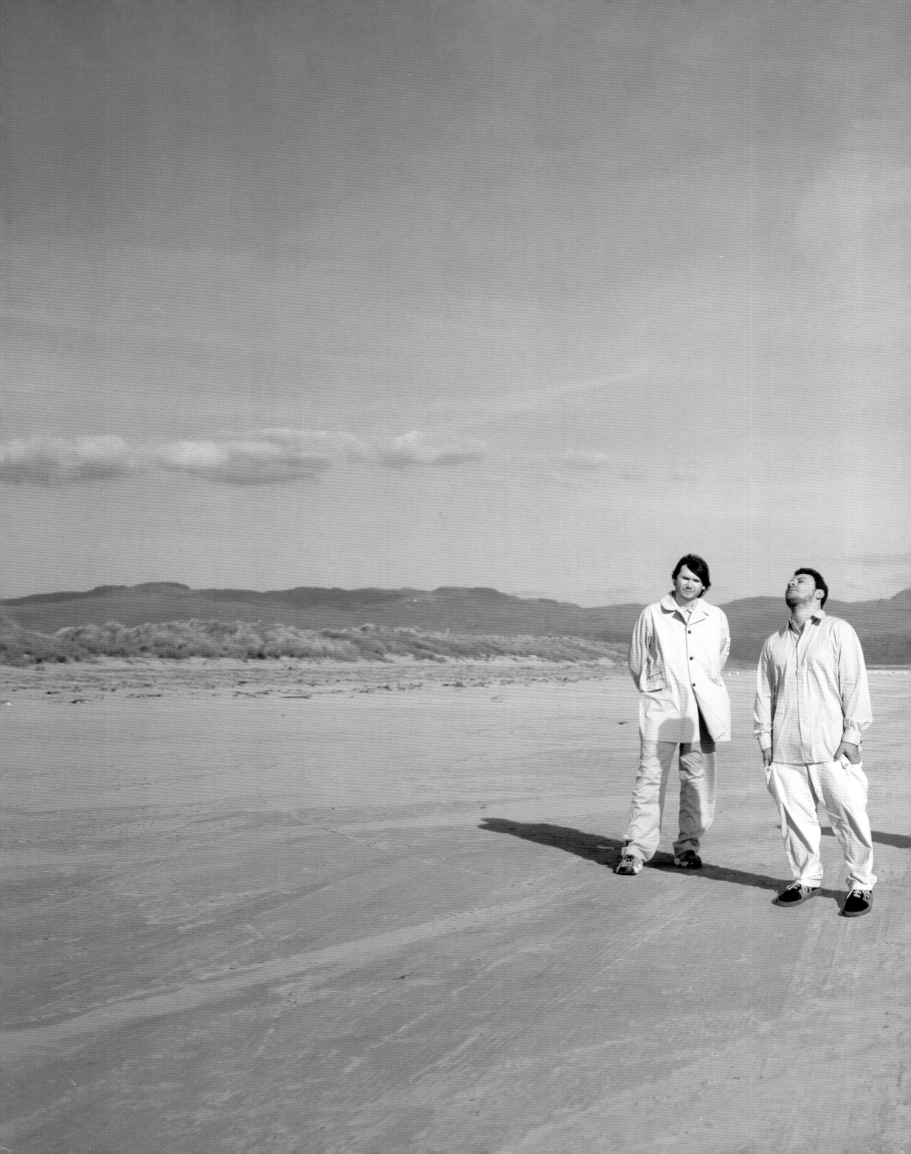

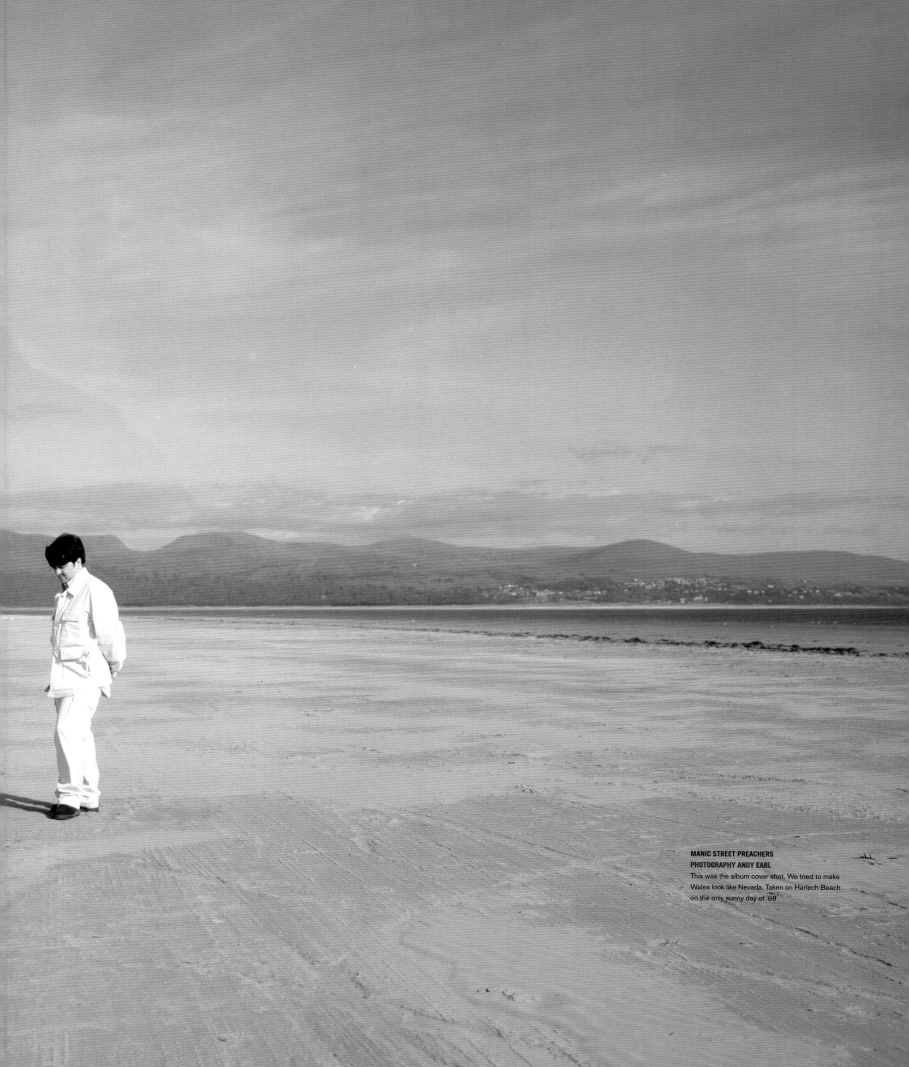

MANIC STREET PREACHERS
PHOTOGRAPHY ANDY EARL
This was the album cover shot. We tried to make
Wales look like Nevada. Taken on Harlech Beach
on the only sunny day of '98

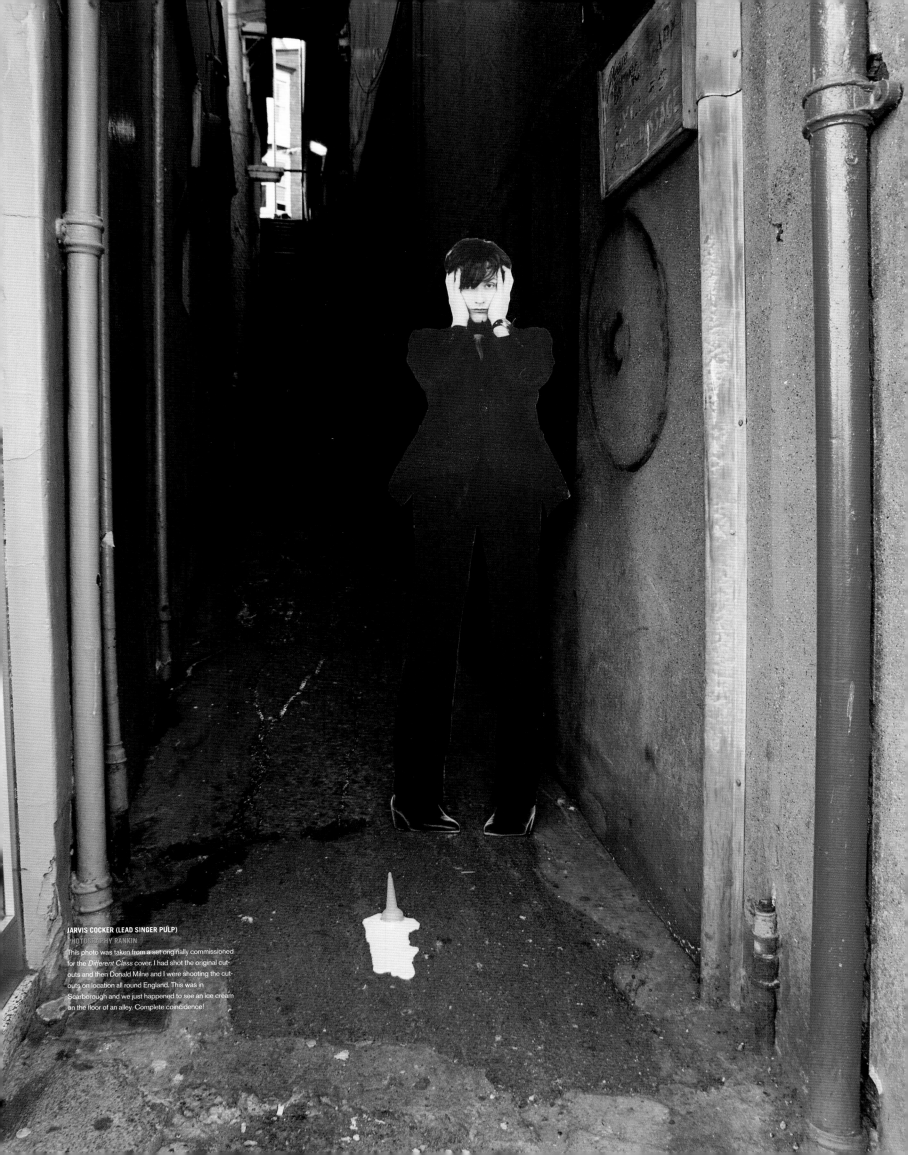

JARVIS COCKER (LEAD SINGER PULP)
PHOTOGRAPHY RANKIN

This photo was taken from a set originally commissioned for the *Different Class* cover. I had shot the original cut-outs and then Donald Milne and I were shooting the cut-outs on location all round England. This was in Scarborough and we just happened to see an ice cream on the floor of an alley. Complete coincidence!

BIOGRAPHIES/1

BARRY MARSDEN

Barry Marsden was born in 1954. He gained a first class honours degree in Fine Art from Loughborough College of Art. On leaving college he promptly gave up painting. It wasn't until he was 30 that he got his hands on his first camera and, with absolutely no formal training, he launched himself into the industry. Barry now has a huge client list, which includes *Vox*, *Vogue*, *Time Out*, *Night And Day* magazine and *Melody Maker*. He has taken photographs of an incredible range of people from Margaret Thatcher to multiple murderers.

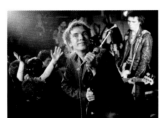

KEVIN CUMMINS

Kevin Cummins was born in Manchester. He attended Salford College in the mid '70s where he studied Industrial Art and Design, concentrating on photography. He took a teaching job at the college when he left and it was during this time that, using college equipment, he took the first photographs of the music scene in Manchester. It was the heyday of punk and the *NME* first used his images in a double page spread about Manchester bands. From then on the *NME* used Kevin as their northern contact until he moved south to London in '87. He continued working for them for the next ten years and now works for a number of publications including *Esquire*, *NewsWeek*, and *Observer Life*. His years in the industry have led to many enduring images. Sex Pistols (past and present), Joy Division, The Smiths, Happy Mondays and Manic Street Preachers are just a few of the bands that have chosen to work with Kevin.

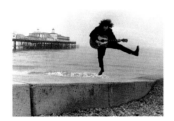

KEITH MORRIS

Keith studied at Guildford School of Art in the mid-late '60s. On leaving he took up a temporary assisting job for David Bailey, which led to other assisting jobs and work with magazines, mainly underground publications. Keith became involved with the magazine *Oz* in the late '60s and started to concentrate on the music industry. This led to commissions for record sleeves, the first of which was Nick Drake's first album for Island Records. Subsequent commissions included sleeves for T-Rex, Led Zeppelin (four of them), ECP, Dr Feelgood and a variety of other artists. Keith was a founder member of Stiff Records in the late '70s and this led to work with a wide range of artists including Elvis Costello, The Damned, Dave Edmunds, Nick Lowe, John Cale, Eddy And The Hot Rods and many more. Keith continues to take photographs, however, he now spends more time teaching.

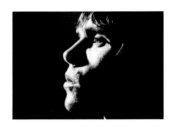

HARRY BORDEN

Harry Borden was born in 1965 in New York but spent his childhood in Devon. After graduating from Plymouth College of Art and Design he moved to London and started working for the NME. In '94 his association with *Observer Life* began and by 1996 he was shooting weekly portraits for the cover. His career expanded rapidly and commissions flooded in from international publications. This period was crowned in '97 with a prize at the internationally renowned World Press competition for a portrait of Richard Branson commissioned by American *GQ*. Success followed success with a prize in the '98 John Kobal Portrait Awards and no less than three of Harry's images were exhibited at the National Portrait Gallery in London. In '99, Harry was again the recipient of a prize in the World Press competition; this time it was a portrait of Björk that impressed the judges. Harry's work is published in countless magazines internationally and his unique visual style ensures his place as one of the foremost British portrait photographers working at the moment.

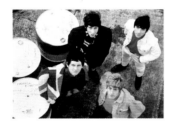

DAVID WEDGBURY

In 1963, armed only with a Marmite sandwich, a camera and a box of film the ambitious teenager, David Wedgbury set off for the famous Cavern Club in Liverpool at the dawn of Beatlemania. His impressions are vivid, "I photographed all these kids waiting outside for The Beatles until it was time to go downstairs. That's when I realised that it really was just a cellar with the toilets blocked up and everyone walking around in an inch of urine... they all had this curious way of walking around on their heels." David Wedgbury's images from the '60s rate as some of the finest and well-known and his work in Liverpool documented the rise of some of the most influential performers of our time. There can hardly be a respectable record collection that doesn't contain at least two of his cover shots; David was responsible for the classic Eric Clapton *Beano* comic session for John Mayall's Bluesbreaker's million seller. He also immortalised the legends of the era such as the Small Faces, Marc Bolan, David Bowie, The Who, The Rolling Stones, Van Morrison and Marianne Faithfull. During the course of his career there seems to be no one that escaped the Wedgbury lens.

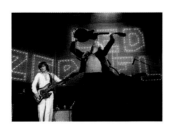

PENNIE SMITH

Pennie Smith was born in London and attended Twickenham Art School in the '60s, where she studied graphics and fine art. On leaving, she set up a studio in a disused railway station in West London. Her first non-paying job was for *Frendz* magazine; the art director of the magazine, Barney Bubbles, persuaded her to take up photography and this led to work for the *NME* in the early '70s. Pennie shot the majority for the covers of the *NME* from '75-'82. Pennie was responsible for the publication of the best selling book *The Clash: Before & After* and has also worked on countless band tours, album covers, books and magazine and newspaper features. Pennie still works freelance and continues to specialise in black and white photography. Her work has been exhibited worldwide and several of her photographs have been purchased for the National Portrait Gallery in London.

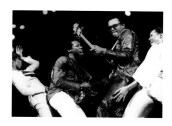

JILL FURMANOVSKY

Jill Furmanovsky was born in Rhodesia in 1953 but came with her family to England in '65. After studying graphic design at Central St Martins School of Art, Jill became in-house photographer at the Rainbow Theatre between '72-'79. There she specialised in live rock concerts and worked with artists such as Stevie Wonder, The Faces, Muddy Waters, Marley, Jagger, The Clash, Sex Pistols, Pink Floyd, Pretenders, The Police, Eric Clapton and many others. Jill works with international publications too numerous to mention and, as well as portraiture, she also turns her hand to photo-journalism, film stills and uses her talents to direct pop promos including two for Oasis, a band she has long and continuing associations with. She has won countless awards over the years and her work has been internationally exhibited.

HAMISH BROWN

Hamish Brown attended the London College of Fashion before deciding to leave prematurely in order to take up a job at the *NME* in 1997. Hamish now shoots *NME* covers, these have included Massive Attack, Beastie Boys, REM, Beck, Mel C, Quentin Tarantino, Iggy Pop, Primal Scream and The Charlatans. Hamish went on tour with Robbie Williams and formed a long relationship with the star, shooting artwork for the "Angels" CD sleeve, press sessions for the record company, tour programmes, video sleeves and Robbie's book *Let Me Entertain You*. Hamish also shoots for *Paper*, *Nylon* and *Instyle* magazines in the US, in addition to his work for numerous UK publications. He regularly works with artists such as Tom Jones, Underworld, The Chemical Brothers and Norman Cook. Hamish was also commissioned to shoot the sleeve for the Prodigy single "Smack My Bitch Up." Hamish's portraits of Robbie Williams and Tim Burgess of The Charlatans are in the collection of the National Portrait Gallery in London.

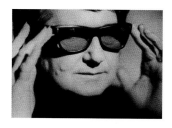

SHEILA ROCK

Sheila Rock started her photographic career largely through the pages of *Face* magazine throughout the '80s. She has particularly strong memories of her session with the artist Sting and sheds light on the lengths that some photographers will go to when working, "The session was for *Cosmo* and I did the shoot at his home in London. We did a few yoga asanas together to get the right feeling." She also has fond memories of her time with Roy Orbison; "I remember his gentle manner, his Southern charm and his diamonds. I was told to make him look like the icon that he is." It is her sensitivity to her subjects that make Sheila such a successful portrait photographer and this success has continued in all her work which now encompasses fashion, beauty and advertising campaigns.

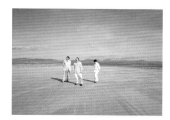

ANDY EARL

Andy Earl was born and brought up in Sussex and before attending Worthing College of Art, he spent some time working as a mechanic for James Hunt. After the foundation course at Worthing he studied at Trent Polytechnic where he was encouraged to concentrate on photography, this led to a scholarship to study in Baltimore. This was a formative time for Andy and he was strongly influenced by American colour photography. The strength of his work led to a show at the Photographers Gallery in London in '78 and the following year his extraordinary vision was celebrated when he was chosen to represent Britain at the Venice Biennale. Malcolm McLaren was so impressed by what he saw of Andy's work that he commissioned him to undertake the controversial Bow Wow Wow album cover, a hugely successful career in the international music business followed. He has shot over 20 music videos for acts including The Rolling Stones.

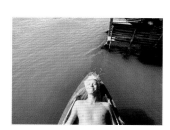

DENIS O'REGAN

At the age of nine Denis forced his mum to take him to see The Beatles at the Hammersmith Odeon in London. He was to return to the venue a decade later to see Queen and David Bowie's Ziggy Stardust. In the intervening years, Denis, a rebellious pupil, had left school early with the intention of going to art school but with no desire to study he ended up taking a job as an insurance broker in the City of London. A further decade later in '83 Denis returned to the Hammersmith Odeon, this time as Bowie's tour photographer on the global *Serious Moonlight* tour. Denis had become a photographer in '78 and his immediate success had lead to his touring with Thin Lizzy in '81 and The Rolling Stones in '82 prior to joining Bowie. Denis also toured with Duran Duran and Spandau Ballet before covering Queen's final tour in '86. Denis was the UK Live Aid photographer and he conceived and coordinated the record breaking *Live Aid* book. Since then, as well as producing other books, Denis has toured again with Bowie, Neil Diamond and Pink Floyd to name just a few. In December '99 he photographed Paul McCartney's Cavern gig; no other photographer was allowed access, a tribute to Denis' reputation and credibility in the music industry. Images from this event are available to view on Denis' website remotemusic.com.

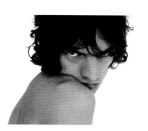

RANKIN

Rankin co-founded *Dazed & Confused* with Jefferson Hack in 1991. At first a low circulation, infrequent fanzine with high-class aspirations, the magazine quickly grew with the creative spirit of the times. Early '90s London saw the rise of club culture, music, art, fashion and film scenes, an explosion of talent that was represented in the magazine. Rankin has photographed nearly every cover story for *Dazed*, a litany of famous and infamous faces. He has also contributed to countless other publications and works for the *Big Issue* on a voluntary basis. Exhibitionist, photographer, publisher and mass media manipulator, Rankin's disguises, vices and creative devices have conspired to make him one of the most high profile and inventive imagists of the late '90s.

BIOGRAPHIES/2

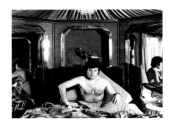

ALAN BALLARD

Alan Ballard started his photographic career at the *Evening Standard* where he assisted the picture editor. He then assisted the eminent fashion photographer John Cowan. Together they travelled extensively on fashion assignments and Alan spent six months in New York working for American *Vogue*. On his return he started to contribute regularly to the *Sunday Times* and later the colour supplement. On one of his diverse assignments Alan took photographs on the set of *The Naked Runner,* which led to almost exclusive access to the stars Frank Sinatra and Mia Farrow who were just married. The pictures were syndicated around the world and made Alan's name as a photographer. His celebrity led to further film commissions including Ken Russell and Fellini films. Film work led to work in the music world and Alan became the official photographer for the Bay City Rollers . With the advent of punk Alan found work providing images for album sleeves for bands such as The Damned and The Clash. In the '80s Alan collaborated with artists as varied as Spandau Ballet, Eric Clapton, Phil Collins and Shakin' Stevens. Alan, now in his 50s, lives in the country where he owns a pub. His photographic work is purely personal at the moment, but Alan is by no means in retirement; with his talent and drive it would be impossible for him put his camera down for good.

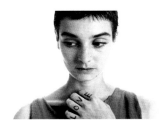

JOHN STODDART

John has been based in London since 1982. He now works from a studio in Soho but obviously travels the world for his art, working in the USA and Europe a great deal. He has photographed everyone from Benjamin Netanyahu to Arnold Schwarzenegger for magazines from *Vanity Fair* to *i-D*. John was responsible for the publication of *It's Nothing Personal,* a hugely successful book that commented on the modern value of fame and brought together some of John's stunning and memorable images from the past 12 years.

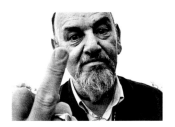

MARTYN GOODACRE

Martyn grew up in Worcestershire and moved to London when he was 17. In London he got himself a place in a squat and at this time he decided to become a photographer. He recalls, "I couldn't do anything else and didn't want to get a proper job." He started to concentrate on street photography and after a spell in a drug rehab clinic he moved to San Jose where he concentrated on taking photographs of street skateboarders. Other assignments at this time were as a pet photographer, taking pictures of cats and hamsters. Although stimulating, he didn't find this very financially rewarding and he finally gave it up when he forgot to sedate a groundhog and it bit him - Martyn still has the scar. In '90 he came back to London and began his association with the *NME* and he has been taking memorable photographs for them ever since.

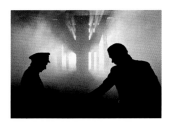

BRIAN COOKE

Brian Cooke studied photography at Hull College of Art, then lectured at Teeside College. His night-time activities, however, set the tone for his future career as he started to "roadie" for a band called The Mandrakes and then took on the role of manager. The lead singer was Alan Palmer, he changed his name to Robert when he later joined the The Alan Bown Set. Through Robert Palmer, Brian was introduced to many other acts and this led to his moving to London in '71 with his wife, a graphic artist. They set up Visualeyes providing independent record companies with photographic and design services. During this time Brian worked regularly with Traffic (Steve Winwood), Vinegar Joe (Elkie Brooks and Robert Palmer), Jethro Tull (Ian Anderson) and Roxy Music (Brian Ferry). Later Brian together with Trevor Key formed the design company Key Cooke and they were credited with over 150 album covers, including *Bursting Out* for Jethro Tull. They were also involved in a turbulent relationship with The Sex Pistols. In the '80s Key and Cooke went their separate ways and Brian moved into taking stills of pop videos, this led to Brian setting up his own video production company. Since the late '80s, Brian has been following his interest in the field of electronic imaging, ensuring his continual place in the vanguard of design and creativity.

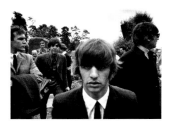

JOHN HOPKINS

John Hopkins, now in his 60s, provided the following CV:
1960: After 2 years as Harwell reactor physicist, ejected from USSR, arrived London as photojournalist: Peace News, Sunday Times, Melody Maker. 1964: Took LSD, co-published Ginsberg, Burroughs in UK. Hung out with NY jazz avant garde. 1965: Recorded Steve Lacy, found Pink Floyd and AMM Music. 1966: Co-founded Notting Hill Carnival, *IT* (*International Times*), started UFO first psychedelic nightclub. 1967: 14hr Technicolor Dream, met Jagger and Richards in Wormwood Scrubs. 1968: Married Susy Creamcheese. 1969: Institute for Research in Art and Technology, started TVX with Jobear Webb & Till Romer, helped by The Beatles, Pete Townshend. Visited KQED met Brice Howard. 1970 with Cliff Evans, Steve Herman, John Kirk made "Videospace" for BBC TV. 1972: Wrote *Video In Community Development*; squatting. 1975-95: Fantasy Factory Video with Sue Hall, worked for UNESCO, Arts Council, CA, Australian Film Commission. Established use of video as defence evidence. 1996: University research in plant tissue culture. 1999: First one man show. 2000: Co-wrote *Planta: Role of Extensin Peroxidase In Tomato Seedling Growth.*

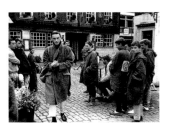

STEVE PYKE

Steve Pyke has exhibited worldwide and worked for many publications, photographing the personalities of the century. His sitters include many of the great religious and political leaders, prominent figures in the arts and popular culture as well as the homeless and dispossessed. He undertakes long-term personal projects, such as portraits of the principal Philosophers of the Western world and *Uniforms*, an investigation of European youth identity. Steve is currently continuing his work with the homeless and is working on a book to be published in Autumn 2000, entitled *Pyke-Eye.*

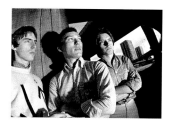

GERED MANKOWITZ

Gered Mankowitz's first assignment was on a school trip to Holland, the photographs that Gered took then showed so much promise that he was offered an apprenticeship by the legendary photographer Tom Blau. Gered left school at 15 with not one formal qualification to his name and worked at Tom Blau's photo agency Camera Press, gaining invaluable experience in all the various departments. In the mid '60s, Gered found his niche working with the show-biz photographer Jeff Vickers, gaining invaluable experience taking portraits of many actors and other personalities. This led to work in the music industry in the '60s at a time when it desperately needed the mould-breaking images Gered could provide. His reputation led to work with Marianne Faithfull and subsequently The Rolling Stones with whom he toured the US. He also worked with artists such as Jimi Hendrix, Free, Traffic, The Yardbirds, The Small Faces and Soft Machine. From the '70s, his images include Slade, Gary Glitter, Suzi Quatro, Sweet, Elton John, Kate Bush, Eurythmics, ABC, Duran Duran and many others. Gered still works in the music business, photographing bands and singers for album covers and magazines such as *Mojo* as well as taking prize winning photos for the advertising industry. His work has featured in several books and exhibitions and his prints are highly sought after. During a recent show in New York featuring images of the Rolling Stones, Tommy Hilfiger bought prints of the entire show becoming Gered's single biggest collector in the US.

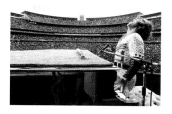

TERRY O'NEILL

Terry O'Neill does not claim that he has always wanted to be a photographer, it is his varied experience of life that ensures his ability to connect with the extraordinary range of sitters he comes into contact with. The rich and famous beat a path to his door. It's his kindness and love of humanity that has made him a firm favourite with those so often in the public eye. O'Neill's lens has captured for posterity the essence of everyone who is anyone for the past 30 years and each of his subjects is painstakingly researched, so that on the day he is able to put them at their ease with informed friendly chat, enabling him to achieve the degree of spontaneity that is "the key to it all". Despite his worldwide reputation, O'Neill has the ability to be critical of his own work and accepts that he might not create a masterpiece every time he shoots. His self doubt is indicative of a lack of ego, which is extraordinary given the incredible success of his portraits of anyone from Queen to *the* Queen.

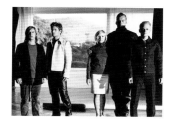

DERRICK SANTINI

Derrick Santini was born in Scarborough in 1965 and started taking pictures with his mum's camera when he was 13. He came to London to attend the London College of Printing and on leaving, immediately found work on a film, spending two months taking stills on set in Texas. He is now a regular contributor to magazines such as *i-D*, American *Vogue*, *Marie Claire* and *Spin* and his work encompasses fashion and portraiture. However, his passion lies in music and Derrick loves his involvement with the industry, continuing to take iconic portraits of a wide range of artists and turning his hand to music video direction.

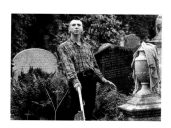

DEREK RIDGERS

Despite telling women in bars for years that he is only 29, it's well known that he was born near the brewery in Chiswick, West London around 1950. A difficult youth, it was thought that he might be artistic and was sent to Ealing School of Art where he even managed to lose out in matters of the heart to a then heterosexual Freddie Mercury. On leaving he embarked on a somewhat chequered career in the advertising world. After being sacked from a dozen jobs in less than a decade he figured maybe photography could be more his thing. He quickly established an appalling reputation in the flea pits and clip joints of inner London photographing punks, skinheads, new romantics and the like and through a combination of bullshit and bluster managed exhibitions at The ICA (*Punks Portraits*, '78) Chenil Gallery (*Skinheads*, '80), The Photographers' Gallery (*The Kiss*, '82) and The Fotogallery (*We Are The Flowers In Your Dustbin*, '83). Turning his so-called talents to the world of editorial portraiture, he managed to hold out long enough to do nearly 150 front covers for magazines like *Face*, *NME*, *Time Out* and *Loaded*. "Like" may be the operative word here - they say that they've never heard of him.

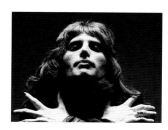

MICK ROCK

After graduating from Cambridge University, Michael Rock decided to follow his fascination with rock'n'roll by taking photographs; his earliest key subject was Syd Barrett, founder of Pink Floyd. In 1972 he met David Bowie just before his Ziggy Stardust period and became his official photographer. Work followed with Lou Reed, Iggy Pop, Queen, and London's "glam" scene. His work is featured on some of the iconographic album covers of the '70s, including *Transformer*, *Raw Power*, and *Queen II*. He moved to New York and worked with the seminal punk performers such as Blondie, The Ramones, Dead Boys and Talking Heads. His photo of Johnny Rotten became the Sex Pistols first national US magazine cover. Mick is a multi-award winning photographer. His iconic rock images, along with more recent photo-collage art and erotica, have been exhibited in galleries all around the world. His enthusiasm for rock'n'roll remains undimmed as he continues to photograph into the new millennium.

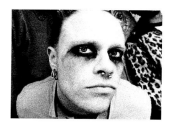

STEVE GULLICK

Steve Gullick was born in Coventry in 1927. After amazingly surviving the city's severe blitz during World War Two, he went on to father 27 children, among them famous names like Kurt Cobain, Thom Yorke, Keef Flint and Bono. Through his children, at the age of 63, Gullick took his photographic hobby into the professional arena where he has amazed the picture viewing public with a million stunning photographs of his most famous children.

ACKNOWLEDGMENTS

I would firstly and most importantly like to thank all the photographers in this book for their tremendous patience, advice and of course their stunning photographs. It has been a privilege and an honour to work with so many talented people and with some of the most famous images in the world. I would also like to thank Terence Pepper who inspired the exhibition and book, and whose expert advice and help are always highly valued. Alan Hamilton has been the back bone of the whole project from start to finish and deserves the lions' share of the credit for its compilation. Joe's Basement have as always been a solid pillar of support - thank you to all the staff there for putting up with our ridiculous deadlines and always managing to laugh rather than shout at us, and most importantly for the consistently high quality of work they produce for Proud Galleries and Vision On. Thanks to the design and production teams, Steve Savigear for his delicate manner and driving force (shame about the football team), Martin, the Tall Guy as we know him, for his tireless devotion to perfect design, Emma at Proud Galleries who heroically absorbs far too much abuse, Sandra for giving too much out and keeping Rankin under some sort of control, and Rankin who has unexpectedly turned into rather a good friend and a damn good business partner. Finally thanks to everyone else who has helped, and I apologise for there being too many too mention, but you know who you are, especially all my friends who have had to put up with me talking about this project for far too long! I hope you enjoy reading this book as much as we enjoyed putting it together.

Alexander E Proud, London. January 2000

Foreword: **Phil Sutcliffe**

Book Design: **Martin**@Fruit Machine

Photographic Prints: **Joe's Basement**

Reprographics: **AJD Colour Ltd**

Print: **Godfrey Lang**

Production Manager: **Steve Savigear**

Production Editor: **Lotte Ould**

Rock'n'Roll Years first published in Great Britain in 2000 by Vision On
+44 207 549 6808
112 Old Street EC1V 9BG
E-mail visionon@visiononpublishing.com

Photography by
John Hopkins, David Wedgbury, Gered Mankowitz, Mick Rock, Keith Morris, Pennie Smith, Alan Ballard, Kevin Cummings, John Stoddart, Martyn Goodacre, Steve Pyke, Sheila Rock, Brian Cooke, Derek Ridgers, Hamish Brown, Steve Gullick, Derrick Santini, Rankin, Barry Marsden, Harry Borden, Andy Earl, Jill Furmanovsky, Terry O'Neill and Denis O'Regan

Photographic copyright
John Hopkins, David Wedgbury, Gered Mankowitz, Mick Rock, Keith Morris, Pennie Smith, Alan Ballard, Kevin Cummings, John Stoddart, Martyn Goodacre, Steve Pyke, Sheila Rock, Brian Cooke, Derek Ridgers, Hamish Brown, Steve Gullick, Derrick Santini, Rankin, Barry Marsden, Harry Borden, Andy Earl, Jill Furmanovsky, Terry O'Neill and Denis O'Regan

The right of **John Hopkins, David Wedgbury, Gered Mankowitz, Mick Rock, Keith Morris, Pennie Smith, Alan Ballard, Kevin Cummings, John Stoddart, Martyn Goodacre, Steve Pyke, Sheila Rock, Brian Cooke, Derek Ridgers, Hamish Brown, Steve Gullick, Derrick Santini, Rankin, Barry Marsden, Harry Borden, Andy Earl, Jill Furmanovsky, Terry O'Neill and Denis O'Regan** as the authors of their work has been asserted by them in accordance with the copyright designs and patents act 1988

A CIP catalogue record for this book is available from the British Library

Rock'n'Roll Years is available
from Vision On
+44 207 549 6808